FASHION GAME CHANGERS
REINVENTING THE 20TH-CENTURY SILHOUET

MODEMUSEUM

BLOOMSBURY VISUAL ARTS

AN IMPRINT OF BLOOMSBURY PUBLISHING PLC

BLOOMSBURY VISUAL ARTS
LONDON · NEW YORK · OXFORD · NEW DELHI · SYDNEY

BLOOMSBURY VISUAL ARTS
Bloomsbury Publishing Plc
50 Bedford Square, London, WC1B 3DP, UK
1385 Broadway, New York, NY 10018, USA

BLOOMSBURY and the Diana logo are trademarks of Bloomsbury Publishing Plc

First published in Great Britain 2016

Cover design by Paul Boudens.

Images © Mark Segal, Comme des Garçons, autumn/winter 2012–13, in Vogue Japan.

Chapters 2, 5, 6 and the sections on Louise Boulanger, André Courrèges and Pierre Cardin in Chapter 8 translated by Worldwide Business.

Translation of Chapter 4 © Isabel Haber.

A catalogue record for this book is available from the British Library.

Library of Congress Cataloging-in-Publication Data
A catalog record for this book is available from the Library of Congress.

ISBN: HB: 978-1-4742-7904-8
 PB: 978-1-3500-6534-5
 ePDF: 978-1-4742-8008-2

Typeset in Univers.
Printed and bound in China.

To find out more about our authors and books visit www.bloomsbury.com and sign up for our newsletters.

FASHION GAME CHANGERS

REINVENTING THE 20TH-CENTURY SILHOUETTE

EDITED BY KAREN VAN GODTSENHOVEN, MIREN ARZALLUZ & KAAT DEBO

MODEMUSEUM

BLOOMSBURY VISUAL ARTS
LONDON · NEW YORK · OXFORD · NEW DELHI · SYDNEY

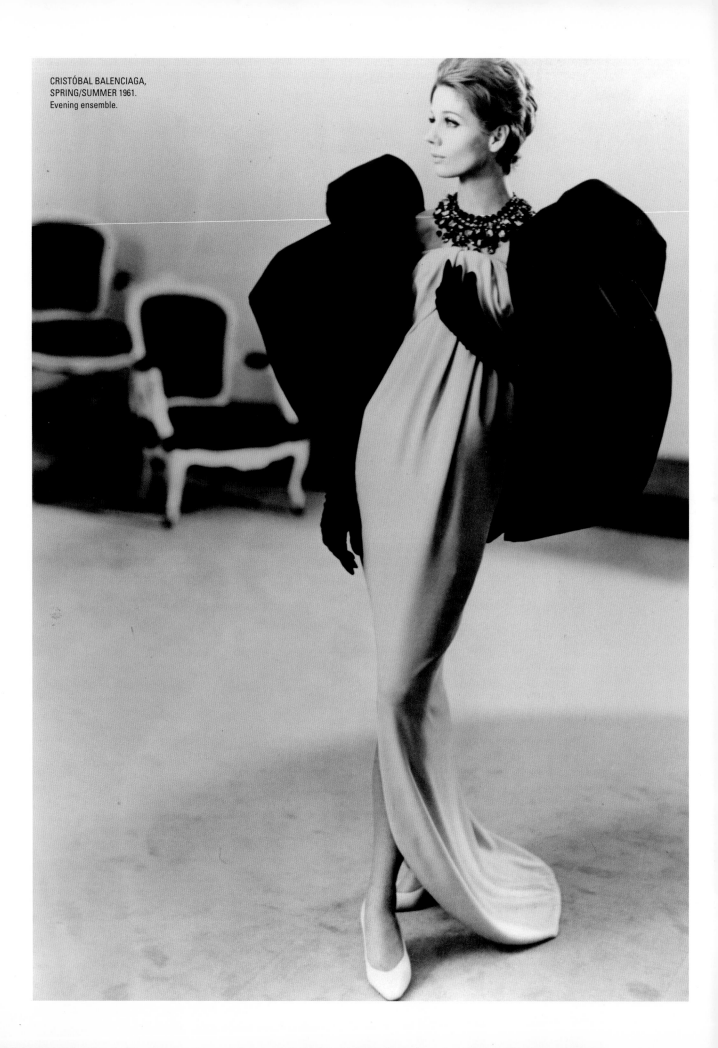

CRISTÓBAL BALENCIAGA,
SPRING/SUMMER 1961.
Evening ensemble.

TABLE OF CONTENTS

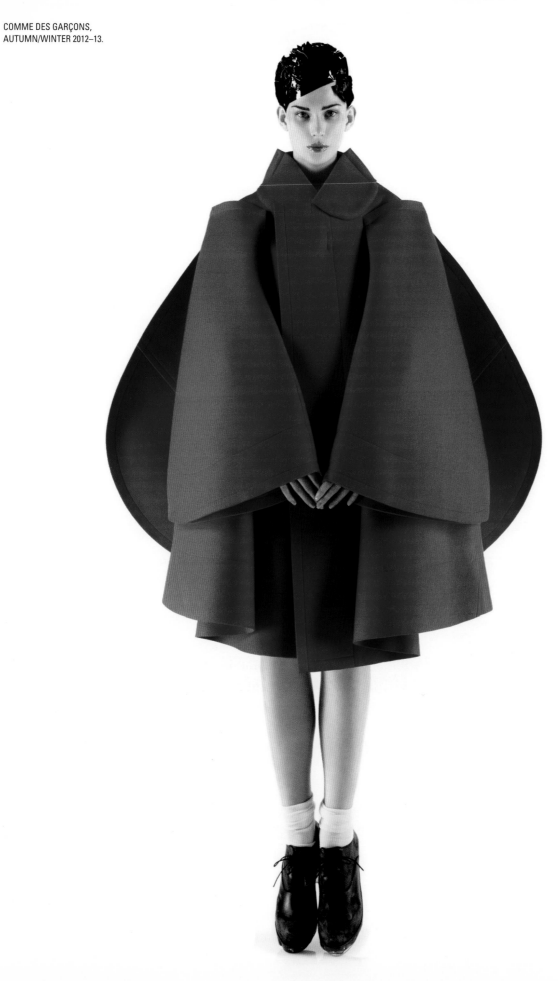

FASHION GAME CHANGERS: REINVENTING THE TWENTIETH-CENTURY SILHOUETTE AN INTRODUCTION

Fashion Game Changers: Reinventing the Twentieth-Century Silhouette is a tribute to those designers who radically transformed the female silhouette in the twentieth century and created alternatives to the hourglass silhouette that had dominated women's fashion for centuries. From the early twentieth century, new silhouettes began to emerge that gave the body more freedom or interpreted the body in more abstract ways, and these continue to echo in our wardrobes today.

This book puts the Spanish designer Cristóbal Balenciaga centre stage of this revolution. His radical innovations in the mid-twentieth century connected pioneers, such as Coco Chanel, Madeleine Vionnet and Paul Poiret, to the later form-innovators of the second half of the twentieth century, focusing in particular on the avant-garde designers of the 1980s. Taking inspiration from, among other things, popular movements such as classicism and orientalism, designers such as Chanel and Vionnet, whom Balenciaga admired greatly, investigated the body's relationship to clothes, and paved the way to more freedom of movement, alternative volumes and novel proportions. In her chapter, Akiko Fukai delves into the influence of Japonism on the Western wardrobe. While Western cuts tend to follow and emphasize the body's curves and lines, traditional Japanese clothing, such as the kimono, shift the focus from the waist to the shoulders. This makes it possible to create flowing silhouettes that wrap the body more than bind it and result in, in Fukai's words, 'a gentle outfit'.

In her contribution, Miren Arzalluz argues that the cocoon or 'barrel' line found in Balenciaga's 1940s designs is strongly linked to the Japonism-inspired innovations of the early twentieth century. As Arzalluz explains, the barrel line marks the beginning of a long series of experiments with forms and shapes, with the construction predominantly emphasizing the back, obliterating the waist and creating much softer silhouettes. Balenciaga's oeuvre and technological ingenuity have exerted a great influence on the female silhouette of the twentieth century. He was a forerunner of the looser silhouette, which is so commonplace in our Western wardrobes that we can't imagine fashion without it. This element was radically reconfigured by the fashions of the 1960s and especially the 1980s by a new generation of iconoclasts.

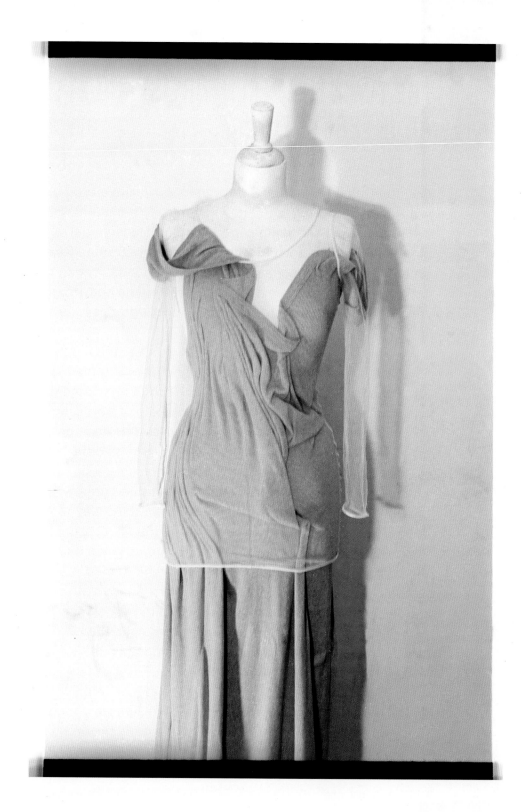

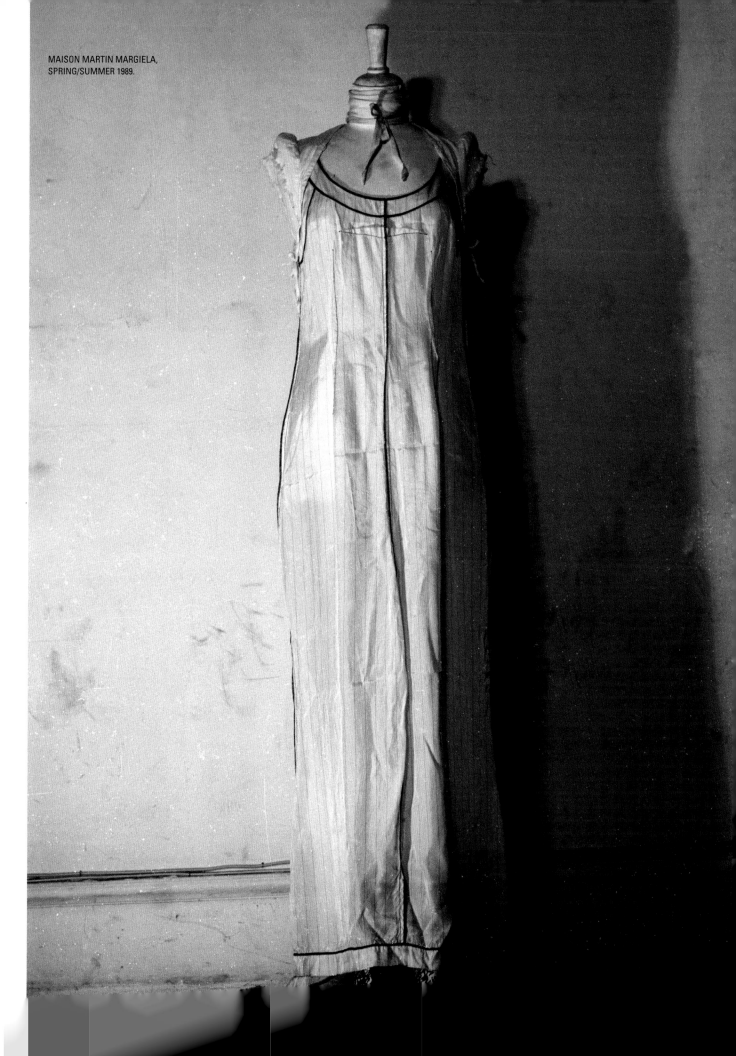

MAISON MARTIN MARGIELA,
SPRING/SUMMER 1989.

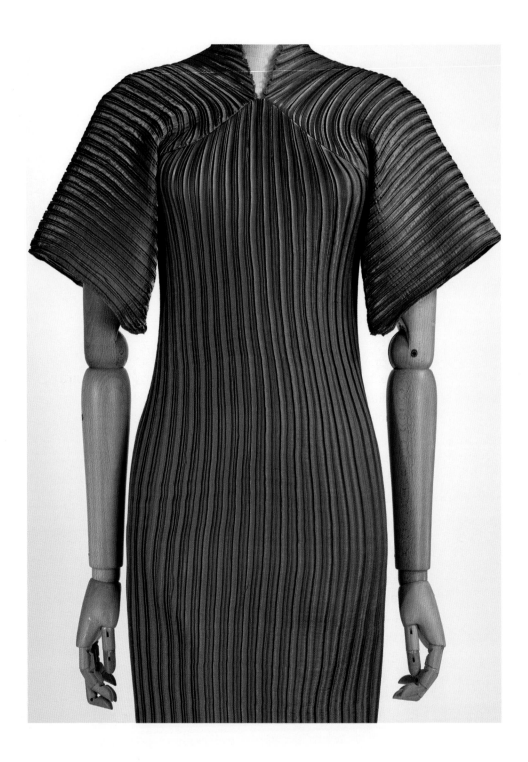

The contribution by Arzalluz illustrates that the mid-twentieth century cannot be simply characterized by the classic couture silhouette, which dominated the 1950s with Christian Dior's New Look. There was also room for radical experiments with forms, which were taken up by and expanded upon by the young designers of the 1960s, such as Pierre Cardin and André Courrèges. The architectural designs of the 1960s were in themselves a bridge to a new era, such as Issey Miyake's label, which was established in the 1970s. It is possible to discern a chain of innovation in the twentieth century, linking a range of otherwise disparate designers: designers who were, using their own vocabulary and in their own social context, fashion game changers. Olivier Saillard focuses on the changing body shape in twentieth-century fashion, which can be found in the collection pieces of his own museum: from Poiret and Vionnet's liberation of the curves, to Chanel's tomboy ideal, and the groundbreaking concept of Rei Kawakubo, for whom clothes became the body, Saillard discusses how shadows of the body remain in the garments after they have been worn. He also looks at the relationship between contemporary fashion and today's craze for surgically altered bodies.

In addition to the thematic chapters, this book includes pen portraits by Miren Arzalluz, Karen Van Godtsenhoven and Alexandre Samson on some of these game changers, who were truly pivotal figures: Louise Boulanger, contemporary of and inspiration to Balenciaga; the Spanish innovator Paco Rabanne; the French futurist and architectural designers from the 1960s André Courrèges and Pierre Cardin; and Briton Georgina Godley who, in the 1980s, explored the boundaries of fashion, garments and the female body. Samson shows their underlying relationships and the familiarity of their design innovations and concepts.

Anabela Becho delves further into the Japanese and Belgian schools, which succeeded each other as breakthrough pioneers on the 1980s fashion stage. Designers such as Yohji Yamamoto, Rei Kawakubo from the Comme des Garçons label, and Issey Miyake, redrew and questioned the Western silhouette, starting from principles that were deeply anchored in an Eastern approach to clothes, textiles and clothing constructions. The Japanese concept of ma, which denotes the space or gap between the body and the garments clothing it, finds its contemporary reinterpretation in the oversized clothing in the collections of Japanese designers, and Belgian designers such as Martin Margiela. Increasingly intense abstraction, distilling shapes and experimenting with certain components such as the shoulder, collar, sleeve or back, together paved a way at the end of the twentieth century for a whole new creative fashion lexicon, and – no less important – an alternative for the then-dominant ideals about femininity.

MAISON MARTIN MARGIELA,
AUTUMN/WINTER 2008–09.
Wool and silk trenchcoat.
MoMu inv.nr. T09/661.

RIGHT:
MAISON MARTIN MARGIELA,
SPRING/SUMMER 2007.
Top and skirt of manmade
fibre net, silk underskirt,
patent leather belt, jersey
bodysuit with padded
shoulders.
MoMu inv.nr. T07/94, T07/95,
T07/92, T07/96.

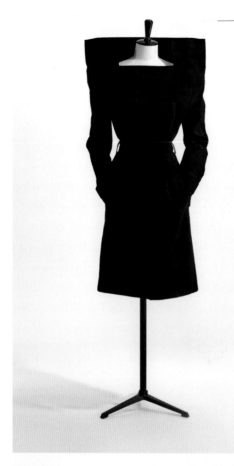

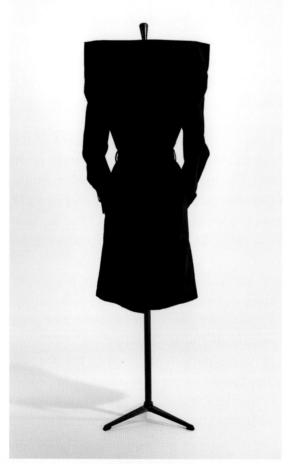

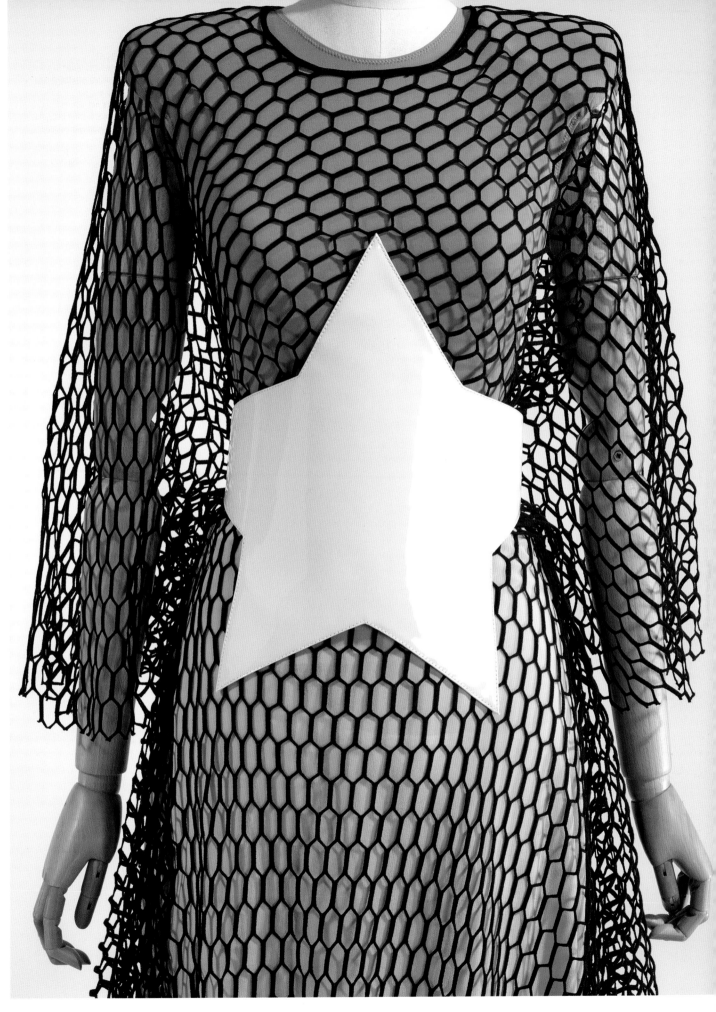

FASHION GAME CHANGERS: REINVENTING THE 20TH CENTURY SILHOUETTE. AN INTRODUCTION

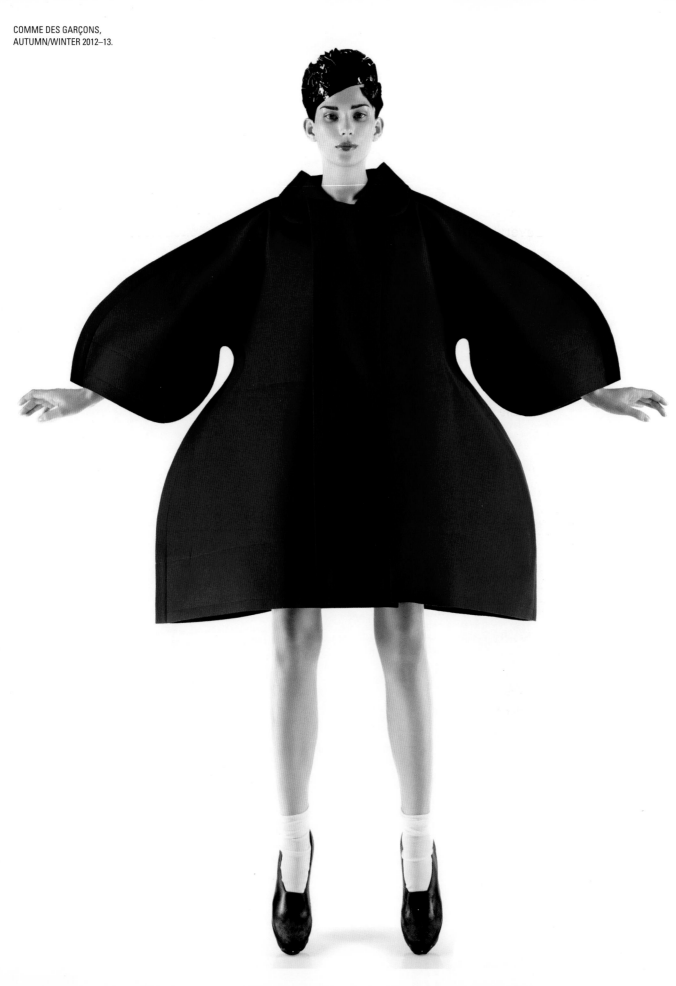

Hettie Judah argues that in the late twentieth century, this new vocabulary required a new visual language that could bring the object-like aspect of the garments to the fore. The Japanese and Belgian fashions, with their voluminous, abstracting and androgynous shapes, obscured the gendered body, which was the antithesis of the 1980s power woman. Judah considers this avant-garde an inclusive movement, as this was the movement where it was perfectly possible to be heavy, old, or both, and still be chic. For this publication, Judah interviewed a number of early adopters of the fashion statements by Comme des Garçons, Maison Martin Margiela or Issey Miyake. Several women told her about their personal experience wearing these clothes and the responses of their environment to these items.

Finally, Karen Van Godtsenhoven investigates in depth the diverse design practices of a number of game changers discussed in this book, and by extension explores the Western and Eastern notions of creation and inspiration. She illustrates how design methods inform the way these designers look upon the relationship between body and garment and how this translates into a specific attitude towards the female body.

This book accompanies the eponymous exhibition that will be on display in the MoMu – Fashion Museum Antwerp in the spring of 2016. I would like to thank the curators of this project, Miren Arzalluz and Karen Van Godtsenhoven, for their greatly valued contribution, as well as the team at MoMu. I would furthermore like to thank the contributors to this book and the lenders for the exhibition at MoMu. A final thank you goes out to the Bloomsbury team, Paul Boudens, the book's designer, and Bob Verhelst, the stage designer for the Antwerp exhibition.

— KAAT DEBO
Director, MoMu – Fashion Museum Antwerp

JIL SANDER BY RAF SIMONS,
SPRING/SUMMER 2011.
Dress in manmade fibre.
MoMu inv.nr. T12/10.

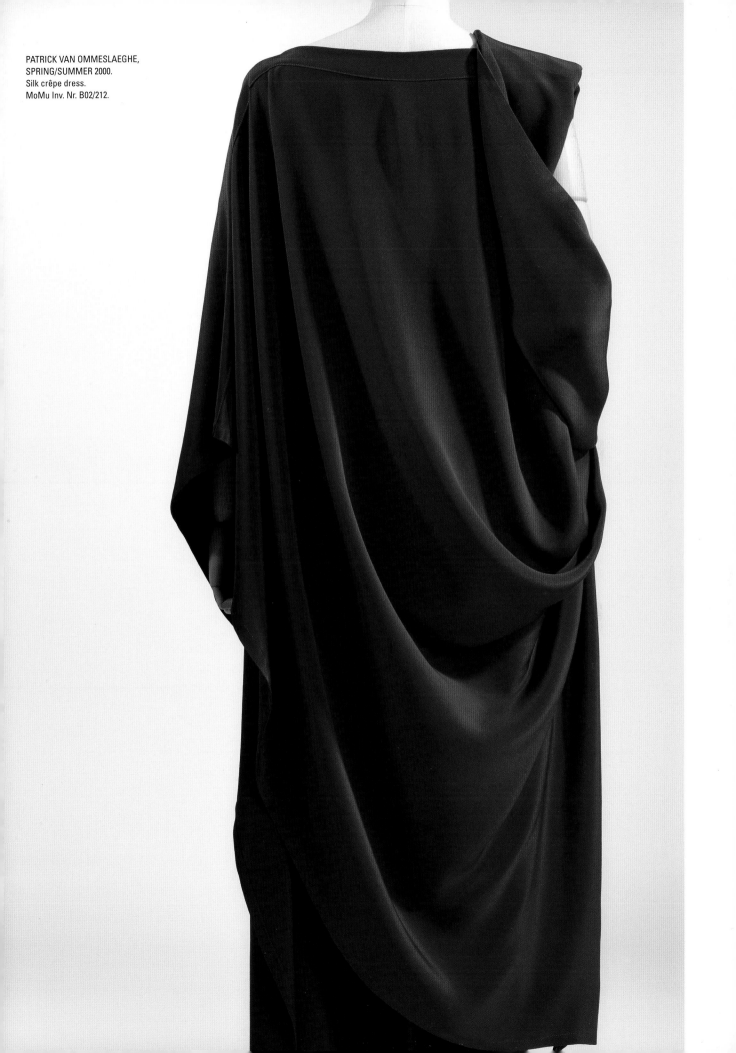

PATRICK VAN OMMESLAEGHE,
SPRING/SUMMER 2000.
Silk crêpe dress.
MoMu Inv. Nr. B02/212.

MAISON MARTIN MARGIELA,
SPRING/SUMMER 1995.
Cotton dress, replica of
an eighteenth-century shirt.
MoMu inv.nr. T96/28.

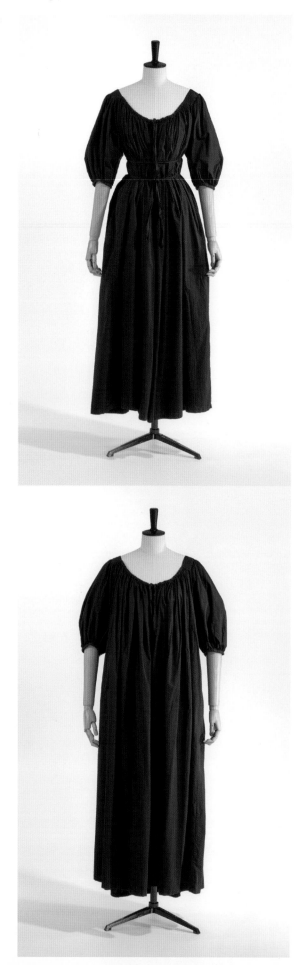

Detail of label from the Maison Martin Margiela
replica of an eigtheenth-century shirt.
MoMu inv.nr. T96/28.

FASHION GAME CHANGERS: REINVENTING THE 20TH CENTURY SILHOUETTE. AN INTRODUCTION

BERNHARD WILLHELM,
SPRING/SUMMER 2007.
Oversized cotton 'baby doll' dress,
patent leather shoes.
MoMu inv.nr. T07/156, T15/626AB.

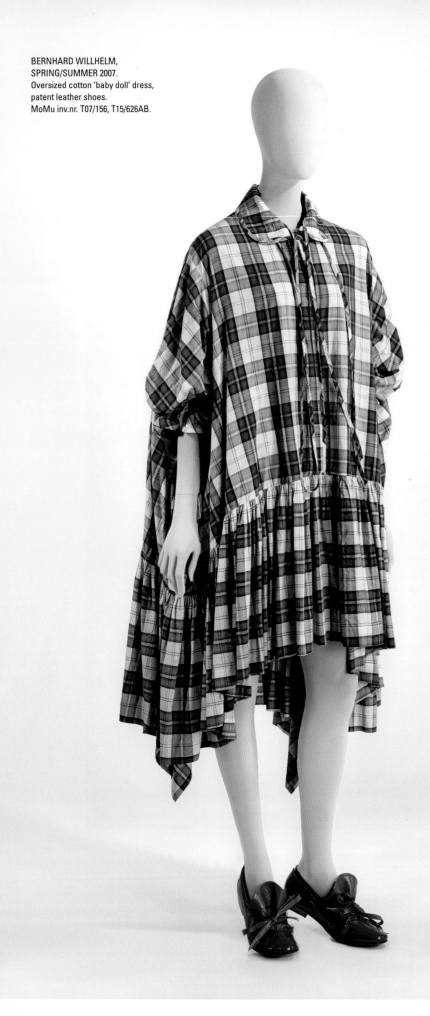

DIRK VAN SAENE,
AUTUMN/WINTER 1999–2000.
Woollen coat with slits,
elastic waistband.
MoMu inv.nr. T99/104.

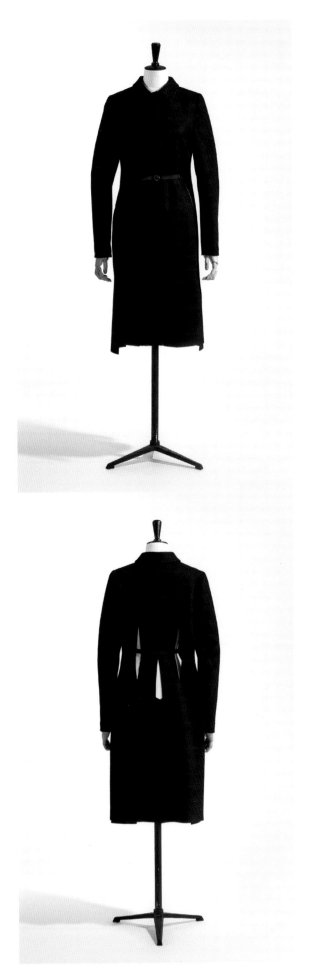

FASHION GAME CHANGERS: REINVENTING THE 20TH CENTURY SILHOUETTE. AN INTRODUCTION

MAISON MARTIN MARGIELA,
SPRING/SUMMER 2000.
Dress in knitted wool and
manmade silk, cotton trousers.
MoMu inv.nr. T13/1329, T01/207.

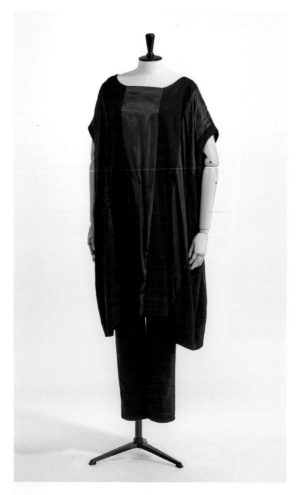

MAISON MARTIN MARGIELA,
C. 1989.
Woollen jacket and jumper,
woollen and cotton skirt.
The long, narrow-shouldered
silhouette of Margiela's first
collections announced the
change in silhouette for
the 1990s.
MoMu inv.nr. T03/356,
T01/203, T13/1335.

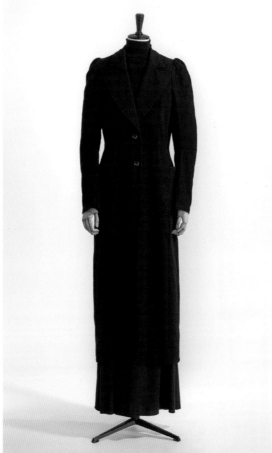

MAISON MARTIN MARGIELA,
AUTUMN/WINTER 2000–01.
Jacket in wool, cotton and manmade silk,
dress in wool and manmade silk,
leather tabi shoes.
MoMu inv.nr. T00/120, B02/145, T98/15.

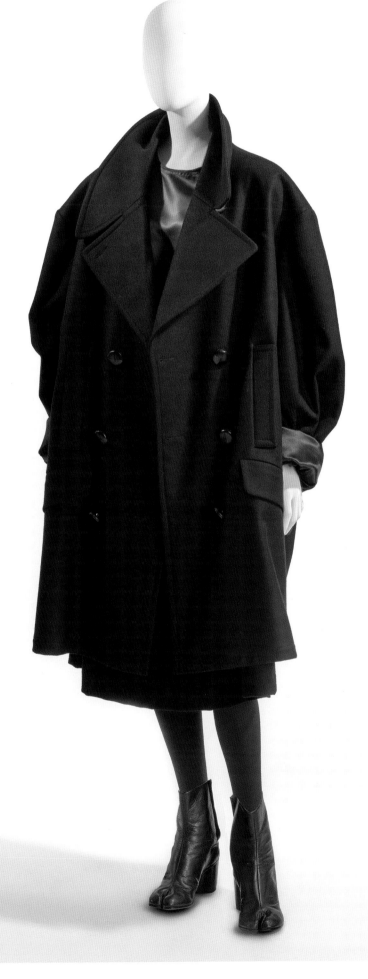

LANVIN, *C.* 1980.
Silk dress.
MoMu inv.nr. T06/1282.

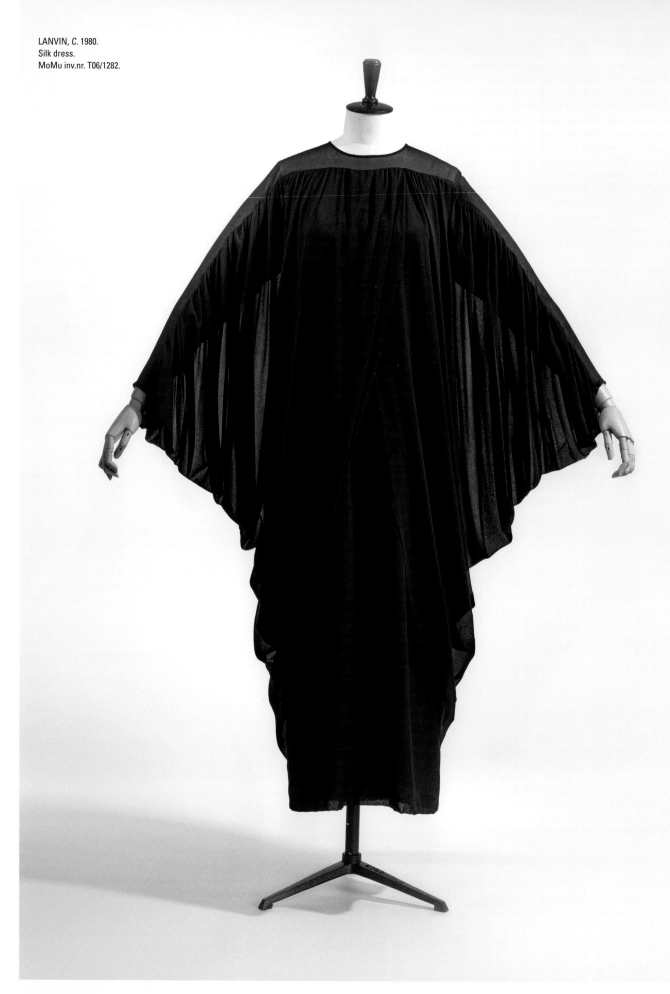

ROMEO GIGLI, AUTUMN/WINTER 1989–90.
Woollen coat.
Italian designer Romeo Gigli was internationally
acclaimed for his bulky, cocoon-like shapes
which gracefully enveloped the body.
MoMu inv.nr. T96/33.

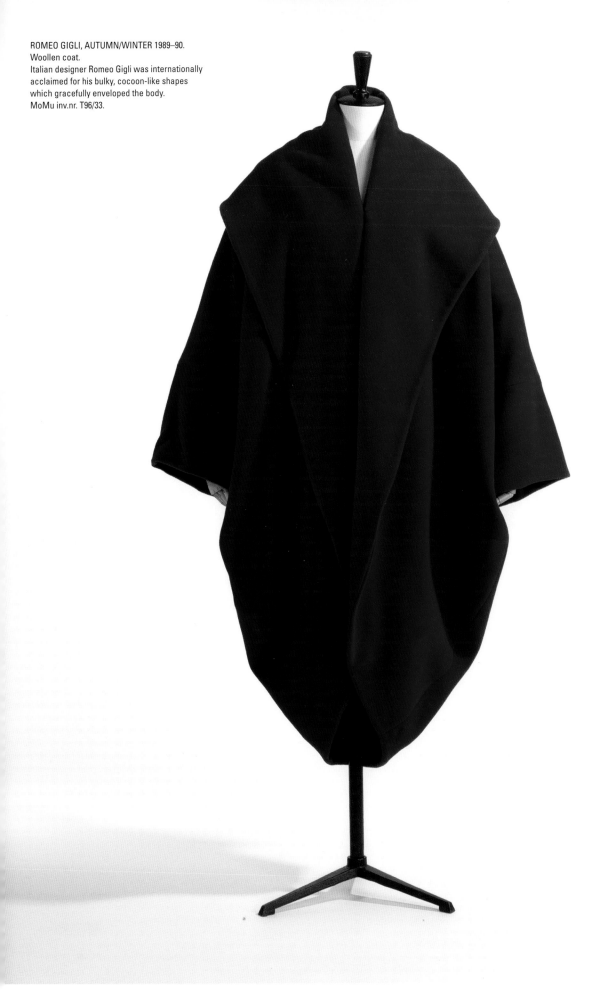

BRUNO PIETERS,
SPRING/SUMMER 2009.
Kimono-sleeve jacket in silk.
MoMu inv.nr. T11/298.

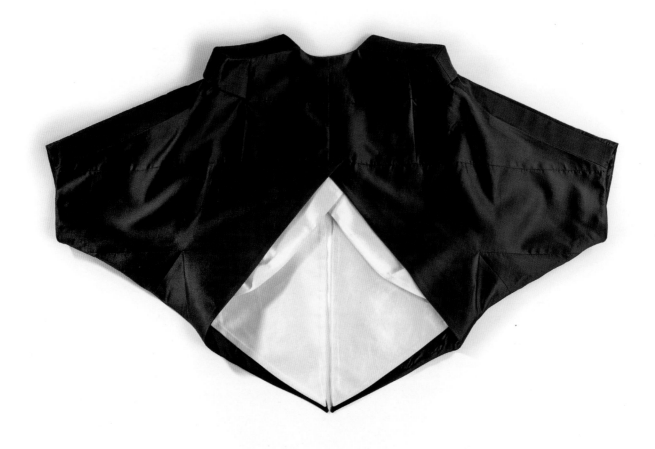

BRUNO PIETERS,
SPRING/SUMMER 2009.
Kimono-sleeve jacket in cotton and man-made fibre.
MoMu inv.nr. T11/301.

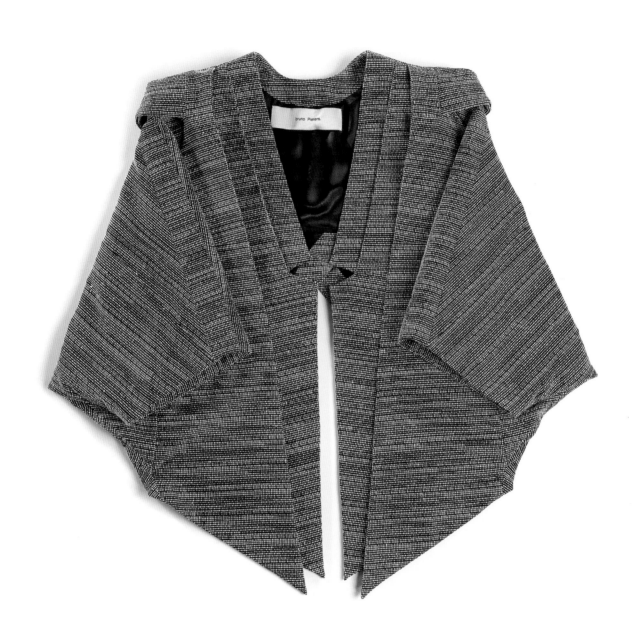

IRIS VAN HERPEN,
'HACKING INFINITY',
AUTUMN/WINTER 2015–16.
Hand burnished, stainless
steel gauze dress.

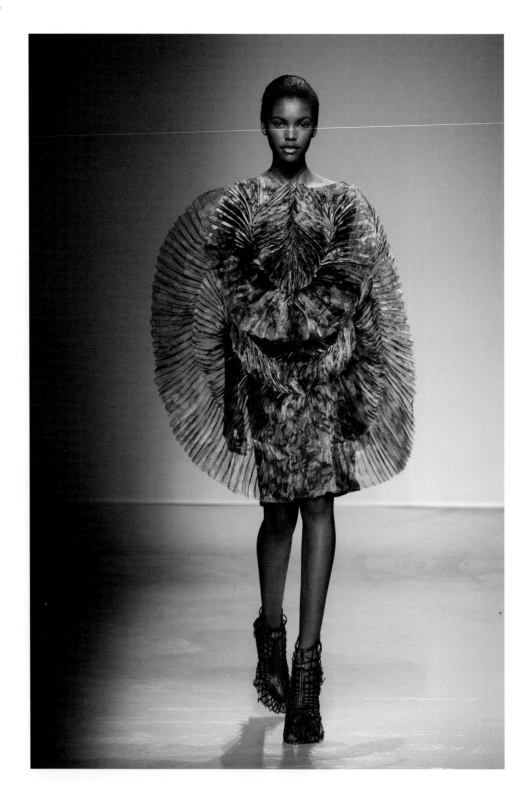

IRIS VAN HERPEN, 'MAGNETIC MOTION',
SPRING/SUMMER 2015.
The Large Hadron Collider, whose magnetic field exceeding
that of earth's by 20,000 times, provided inspiration for 'Magnetic Motion'.
The 3D printed surface of the dress echoes the body's movement.

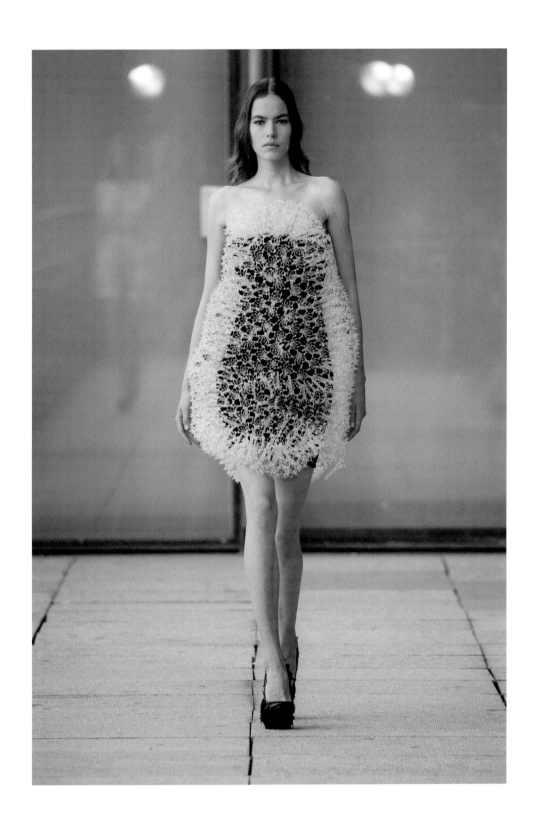

IRIS VAN HERPEN,
'MICRO', HAUTE COUTURE,
SPRING 2012.
Van Herpen's designs allude
to armature, tentacles,
cell structures, and plasma.
Some seem moist, others
glow and move while being
worn, coming to life on the
body.

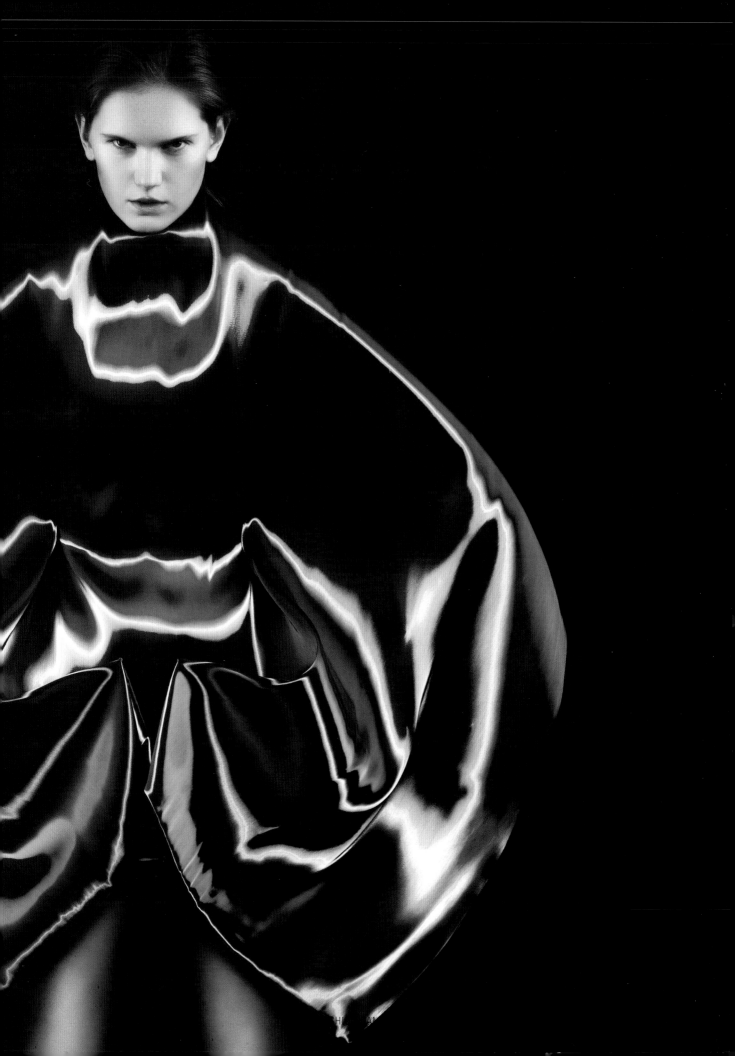

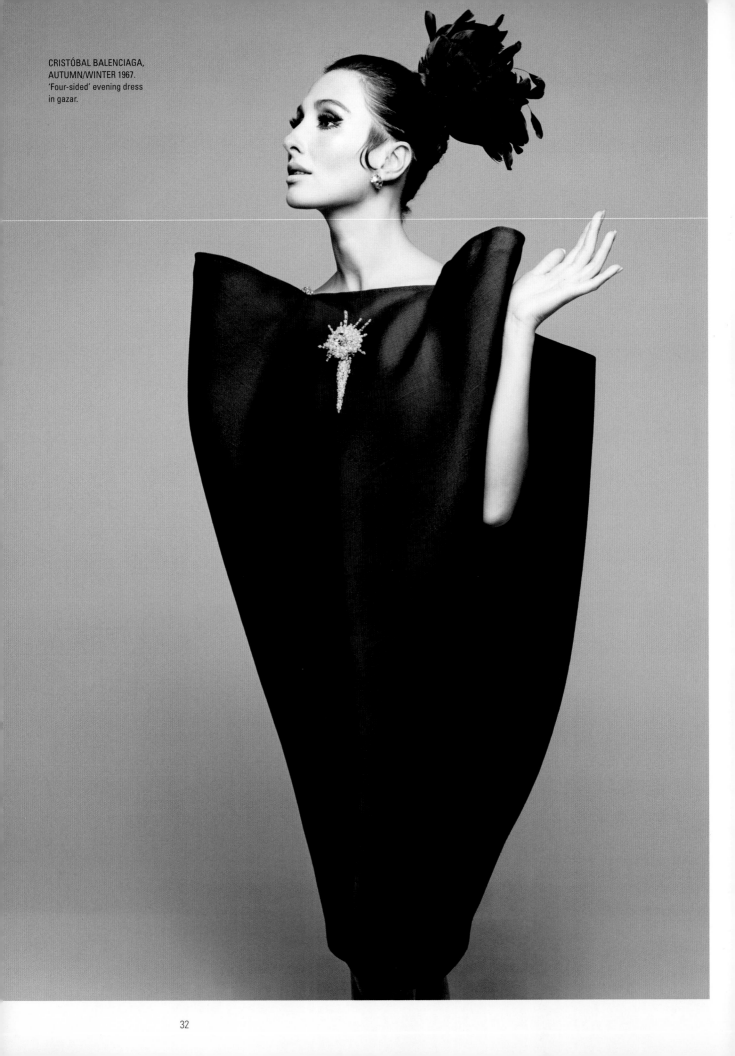

CRISTÓBAL BALENCIAGA,
AUTUMN/WINTER 1967.
'Four-sided' evening dress
in gazar.

ICONOCLASTIC VISIONS OF THE SILHOUETTE: CRISTÓBAL BALENCIAGA

— MIREN ARZALLUZ

Balenciaga sculpts, paints, writes in the act of making dresses. That is why he is above the others. To create dresses, beginning endlessly over and over again with the same model, the body, is to choose incessantly, without respite. As we breathe in order to live. To choose is to help the formless to breathe, to give life to what is unborn. In this, Balenciaga is supreme.[1]

Violette Leduc came to this conclusion, with characteristic passion and clarity, in an article for *Vogue* magazine about her much-admired couturier Cristóbal Balenciaga. Written at the height of her career, following the success of her autobiographical novel *La Bâtarde*, Leduc gives an obsessively thorough description of Maison Balenciaga's summer 1963 collection, a show whose every detail filled the writer with a host of memories and emotions. It had been more than twenty years since her previous visit to Balenciaga when her job as a novice fashion journalist took her, in the midst of the Nazi occupation, to the salons of number 10, avenue George V, Paris. Captivated since then by Balenciaga's rigour and strength, Leduc was returning, eager and excited to relive the feelings that had accompanied her for so long. She was, as it turned out, overwhelmed by the beauty of the designs – in which her mind saw real marble sculptures – being paraded down the catwalk before her very eyes. 'From his statues emerge an arm, a shoulder, a throat. It needs an immense amount of love to create warmth out of a marble. Balenciaga has taught me that a great dress he creates endures as long as a marble sculpture.'[2]

By the 1960s, Balenciaga's work had already bathed itself in an aura of perfection, calm and timelessness, drawing constant comparisons to various art forms, such as the ones Leduc cited with such devout enthusiasm. Indeed, the progressive refinement of construct and form found in Balenciaga's creations throughout the decade, as well as the abstraction increasingly found in his radical designs at the end of it, placed him at the heart of the debate around whether fashion could be considered art. There is no doubt that – like some vital sartorial epilogue – certain designs in his last collections, in 1967 and 1968, did take on architectural qualities and an unprecedented degree of independence with regard to the body, becoming genuine icons of twentieth-century fashion history. These designs were the culmination of a long and productive career based on technical perfection and experimentation with form. Guided by the ideas about dress and pro-

CRISTÓBAL BALENCIAGA,
AUTUMN/WINTER 1952.
Large-collared day coat.

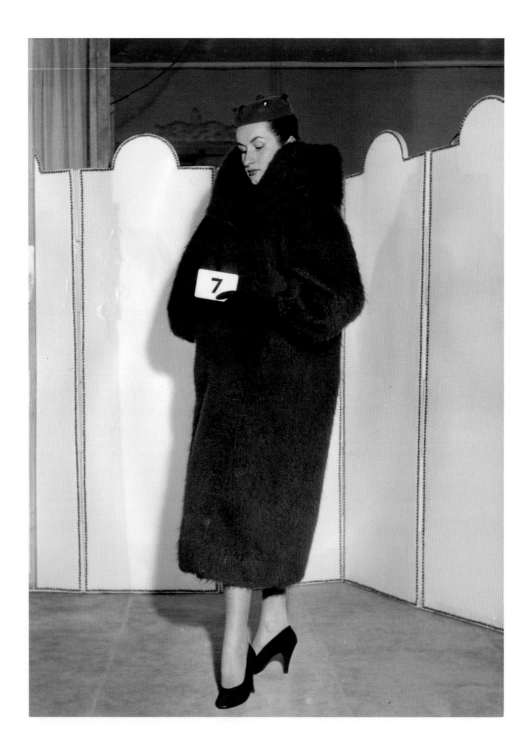

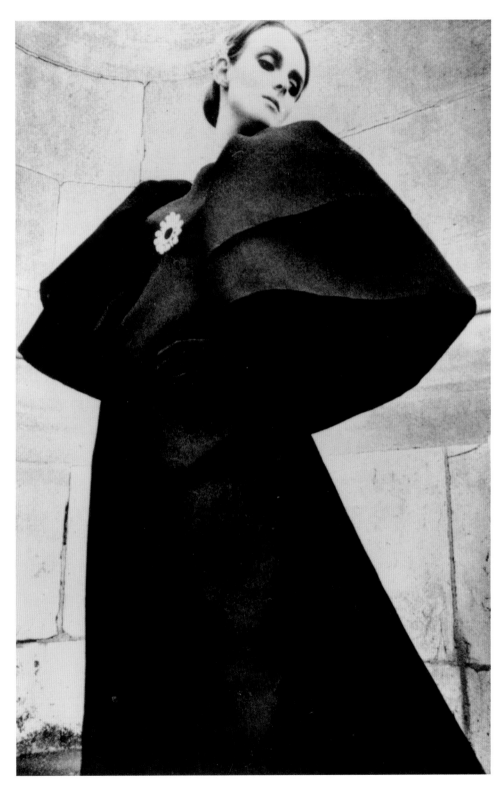

CRISTÓBAL BALENCIAGA, AUTUMN/WINTER 1964.
Evening dress in gazar.

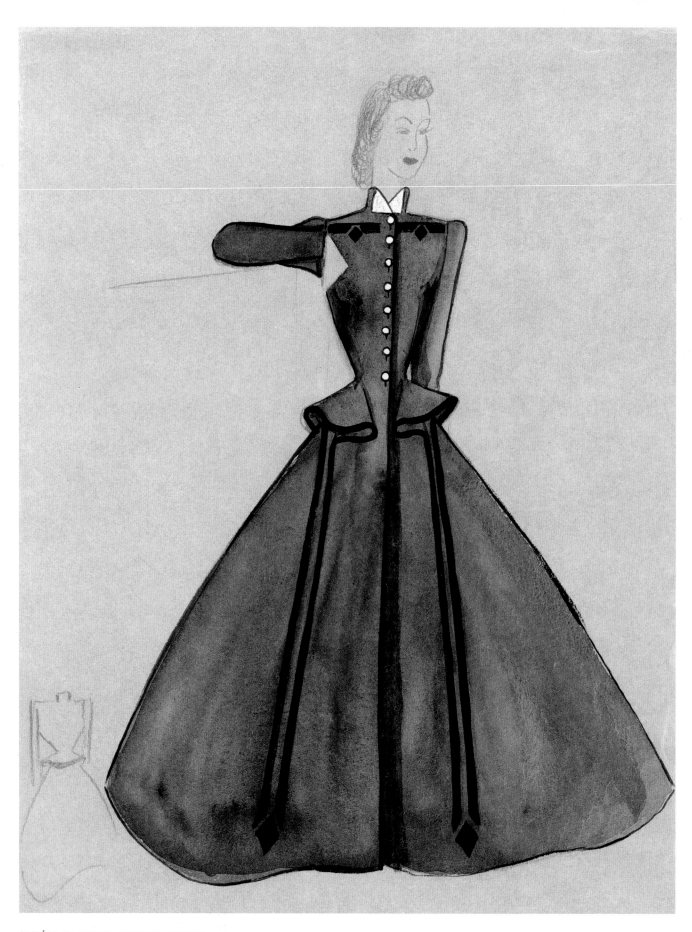

CRISTÓBAL BALENCIAGA, AUTUMN/WINTER 1939.
'Infanta'-style evening dress.

portion he had established at the beginning of the century, Balenciaga dedicated himself to the unremitting task of initiating a new relationship between body and garment, offering women an alternative silhouette at the height of the New Look furore, not only foretelling but influencing what fashion would become over the next few decades.

THE HISTORICIST SILHOUETTE OF THE 1930S

His commitment to the abstraction of the body and the search for alternative volumes was not always apparent in Balenciaga's work. After establishing himself in Paris in 1937 and presenting his first collection in August of the same year, Balenciaga quickly earned a place among the most famous haute couture houses of the day. Critics were quick to pick up on the impeccable cut of his suits, the simple sophistication of his evening wear and his references to Spanish culture, received enthusiastically by a Parisian audience historically fascinated with displays of Iberian exoticism. The historicism that typified Parisian collections of the late 1930s also found its way into Balenciaga's designs, which featured explicit references to some of the most characteristic elements of nineteenth-century fashion.

In 1939, Balenciaga was able to use an internationally significant cultural event to distinguish himself from his competitors. An extraordinary exhibition, organized by the League of Nations, was held that summer in Geneva, including masterpieces from the Museo del Prado's magnificent collection: paintings by Velázquez, Goya and El Greco, together with thousands of works from Spanish heritage that had been salvaged and transferred to Geneva by the republican authorities while bloody civil war was tearing through the country. Unanimously considered the most important cultural event of the year in Europe, the exhibition swiftly made its influence felt in the collections being prepared by Parisian designers for the new winter season. Balenciaga, holder of cultural keys that his rivals lacked, found himself in an advantageous position from which to interpret the sobriety with which Velázquez portrayed the magnificence of Habsburg Spain. His so-called 'Infanta' dresses, made from winter 1939, quickly became his first great success, acclaimed by clients and buyers across the world. The dresses in question closely replicated the silhouette of seventeenth-century Spanish court dress, characterized by a rigid bust and a tight waist, descending with stark contrast into a voluminous skirt with full hips. Balenciaga seemed more dedicated and eager than any of his contemporaries to join the new historicist trend and, ever the perfectionist, did not hesitate to use the most effective methods for reproducing the desired silhouette. Thus, Rosette Hargrove, a correspondent for the Newspaper Enterprise Association, reported with significant astonishment from Paris:

CRISTÓBAL BALENCIAGA,
SPRING/SUMMER 1947.
Cocoon-shaped coat.

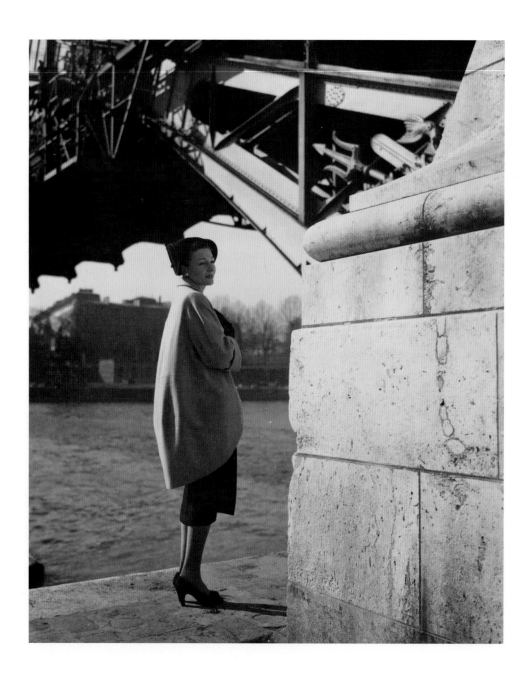

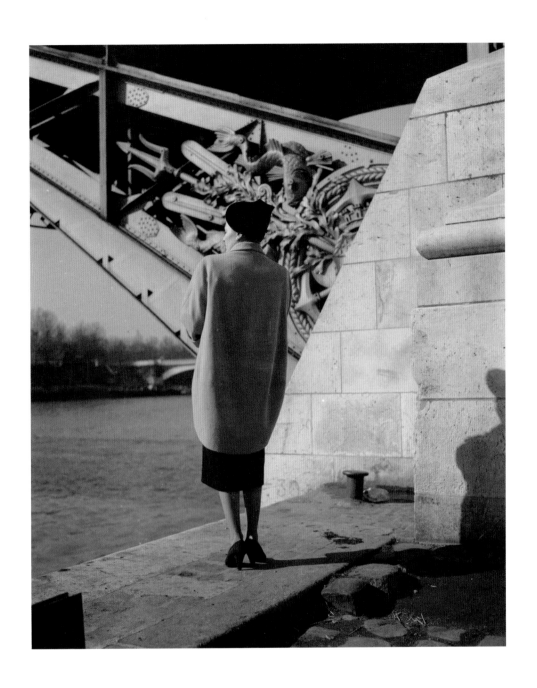

CHAPTER 2 — ICONOCLASTIC VISIONS OF THE SILHOUETTE: CRISTÓBAL BALENCIAGA

CRISTÓBAL BALENCIAGA,
AUTUMN/WINTER 1950.
Taffeta evening ensemble.

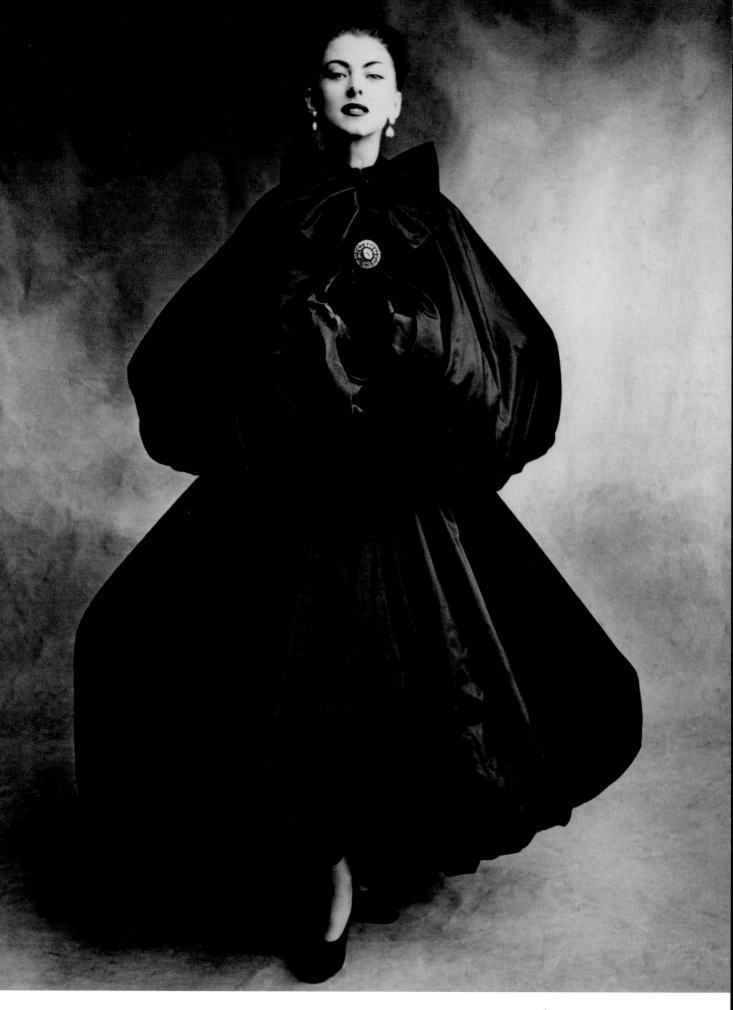

CRISTÓBAL BALENCIAGA,
AUTUMN/WINTER 1942.
Day ensemble. Balenciaga
introduced his characteristic
cocoon-shaped silhouette in
1942 initiating a long process
of experimentation with form
and construction.

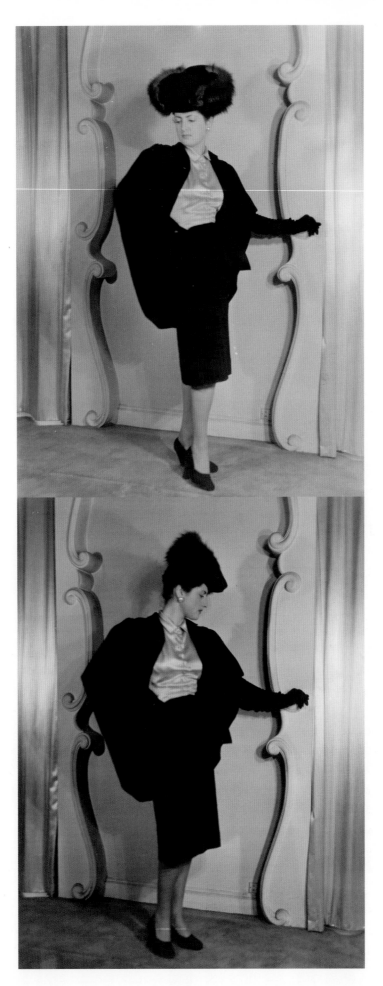

Wasp waists are in again – despite the scoffers. Hips are also to be cultivated, if you want to wear some of the new styles convincingly. Rounded hips, in fact, are fast showing promise of becoming one of the canons of 1939 beauty, rather than the defect women have striven so hard to eliminate these past years. Balenciaga, the most recent and very successful addition to the ranks of the top-flight couturiers, had at least three of his mannequins wearing boned corsets. These simply took inches off their waists and made their hips bulge somewhat disconcertingly to the eyes of the unprepared onlookers.[3]

The outbreak of the Second World War and the occupation of Paris in June 1940 imposed a drastic change of rhythm upon Parisian fashion, and it would not be until 1947 that the 1939 silhouette would shake the world with overwhelming force, led this time by Christian Dior. Meanwhile, Cristóbal Balenciaga was heading in a new direction, based on ideas quite contrary to what became known as the 'New Look'.

THE GENESIS OF AN IDEA

The privations of the occupied city and the severe restrictions on material that the authorities imposed on the diminished haute couture industry played a determining role in the development of collections from 1940 onwards. Sobriety, moderation and functionality were the order of the day for the few couturiers who decided to continue. Balenciaga drew upon his rigorous sartorial training and profound mastery of technique to stand out in this challenging climate, in a city where determined Parisian women, dressed in ingenious suits and extravagant hats, refused to forgo fashion. Thus, what seemed at first to be a bleak desert of creativity became the testing ground for Balenciaga's fruitful experimentation with the silhouette.

Of all the preparatory sketches Balenciaga produced for the summer 1942 collection, the curved, fluid lines of one particular schematic drawing stand out. It was a three-quarter-length jacket arching around the shoulders and broadening at waist-level before gradually narrowing out to below the hips.[4] The piece in question, its curved shape reminiscent of an enveloping cocoon, was to feature in the winter collection of the same year. Pictured in various fashion magazines, it was in stark contrast to the almost military straightness of designs typical not only of that season but of the war years in general. It could, then, be argued that Cristóbal Balenciaga ushered in what would come to be known popularly as the 'barrel' line, years before the term became officially recognized, in February 1947. After launching his winter 1942 line, the couturier put this particular experimentation on temporary hold, probably due to restrictive circumstances or the muted reception of such a radical venture. In this way, there emerged what was to become standard throughout Balenciaga's career: the presentation of a new silhouette that was considered too radical due to its profound

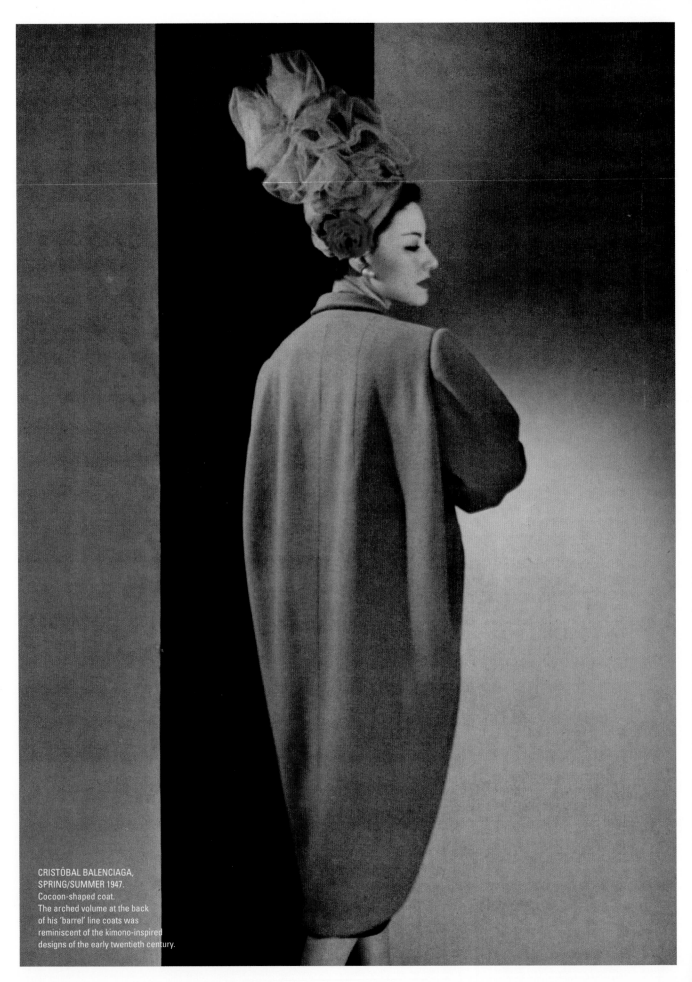

CRISTÓBAL BALENCIAGA,
SPRING/SUMMER 1947.
Cocoon-shaped coat.
The arched volume at the back
of his 'barrel' line coats was
reminiscent of the kimono-inspired
designs of the early twentieth century.

clash with the prevailing style, and its later reintroduction to and success with a public already accustomed to said silhouette. Three-quarter-length jackets and coats of identical profile were indisputably the stars of his summer 1947 collection and, although it enjoyed a relatively moderate amount of attention compared to the stunning success of Christian Dior's 'Corolla' line, the 'barrel' line soon established itself as a solid alternative that most couturiers endorsed in subsequent seasons, including, of course, Dior himself. Beyond designing a concrete line, though, in 1942 Balenciaga was beginning to rethink the clothed feminine figure, and the relationship between body and garment; and was considering how to technically realize his alternative vision, so closely related to proportion and movement.

The success of his collection after the opening of his house in Paris in 1937 had afforded Cristóbal Balenciaga the authority he needed as a creator to explore and introduce new directions. By then Balenciaga already had a twenty-year career to fall back on: a period of training, development and technical and aesthetic maturation that would form the backbone of his success and the root of his contribution to the history of fashion.

THE EARLY YEARS AND THE INFLUENCE OF THE MODERNISTS

Balenciaga's professional journey can be traced back to 1917, the year he founded his first fashion establishment in San Sebastián, a spa town par excellence on the Spanish Basque coast.[5] After beginning dressmaking under his mother's wing while still a child in his native Getaria, Balenciaga became a tailor's apprentice in 1907 at one of San Sebastián's renowned tailoring establishments, thanks to a recommendation from the elegant Marchioness de Casa Torres. The marchioness was an aristocrat and a loyal customer of Paris's finest couturiers, who allowed Balenciaga to pore over her impressive wardrobe during her long stays in the summer villa that her family owned in Getaria.[6] From that moment on, Balenciaga's life would be inexorably linked to Parisian couture and to the work of its supreme exponents. After rigorous technical training, Balenciaga began working as a tailor in the new San Sebastián branch of the Parisian department store Au Louvre, which opened in 1911, where his outstanding talent for dressmaking soon earned him the position of head tailor of the ladies' dressmaking workshop. Aside from getting to know the ins and outs of the not-so-exclusive world of off-the-peg dressmaking, his new job would provide him with the opportunity to see Paris at last, and in turn the world of haute couture which he aspired to join. After a brief experience in Bordeaux, Balenciaga opened, under his own name, an establishment offering carefully selected designs from the main haute couture houses, which he himself would select on his frequent trips to Paris. It

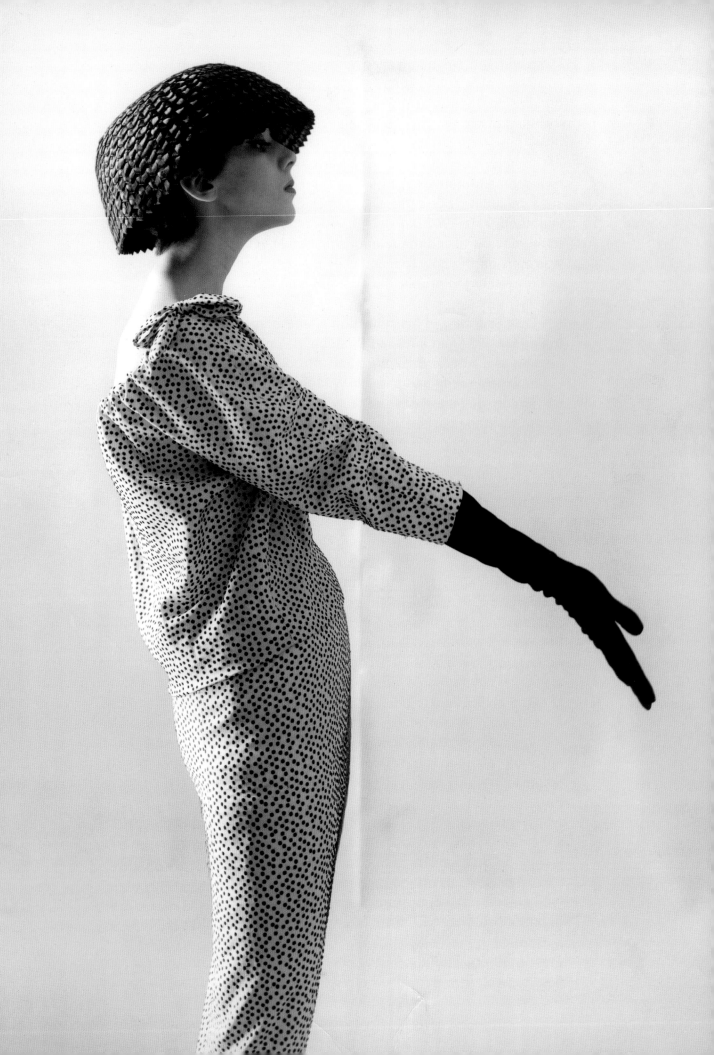

CRISTÓBAL BALENCIAGA,
SPRING/SUMMER 1955.
Two-piece bloused day ensemble.

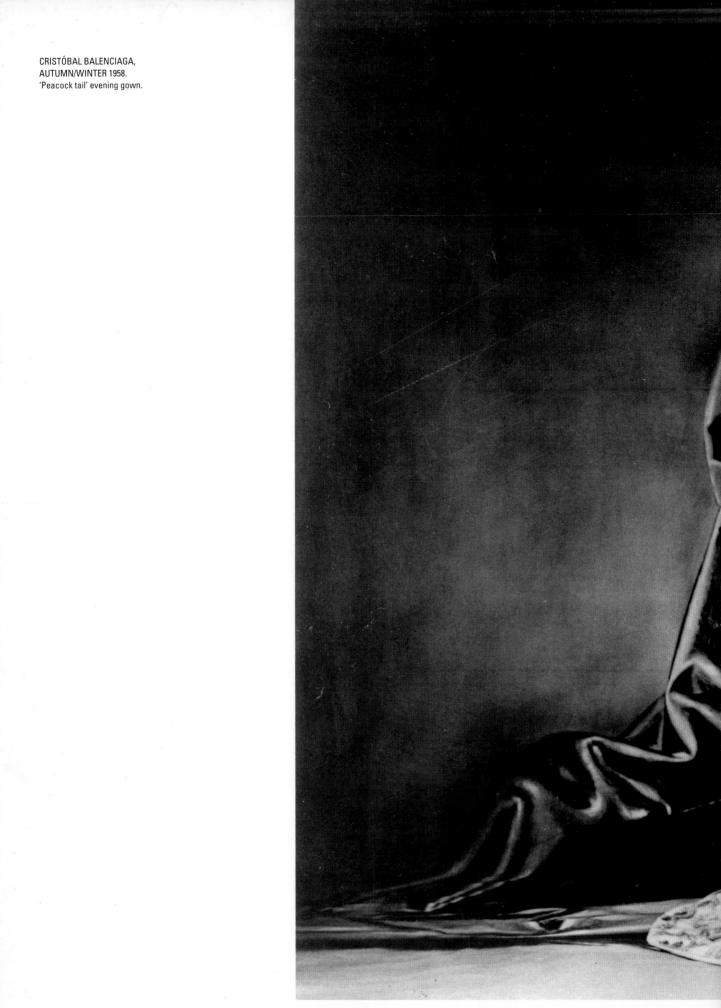

CRISTÓBAL BALENCIAGA,
AUTUMN/WINTER 1958.
'Peacock tail' evening gown.

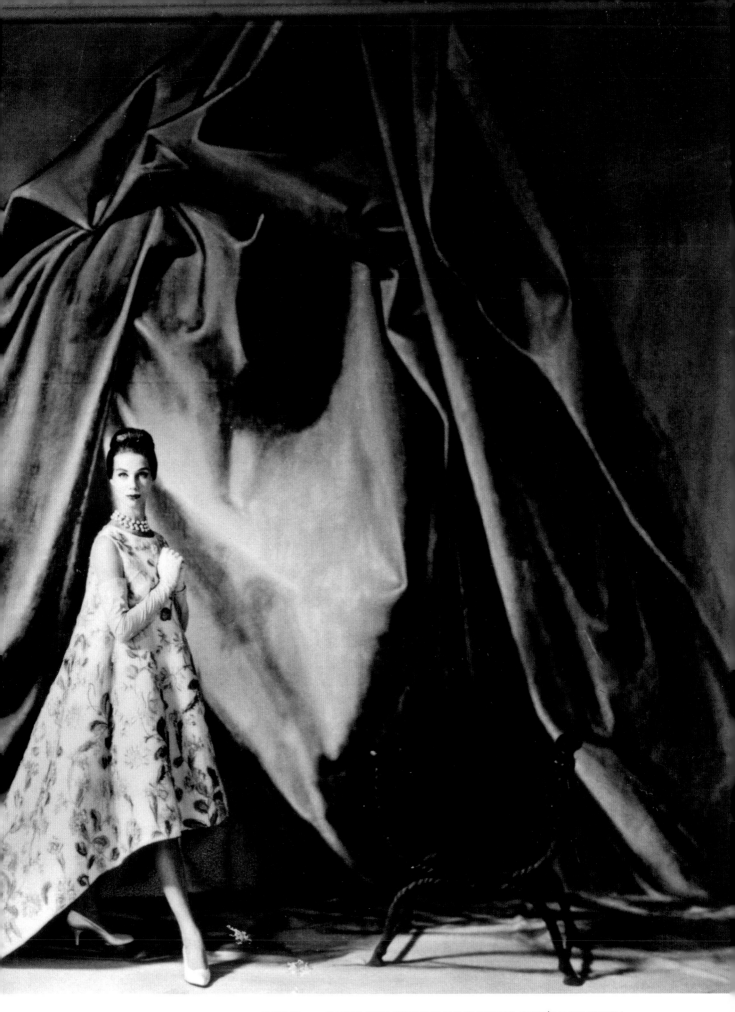

CHAPTER 2 — ICONOCLASTIC VISIONS OF THE SILHOUETTE: CRISTÓBAL BALENCIAGA

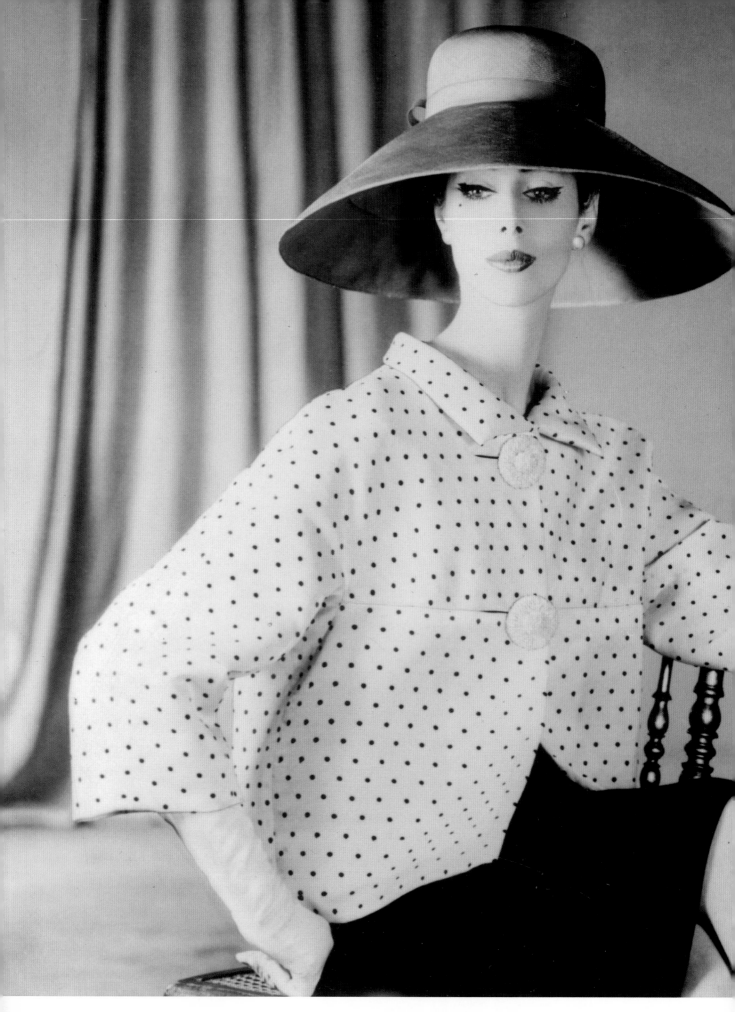

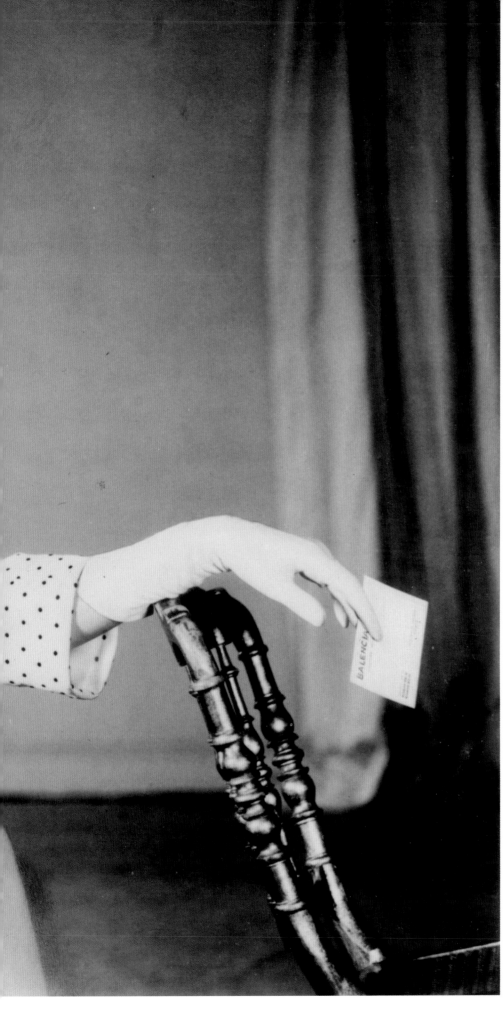

CRISTÓBAL BALENCIAGA,
SPRING/SUMMER 1957.
'Sack'-style dress.

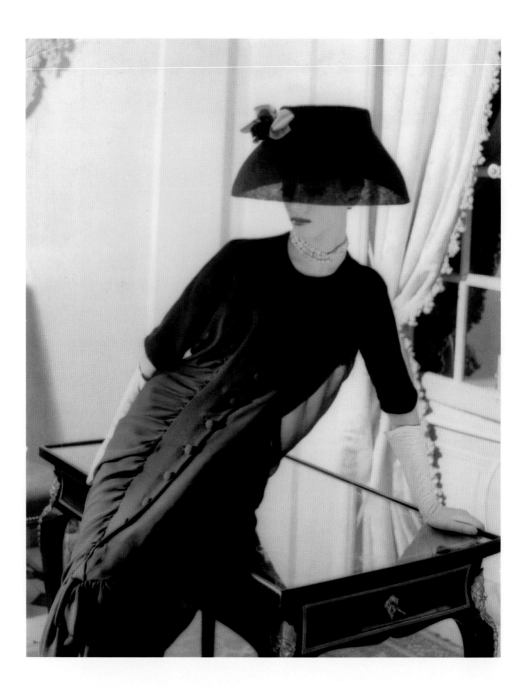

CRISTÓBAL BALENCIAGA,
SPRING/SUMMER 1957.
'Sack'-style dress.

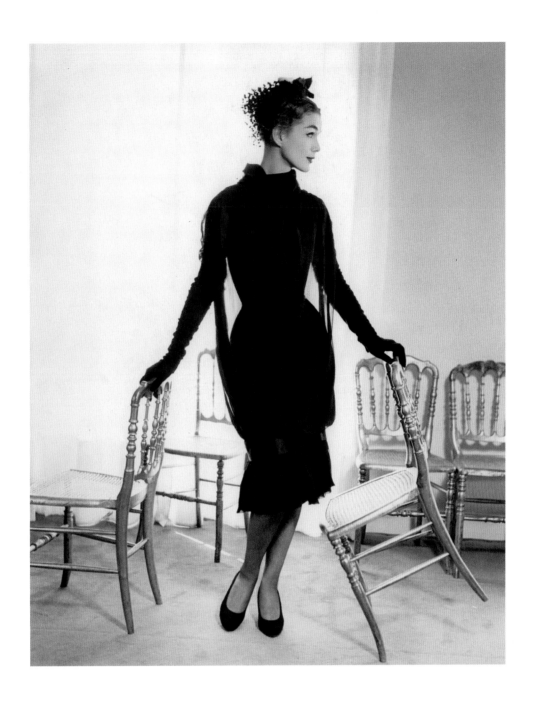

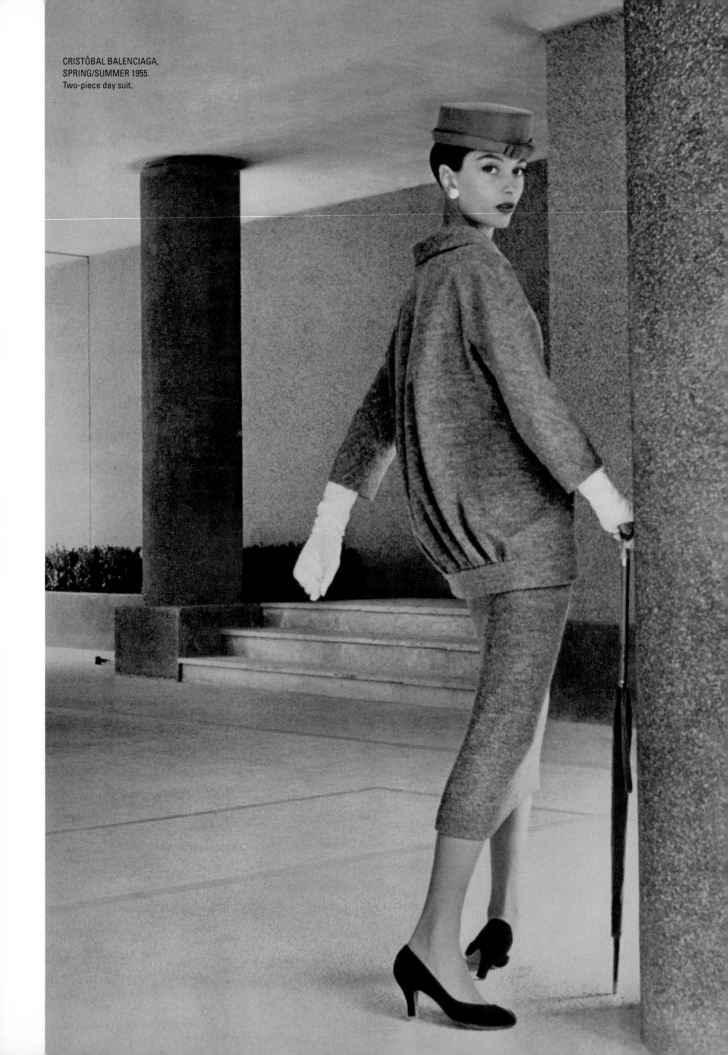

CRISTÓBAL BALENCIAGA,
SPRING/SUMMER 1955.
Two-piece day suit.

is beyond question that Balenciaga's choice of designs was made with the tastes and needs of his desired aristocratic clients in mind. However, his position as an international buyer provided him with the access to acquire first-hand experience of the work of the most innovative creators in Paris, at a time when ideas about silhouette and fabrication were undergoing great changes.

Unfortunately, little evidence remains of the relationships that Balenciaga maintained for almost two decades with some of those creators, whose influence on his work would turn out to be crucial. In November 1918, in Spain, Maison Lanvin announced that it would be opening a branch in Barcelona; with the announcement was a list of the few establishments authorized to sell the firm's designs, which included Cristóbal Balenciaga.[7] Balenciaga's relationship with the house continued throughout the next decade, as testified by a dress designed by Lanvin and made in Balenciaga's workshops in 1929 in San Sebastián, which today is to be found in the collection of the Balenciaga Foundation in Getaria.[8] The Balenciaga Archive in Paris also holds countless documents that Balenciaga took with him when he moved to Paris in 1936. These schematic drawings were made and annotated by Balenciaga himself, including ideas for new designs mixed with sketches by the great designers of the day. Designs by Worth, Molyneaux, Bruyère and Maggy Rouff are among the most numerous, after Lanvin, Chanel and Vionnet. Although it is likely that Balenciaga did not acquire absolutely all the designs portrayed in his vast collection, these sketches are without doubt indicative of the creators whose work most interested him. In retirement he openly confessed his deep admiration for Chanel and Vionnet, whom he named, together with Louise Boulanger, the greatest fashion designers of all time.[9] The close friendship between Balenciaga and these women dated back to when he was making his first forays as a couturier in San Sebastián.

Balenciaga's formative years and early development coincided with the explosion of Modernism, a period of obsessive experimentation, common to all the arts and driven by an energetic desire to make a deliberate break with the past. Fashion, in the same way as painting, literature and music, was voluntarily putting itself through its own stylistic revolution, inciting the proliferation of a myriad of silhouettes, each replacing the last at breakneck speed. The empire silhouette, the hobble skirt, the harem trousers, the lampshade skirt – all appeared in quick succession in the years leading up to the First World War, which itself did not put a stop to experimentation. Thus, under the premise of the supposed simplicity and functionality dictated by the circumstances, new lines such as the war crinoline, the straight dress, the barrel dress and the chemise dress, created in flexible fabric and in natural tones, reigned over wartime fashion. In any case, both the disappear-

CRISTÓBAL BALENCIAGA,
AUTUMN/WINTER 1951.
Day ensemble.

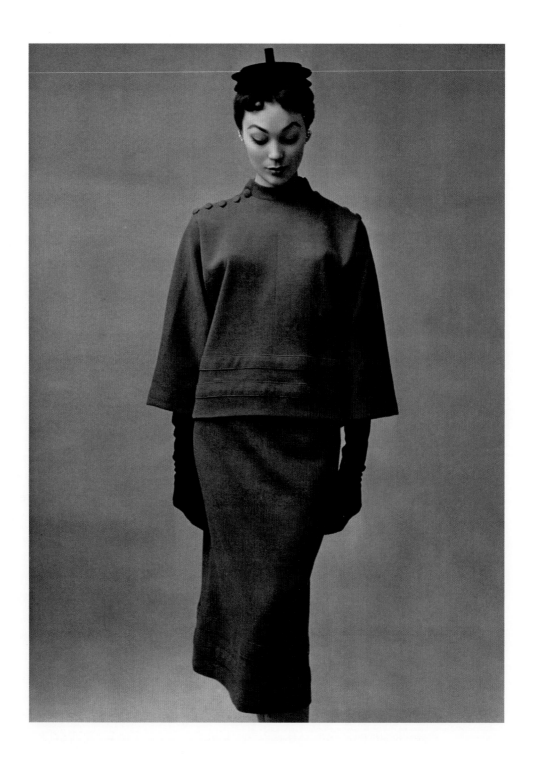

ance of the corset and the shortening of skirts – processes that have historically been linked to the needs and demands of the war – began years before its outbreak, and continued progressively through to the 1920s.

THE EVOLUTION OF THE SILHOUETTE IN BALENCIAGA: 1917–1957

Balenciaga embraced with particular intensity the formal and stylistic changes occurring at the precise moment when he decided to open his own haute couture house in San Sebastián. In March 1917, Spanish magazine *La Esfera* ran an illustration of a design by the recently established young couturier, which may be the first published reference to his work. The article began by making reference to the appearance of new 'tonneau' designs which, unlike 'the straight lines of this winter's outfits […] are wide at the hips and gradually narrow down into a skirt'.[10] In her eagerness to illustrate the two silhouettes *du jour*, the writer first gives an example of the new line, followed by a description of a straight design towards which she herself seems rather inclined:

The latest design is very accentuated. I have seen Balenciaga present a chic interpretation of it in San Sebastián: over a skirt with small, lightly emphasised box pleats goes a shorter skirt, in front, so that the underlying pleatwork may be seen. From the torso to the hem there runs a stole with chenille embroidery at the end, vividly-coloured yet discreetly tied in with the rest, fully deserving of its maker's signature. The extremely simple back falls straight down over the hips and is cut in a special way so as to peak at mid-back. It's nothing, but all the parts add up to an elegant outfit.[11]

As the description points out, Balenciaga *interprets* the design the writer calls 'very accentuated', meaning it could be based on a design by one of the most avant-garde houses of the day. The garment in question closely resembles some designs found in Gabrielle Chanel's summer 1917 collection, such as the tunic featured in the American edition of *Vogue*, also in March of that year.[12] Balenciaga had detailed, first-hand knowledge of Chanel's work from the start and admired her simplification of ladieswear, as well as her obsession with getting rid of superfluous ornamentation, something that would become Balenciaga's own trademark. As he himself nostalgically praised after his retirement, 'Chanel took all the chi-chi and fuss out of women's clothes'.[13] Balenciaga was her natural successor.

It is interesting to note how some of the key elements of one of the most characteristic silhouettes in Balenciaga's career are identifiable in this early design. Balenciaga favoured, like Chanel, the simplicity of straight lines, albeit with a slight margin to accommodate the body's outline, still far from the radical interpretation that would be rendered in the second half of the 1920s. With this goes the playful overskirt, shorter than the skirt beneath, drawing one's eye to the hem.

CRISTÓBAL BALENCIAGA,
SPRING/SUMMER 1958.
'Sack' dress. The sack dress
exaggerated the volume
of the 'barrel' line,
obliterating the waist
at both the front and
back of the garment.

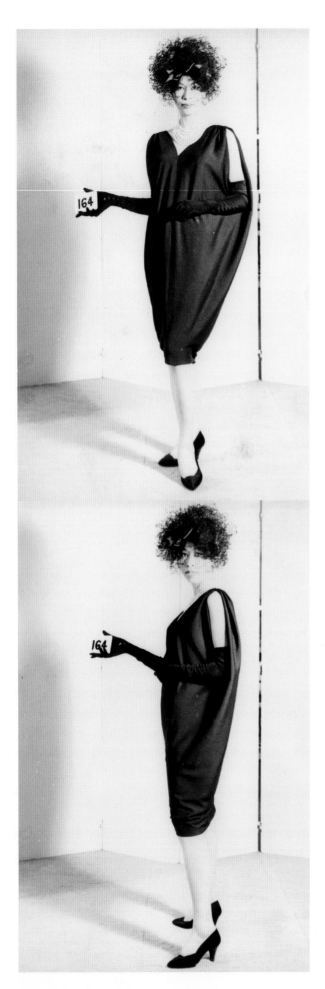

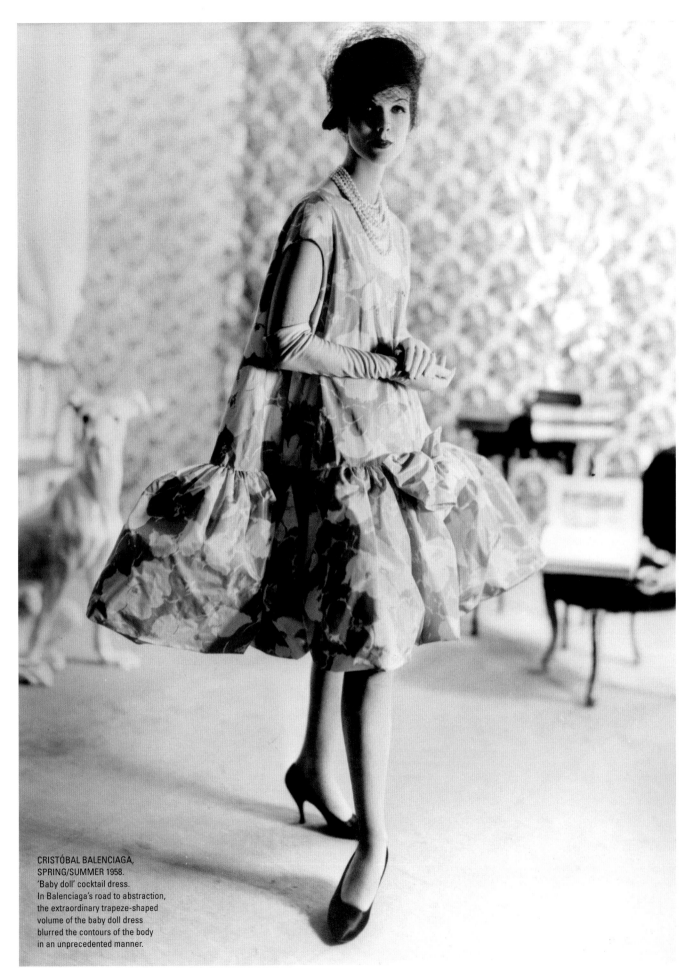

CRISTÓBAL BALENCIAGA,
SPRING/SUMMER 1958.
'Baby doll' cocktail dress.
In Balenciaga's road to abstraction,
the extraordinary trapeze-shaped
volume of the baby doll dress
blurred the contours of the body
in an unprecedented manner.

CRISTÓBAL BALENCIAGA,
SPRING/SUMMER 1958.
Cocoon-shaped coat.

CRISTÓBAL BALENCIAGA,
SPRING/SUMMER 1959.
'Baby doll' dress.

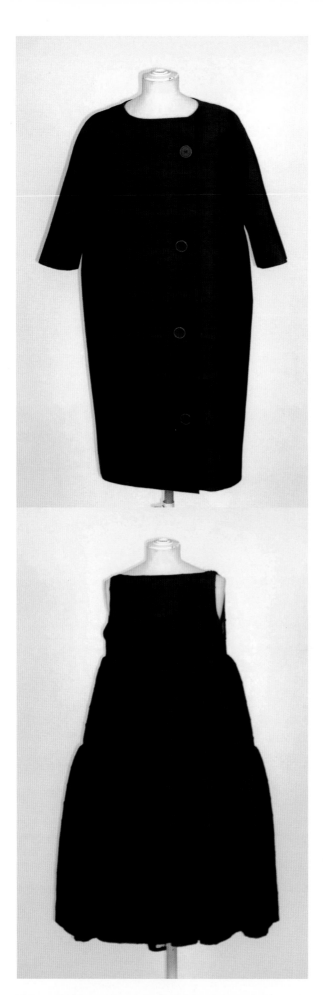

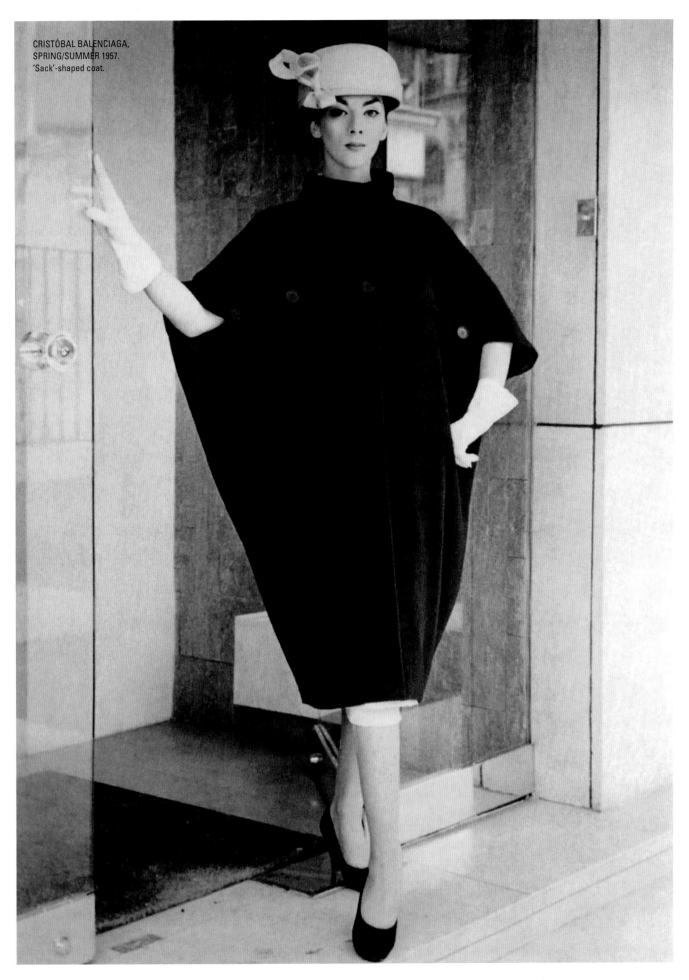

CRISTÓBAL BALENCIAGA,
SPRING/SUMMER 1957.
'Sack'-shaped coat.

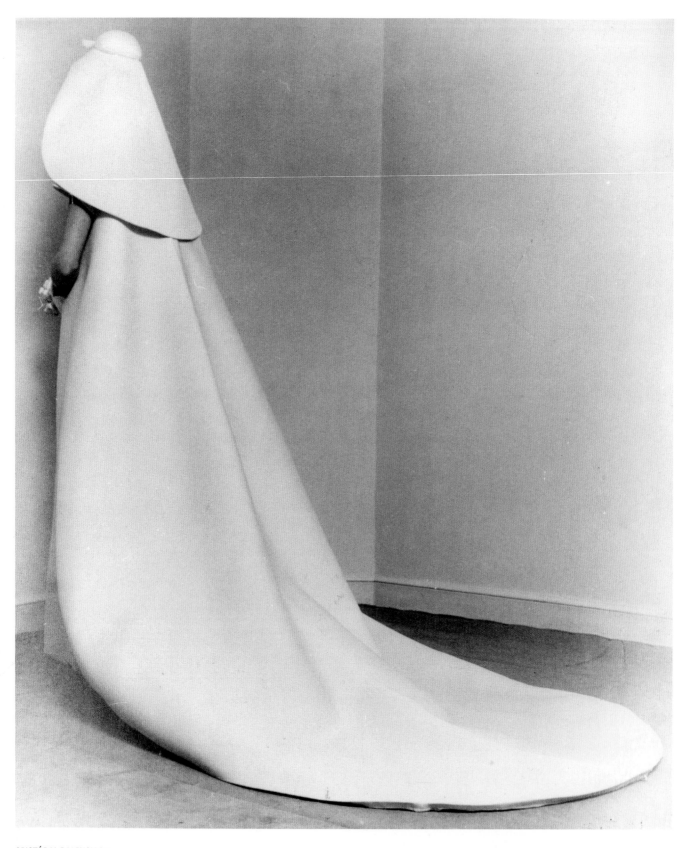

CRISTÓBAL BALENCIAGA,
SPRING/SUMMER 1967.
Wedding gown in gazar.

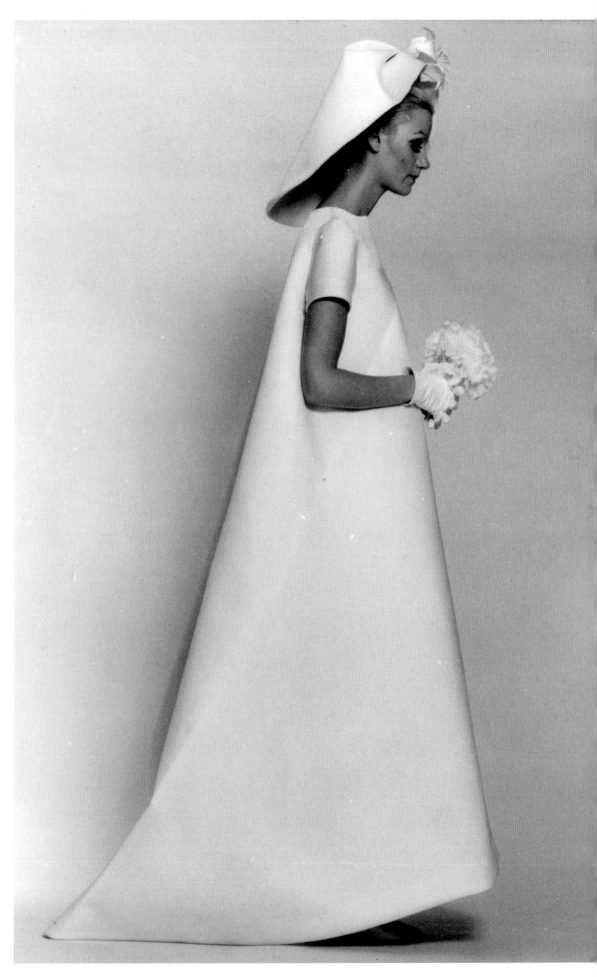

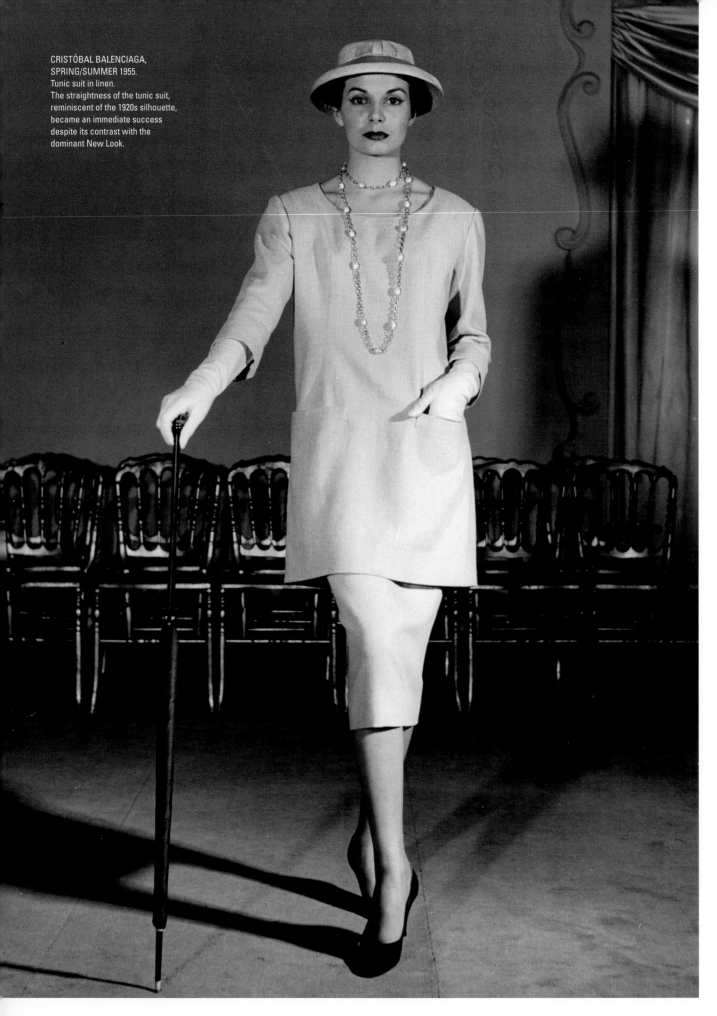

CRISTÓBAL BALENCIAGA,
SPRING/SUMMER 1955.
Tunic suit in linen.
The straightness of the tunic suit,
reminiscent of the 1920s silhouette,
became an immediate success
despite its contrast with the
dominant New Look.

The waist is relatively undefined, although in this case one can guess at it above the natural waistline, and the back attracts some attention thanks to a subtle effect made by the cut. All this does not differ greatly from his tunic designs that were so sensationally successful in the summer of 1955.

At the most pivotal and extravagant time of the so-called New Look, and after years experimenting with different versions of the cocoon profile, Balenciaga introduced the tunic, a simple knee-length garment worn over a straight, longer skirt which revealed a glimpse of its hem. The outfit suggested the wearer's outline through the clever use of darts, but the generous space between the wearer's body and the garment afforded her free movement. The extreme simplicity of the outline was only slightly altered at the back, where the tunic buttoned down one side and a strip of fabric provided a gentle blousy drape. Its liberating and elegant simplicity ensured instant success and impact. The Tobé report on Balenciaga's collection in summer 1955 predicted that the US market would devour the new line, affirming in his usual telegraphic style, 'Balenciaga's fascinating seven eights tunic is extreme new expression of long body line. Appears to be cut bias front, straight back with single oblique darts, all so subtle resembles a sack in the hand, a triumph on the body'.

The Tobé report of February 1955 considered 'Balenciaga's collection most stimulating to fashion thinking of season. After five years he has changed his line and given press and buyers who have complained of his sameness something to test their fashion sense.'[14] Indeed, the tunic line did turn out to be groundbreaking, not only compared to the rest of the season's collections but also in relation to the creations that Balenciaga himself had previously presented in Paris. It is certain that the supposed monotony to which the Tobé writer alluded was nothing but the scrupulous consistency that Balenciaga applied to his work. Contrary to the preferences of the frenetic fashion world, Balenciaga remained loyal to a small batch of ideas and principles that governed his vision of clothing, which he submitted, season after season, to continual refinement and perfection. Unfortunately for the buyers that Tobé informed, Balenciaga's reinterpretation of the tunic soon became a new classic in his repertoire and reappeared under different guises – day, cocktail and evening wear – in every collection presented at George V, from February 1955 to the last one in February 1968.

But if one case most exemplifies the loyalty to one idea in Balenciaga's career, it is without doubt the cocoon silhouette, an aesthetic premise without which it is impossible to understand Balenciaga's work worldwide and his role in the history of fashion. His so-called cocoon, or 'barrel' line silhouette, especially in its first incarnation,

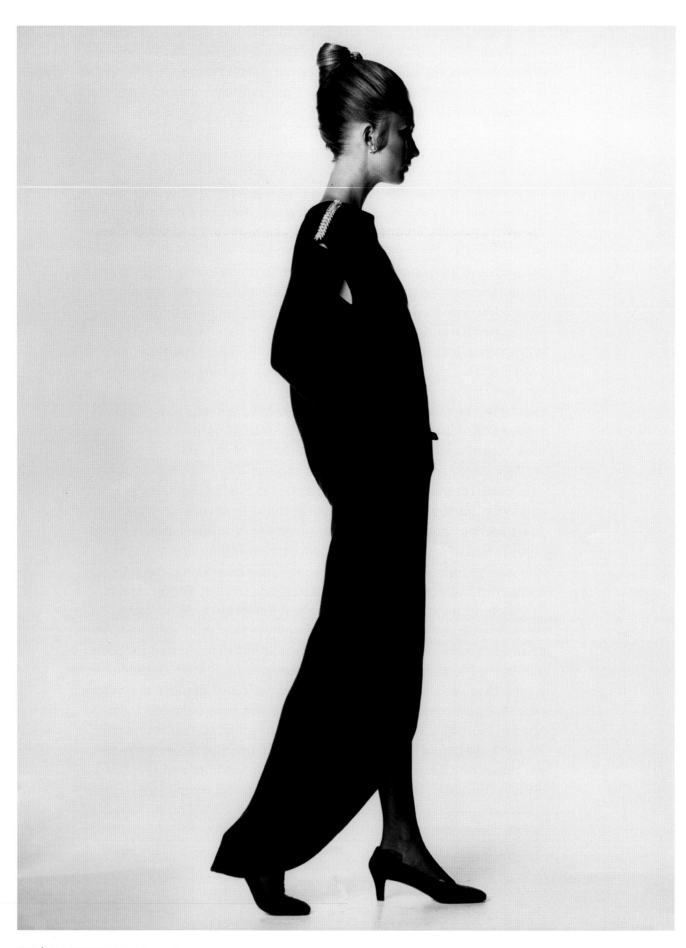

CRISTÓBAL BALENCIAGA, AUTUMN/WINTER 1967.
Crêpe gown.

introduced by the couturier in 1942 and 1947 respectively, is closely related to the Japonism that influenced fashion at the beginning of the twentieth century. Couturiers such as Paul Poiret and Callot Soeurs incorporated the Japanese kimono into Western ladieswear, bringing with it an unfamiliar silhouette that would revolutionize fashion over the next few decades. The characteristic arch over the back, the collar falling back to reveal the nape, the asymmetrical long hem, shorter at the front and longer at the back: these are the most definitive characteristics of this first Japonist silhouette, perfectly detectable in Balenciaga's creations from 1942 to 1968. Balenciaga would have seen with his own eyes, the creations by Poiret, Callot Soeurs and other great couturiers, who soon caught on to the new trend. However, it was thanks to his admiration for Madeleine Vionnet and the exhaustive analysis of her creations that Balenciaga incorporated into his fashion vocabulary the most innovative dressmaking techniques derived from the discovery of the kimono, such as her famous bias cut.[15]

However, the 'barrel' line of the late 1940s was only the beginning of a long and fruitful experiment in silhouette that would retain three main themes: the characteristic volume at the back, the obliteration of the waist, and the progressive softening of the body's outline. After its consolidation in 1947, Balenciaga seems to have kicked off the 1950s imbibed with the iconoclastic spirit of the creators of the 1910s and 1920s. In the summer 1951 collection the couturier put forth various ideas based on the same original silhouette, including the semi-fitted line that caused the most controversy. In its early days the line featured tailored garment designs that comprised a straight skirt and a jacket going down to the waist, whose most notable feature was the bulky arch falling onto the back, in stark contrast to the front, which flawessly hugged the waist. Despite many people's incredulity and cold reception to the simplicity of this silhouette and the complexity of its cut, the line was widely featured in the main fashion magazines and constituted a milestone in the history of the Balenciaga house. After that gamble paid off, the summer 1952 collection surprised with its liberal interpretation of the semi-fitted figure in daywear, dresses and two-piece suits, straight-lined and loose, reminiscent of the late 1910s and early 1920s, which would evolve over the following seasons in two similar, although distinct, directions: one design in which a band in the same fabric hugged the body at hip height, creating Balenciaga's now legendary loose effect; and another design where straight lines prevailed and which became gradually longer between 1952 and 1955, finally ending up as the aforementioned tunic line. After the presentation of the summer 1955 collection, Carmel Snow recognized Balenciaga's authority:

For Balenciaga, the future is never a matter of hazardous conjecture. He has the assurance of a clear insight into the evolution of women's taste; and eventually, that insight always proves true.

CRISTÓBAL BALENCIAGA, AUTUMN/WINTER 1956.
Large collared tunic suit.

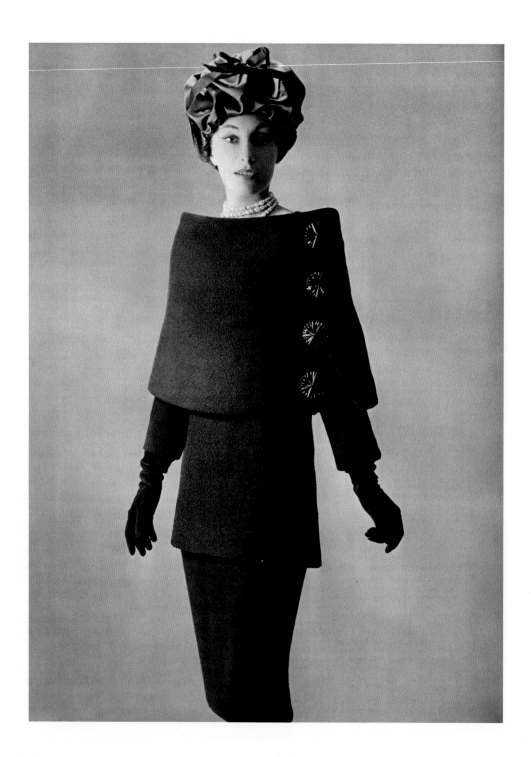

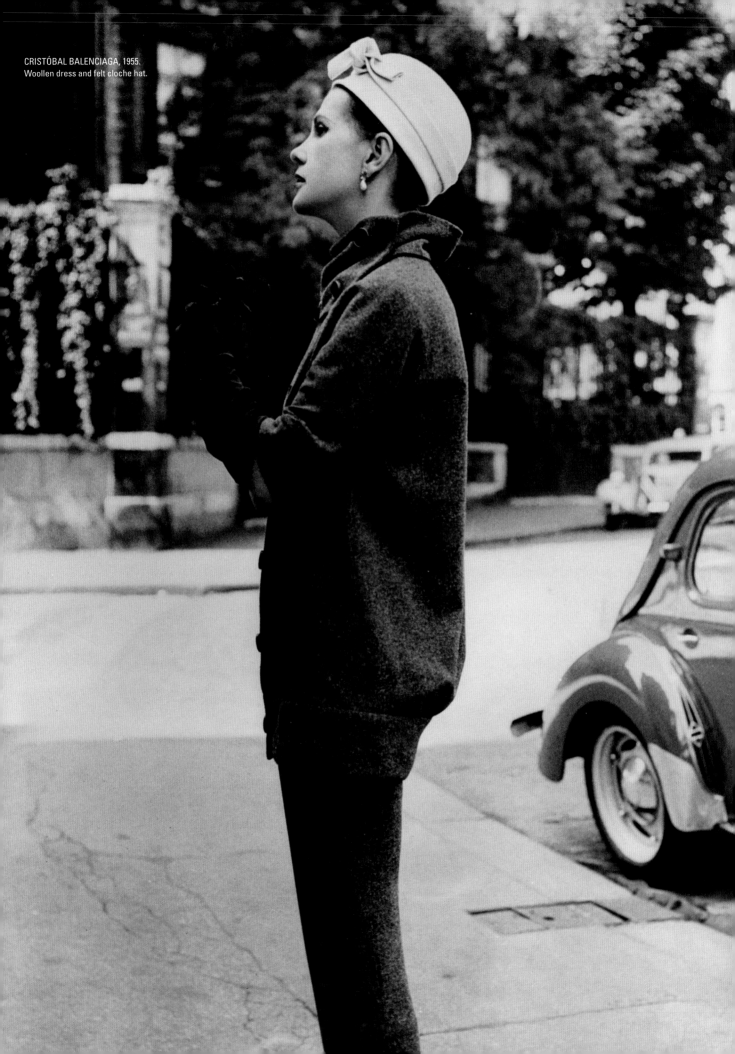

CRISTÓBAL BALENCIAGA, 1955.
Woollen dress and felt cloche hat.

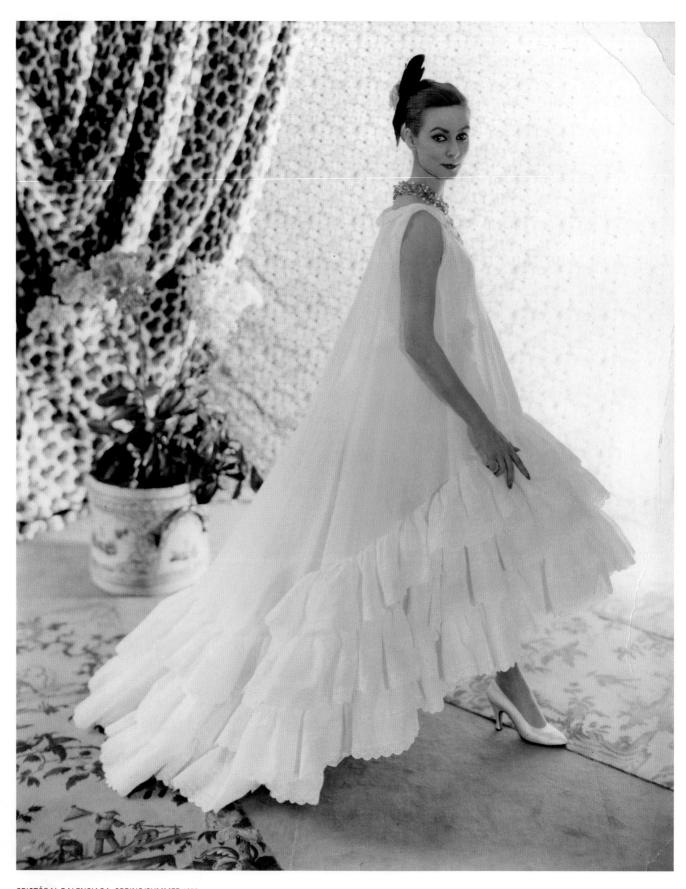

CRISTÓBAL BALENCIAGA, SPRING/SUMMER 1958.
Trapeze-shaped 'baby doll' evening dress.

Since he designs two seasons ahead of everyone else, fashion history starts all over again with the present Balenciaga collection.[16]

In August 1957 Balenciaga celebrated the twentieth anniversary of the Paris house with the presentation of his most radical offering to date: what the media baptized the sack dress. This was a new line where the arch at the back extended to the whole outfit and narrowed sharply down to knee height, removing any reference to the waist or hips. Thus the usual darts, belts or bands, which until then had helped suggest the body's shape, were disposed of. The body became an abstract being that moved freely inside the unfamiliar space it now inhabited. Just as had happened with Balenciaga's latest, loosest offerings, it was received coldly, even sceptically. Once again, Balenciaga seemed to be ahead of his time. The Tobé report of 1957 reveals, with striking astuteness, the role Balenciaga played in the fashion world:

Avant-garde movement in art and literature and all creative arts is finally becoming [a] recognized factor in fashions as well. This rightly so, as creation of fashion is a major art today. Therefore we can expect that there will probably always be some new avant-garde fashions from now on even after current examples of loose shift or chemise dresses have passed into history.

Everyone – fashion editors, stylists, designers, manufacturers, must learn to recognize these when they appear and not judge them by old established standards. Granted they may be extreme and even ugly in first presentation, sooner or later some will make them pretty and wearable without changing their basic character.

Dior has accomplished this with [the] shift silhouette two years after it was launched by Balenciaga and Givenchy who are chief exponents of avant-garde fashions.[17]

This revelatory observation gives us a better understanding of the famous phrase attributed to Christian Dior: 'Haute Couture is like an orchestra whose conductor is Balenciaga. We other couturiers are the musicians and we follow the directions he gives.'[18]

THE ROAD TO ABSTRACTION

Within the wide-ranging category of the shift or chemise dress, the winter 1957 collection also included a series of less controversial trapezoid-silhouette cocktail designs. Underneath a trapezoid lace dress of a manifest line, the design sported a second, tight-fitting, dress that outlined the wearer's real body shape, resulting in a kind of compromise between an expression of the waist and its denial. Balenciaga, following his impulse for innovation, decided to exaggerate the volume in a much more radical version of the trapezoid in the following collection in summer 1958. This would become known as the 'baby doll' dress, the last of the landmarks resulting from the intense experimentation with form developed by Cristóbal Balenciaga during the 1950s. It marked the beginning of his most abstract phase, based on the revision and abstraction of all of his previous work.

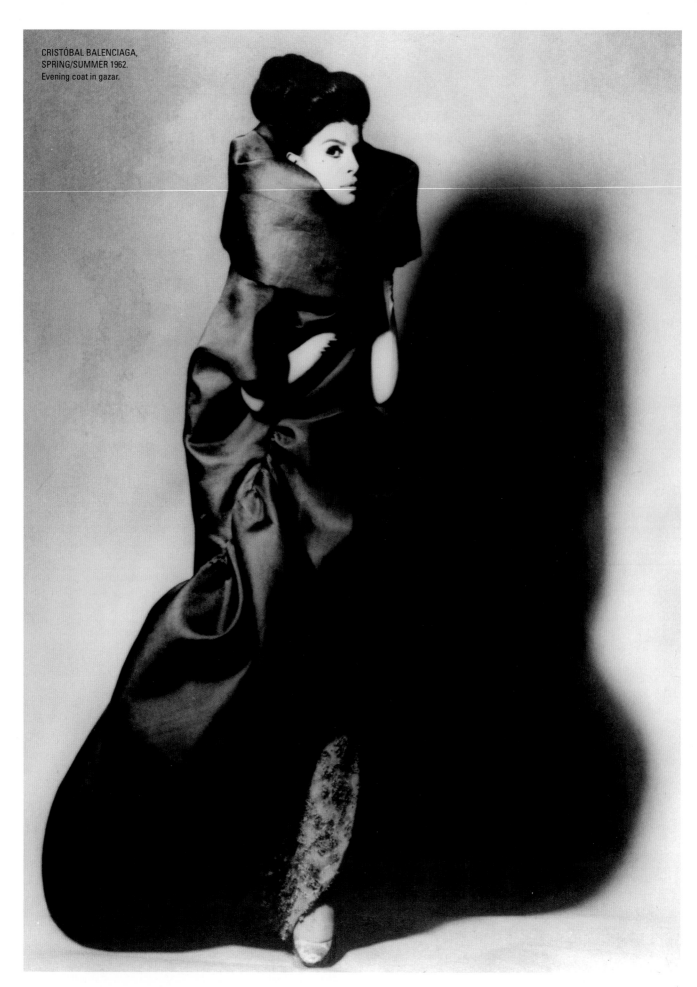

CRISTÓBAL BALENCIAGA,
SPRING/SUMMER 1962.
Evening coat in gazar.

As the 1960s went on, Balenciaga's collections fundamentally comprised refined reinterpretations of all the silhouettes he had produced to date. The cocoon silhouette, the tunic, the loose outfits, the semi-tailored dresses and the voluminous trapezoid were paraded one after the other – be it in daywear, cocktail wear or evening wear – in their most minimalist and architectural versions yet. Experimentation with fabrics during this phase was key and led to Balenciaga's collaboration with suppliers, such as Abraham or Ascher, increasing dramatically. The lightness and sculptural quality of the gazar or the super-gazar, together with Balenciaga's absolute mastery in dressmaking technique, gave rise to some of the most spectacular creations in the couturier's career towards the late 1960s. Balenciaga's final evolution grew in parallel with a growing disinterest in the demands of an ever more complex industry that questioned both his work and his methods. His increasing introspection undoubtedly played a vital role in the blossoming of his creative genius.

Cristóbal Balenciaga finally decided to retire in summer 1968, after a lifetime dedicated to perfecting his art. Initially moulded by some of the most innovative creators in the history of fashion, Balenciaga was from then on the holder of a set of aesthetic and technical fundamentals, as well as a particular vision of the body and an iconoclastic spirit that would infuse his own work for the rest of his life. These were the roots that placed Balenciaga at the head of sartorial and aesthetic innovation in the mid twentieth century. His offerings contributed not only to the conception of alternative ideals about femininity, but they also offered women a new way of experiencing clothes. In the final years of his career Balenciaga was guided by an incessant search for the essence of his own creations, subjecting them to unprecedented technical and formal refinement.

Shortly after Balenciaga's house shut its doors for the last time, Paris was rocked by the arrival of a group of young Japanese designers ready to challenge established notions of beauty and femininity. Many critics thought then that what they were doing was turning fashion into art. Whether they knew it or not, Balenciaga's spirit would live on through their work.

CRISTÓBAL BALENCIAGA, AUTUMN/WINTER 1958.
Balloon-shaped cocktail dress.

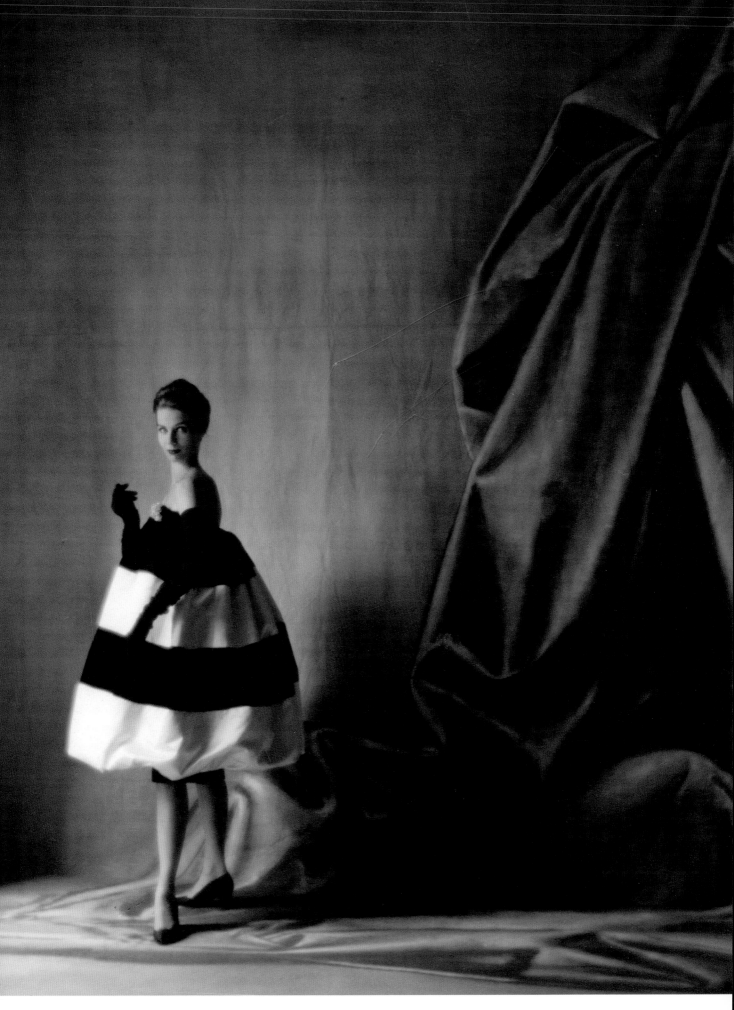

DRIES VAN NOTEN,
SPRING/SUMMER 2012.
The Belgian designer
brought a homage to
Balenciaga in this
collection.

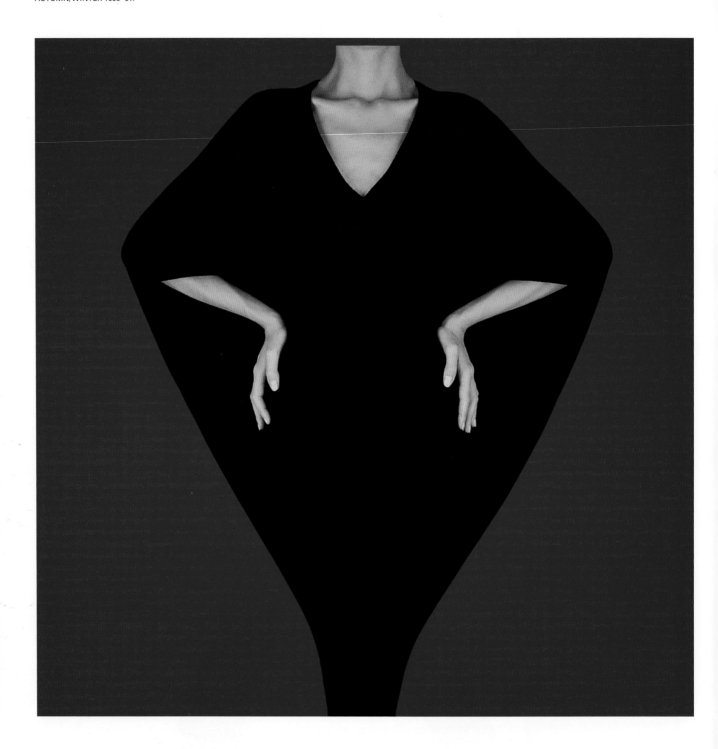

SYBILLA

In 1987, a promising young designer won the Cristóbal Balenciaga national fashion design award in Spain. That woman was Sybilla Sorondo Myelzwynska, New Yorker by birth (1963) and Spanish by adoption, the daughter of an Argentine diplomat and a Polish designer. Much like Balenciaga, Sybilla creates enveloping volumes that caress rather than restrict the body. She uses soft warm colours, inspired by nature, shying away from anything loud and artificial. Her mastery of cut can be seen in the formal simplicity of her sculptural coats and evening dresses. After a long break, Sybilla returned in 2014 – one of the most highly anticipated comebacks in the fashion world – at the height of her creative maturity.

SYBILLA,
AUTUMN/WINTER 1998.
Wedding gown.

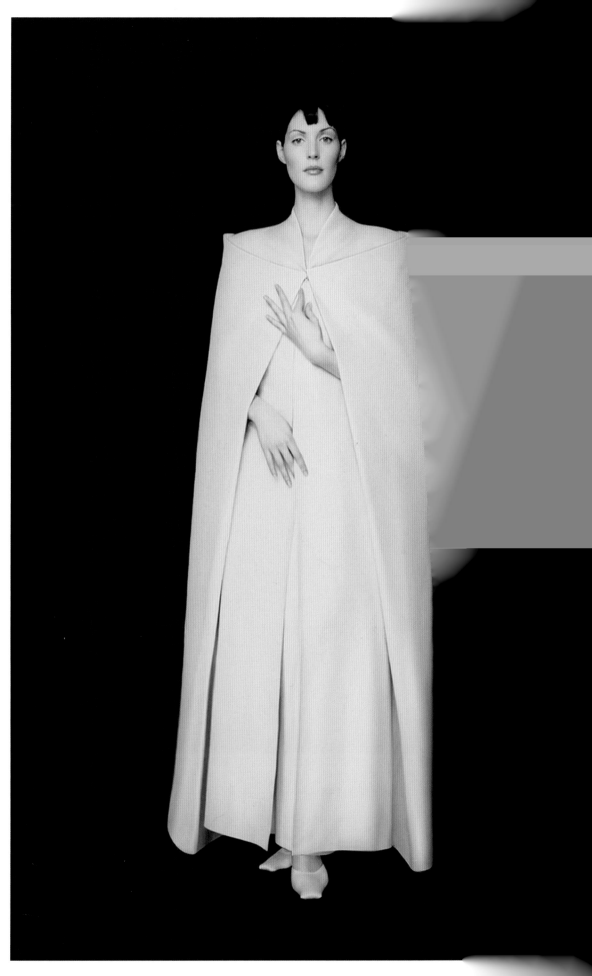

SYBILLA,
AUTUMN/WINTER 2015–16.
Cocoon-shaped coat.

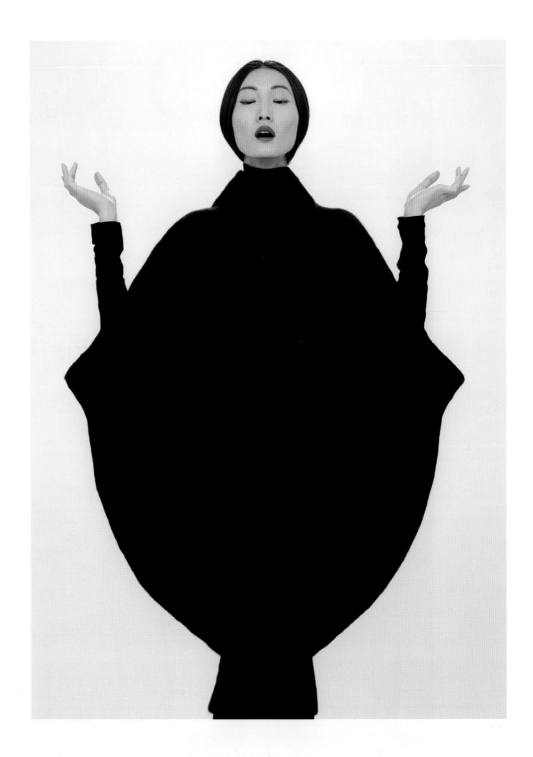

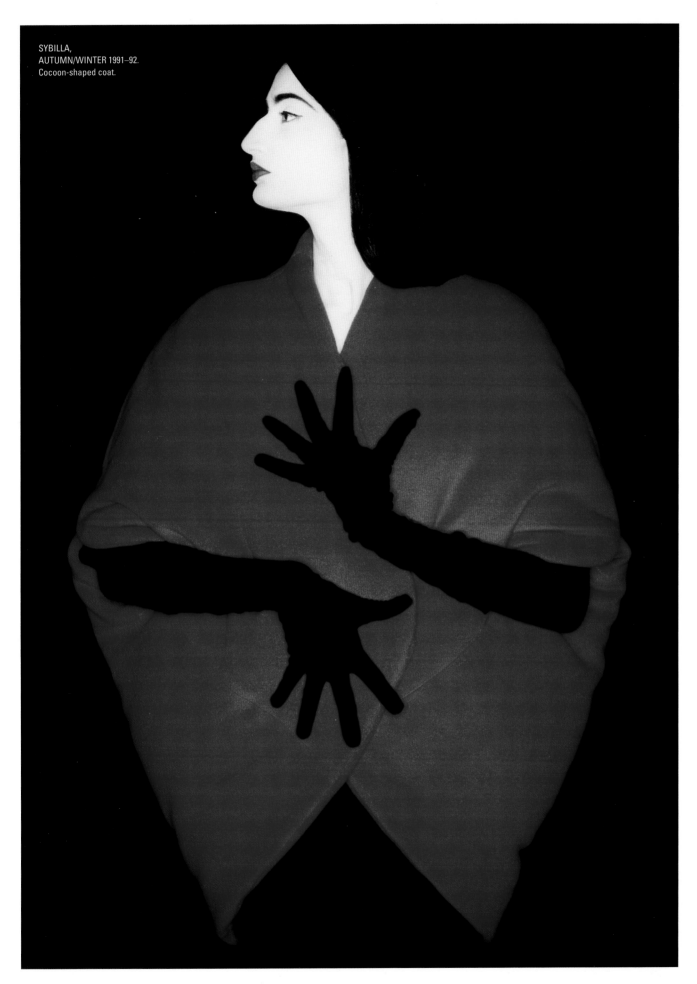

SYBILLA,
AUTUMN/WINTER 1991–92.
Cocoon-shaped coat.

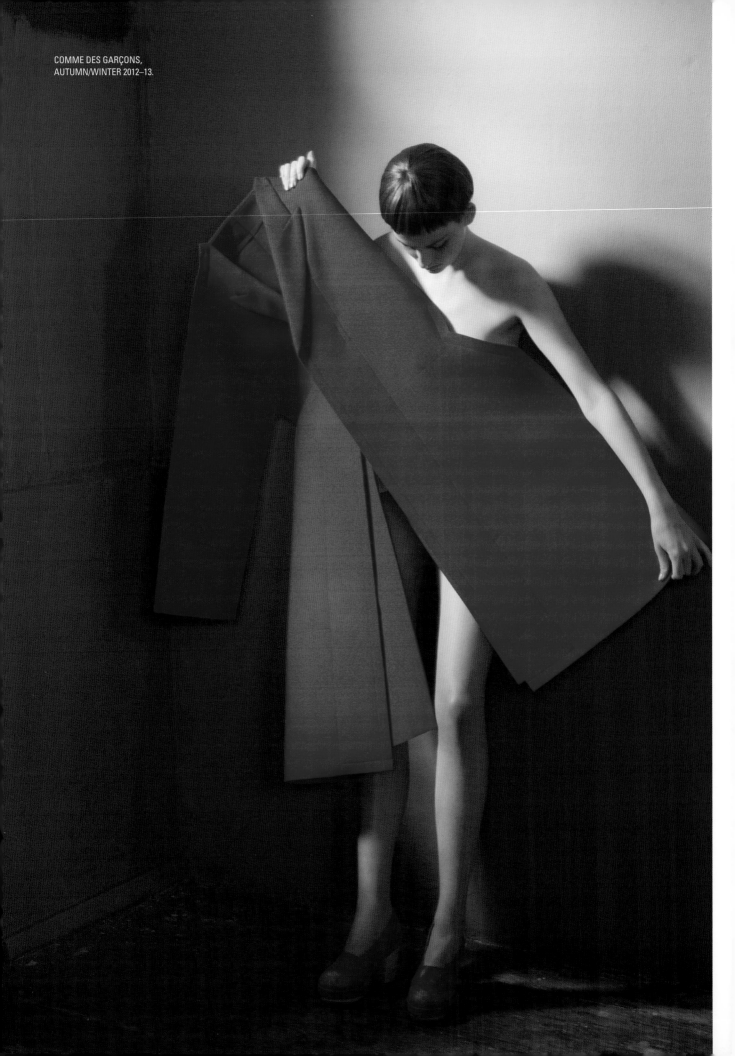

COMME DES GARÇONS,
AUTUMN/WINTER 2012–13.

SELF-TAUGHT AND EXPERIMENTAL: A NEW APPROACH TO THE BODY

— KAREN VAN GODTSENHOVEN

I am working on things that don't exist.
It's like working on a Zen koan [riddle].

— Rei Kawakubo[1]

Since the Romantic era, the West has broken with the idea of the artist as the head of an atelier, turning him instead into the lone genius in a studio. Together with this idea, the importance of craftsmanship has been abandoned in favour of the idea of the 'innate genius' of the artist. In Kant's *Critique of Judgment*, he states about the learnability of creativity, 'Genius is the innate mental disposition through which nature gives rule to art.'[2] Hence for Kant, art is spontaneous, informed by nature and impossible to define – originality is its most important characteristic. From this viewpoint, autodidactic and experimental approaches to making art are seen as close to nature and 'avant-gardistic'. Eastern notions of art, on the other hand, are inextricably linked to craftsmanship, with no distinction between fine art and applied art. Whereas the West sees inspiration as an immaterial, divine kind of 'breathing into', the Eastern idea of creation presupposes a direct relationship between the maker and the matter. Creativity in fashion, as an applied art, combines these notions: mastery of cutting and working with fabric is highly esteemed, but the concept of a designer as an ideas person – a thinker rather than a cutter – is much more accepted in today's fashion world than in the earlier days of haute couture.

When surveying the early careers, apprenticeships and (informal) education of the designers in this book, we can see that most of them developed idiosyncratic practices, independent of their training or background. Some of them came to fashion from other disciplines (Miyake, Kawakubo, Godley), some through apprenticeships in ateliers (Vionnet, Chanel, Balenciaga, James, Miyake), and some had classical training (Yamamoto, Margiela, Demeulemeester), but it was their individual practice and designs that led to their status as avant-garde designers. Whether coming into the system as an outsider or a fully trained insider, their challenge of the status quo and radical approach to fashion design is something they all share.

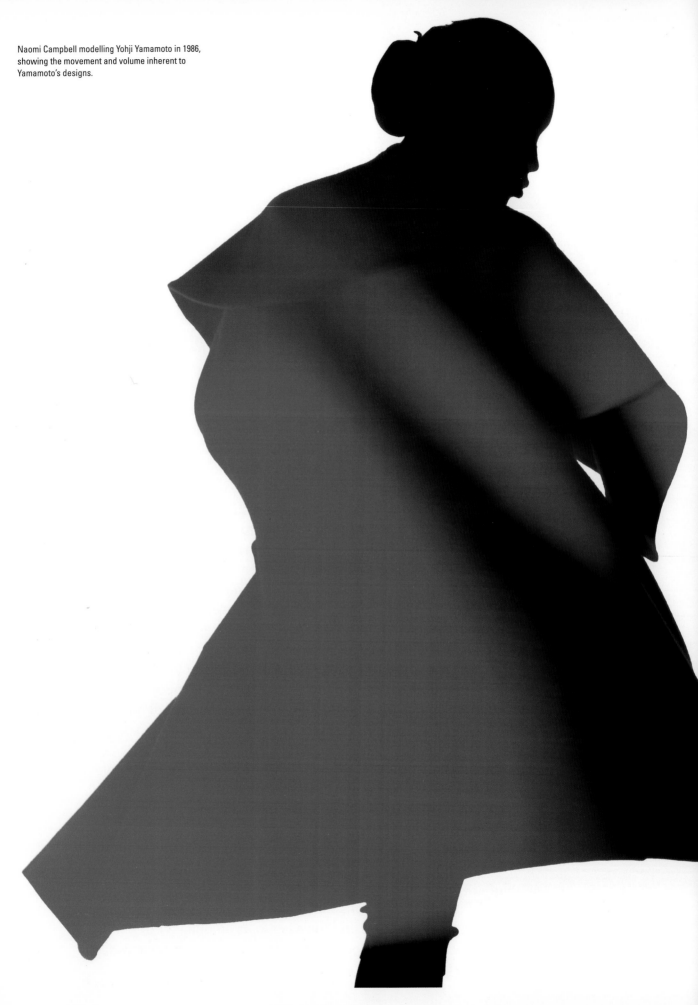

Naomi Campbell modelling Yohji Yamamoto in 1986, showing the movement and volume inherent to Yamamoto's designs.

CHAPTER 3 — SELF-TAUGHT AND EXPERIMENTAL: A NEW APPROACH TO THE BODY

Naomi Campbell modelling Yohji Yamamoto in 1986,
showing the movement and volume inherent to
Yamamoto's designs.

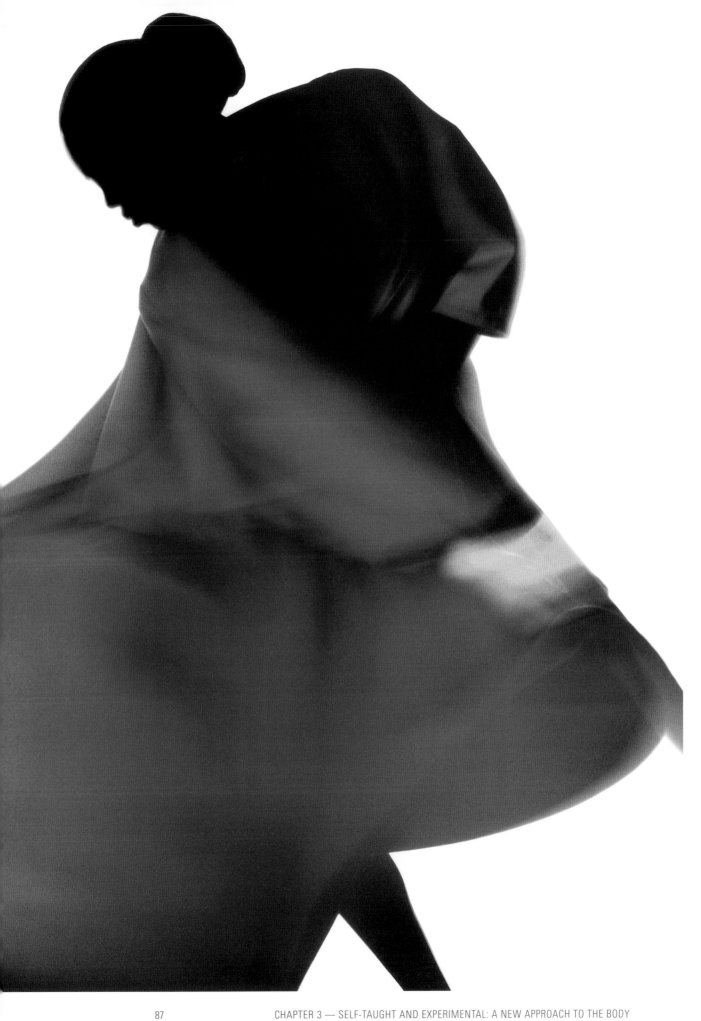

CHAPTER 3 — SELF-TAUGHT AND EXPERIMENTAL: A NEW APPROACH TO THE BODY

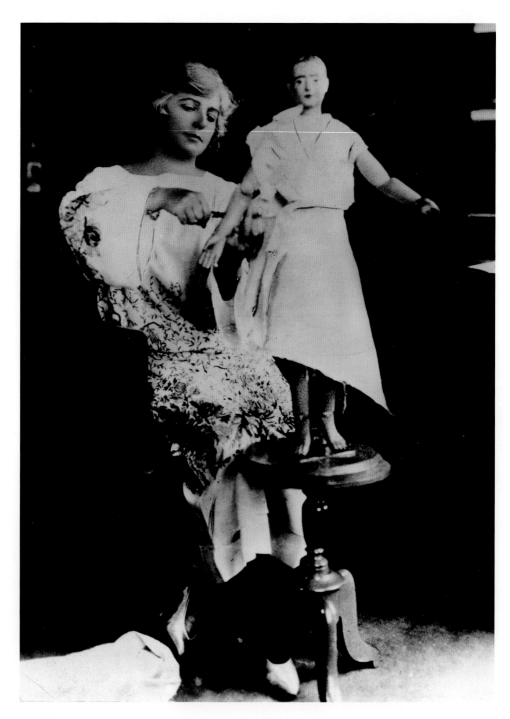

Madeleine Vionnet working on her mannequin, *c.* 1930.

There is no measure to say how much a successful designer should know about patterns and construction, and what kind of training is most useful, as Kawakubo states: 'It helps to have had a fashion training, of course, but I don't regret not having done it that way. If you can afford to take the time to train your eye and develop a sense of aesthetics in a natural way, it has a lot to recommend it.'[3] Harold Koda points out the creative freedom[4] this position entails: 'Kawakubo is free of any preconceptions associated with the technical aspects of fashion. Liberated from the rules of construction, she pursues her essentially intuitive and reactive solutions, which often result in forms that violate the very fundamentals of apparel.'[5] This link between mental freedom, autodidacts and avant-garde design strikes some resemblance with the intellectual idea of design which can be found in descriptions of the couturiers' work, like Vionnet, James and Balenciaga. In their case, however, the 'mental' conjuring up of a shape is still linked to the fabric and the hands that give life to the idea:

'For me, the idea of a dress is mental: I conceive it and create it by dreaming. And finally, after searching, I end up holding it in my hands.' […] By constantly manipulating the muslins, kneading them like clay, Vionnet was able to discover the innovative sewing techniques that would ensure her fame. Her hands linked her spirit to the material.[6]

It is also interesting to note that Vionnet's mentor, Madame Gerber at Callot Soeurs, was self-taught: 'Marie never knew how to sew, not even a hem. […] As opposed to the method usually used by dressmakers, for her, creation took place directly.'[7] Vionnet's training with an unorthodox teacher, whom she had to interpret technically, could have been instrumental for her intuitive approach, draping the fabric directly onto her wooden dolls (mannequins).

More famously, Gabrielle Chanel was not well versed in pattern construction and often got criticism for her lack of technical insight. She also draped directly on the living model: 'She knew precisely what she wanted to create, but often failed to communicate this adequately and berated her workroom staff when the results were not as she intended. Later in life she acknowledged: "I have never been a dressmaker."'[8]

Charles James, the 'calculus of fashion' is often called an engineer or scientist, but Koda nuances this by explaining that his science was an intuitive process:

It was a science largely of his own invention, although he had spent some time in 1932 in Paris studying or exposed to the practices of an haute couture atelier. While he mentions deploying classic dressmaking techniques […] his methods are frequently at odds with common practice. He does not begin with a sketch. Because his designs are essentially imagined, then constructed with his own hands rather than executed by others, there is a quality of spontaneity to their resolution. Any 'science' is primarily a tool for his intuition.[9]

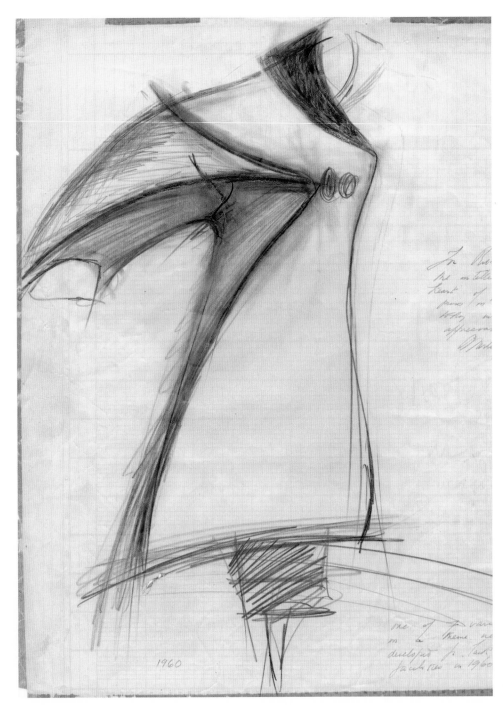

CHARLES JAMES DRAWING, 1960.
Pen and pencil on paper.
This coat design attests to his architectonic shapes and body abstraction of his daywear designs,
which existed alongside his more body-hugging evening gowns.

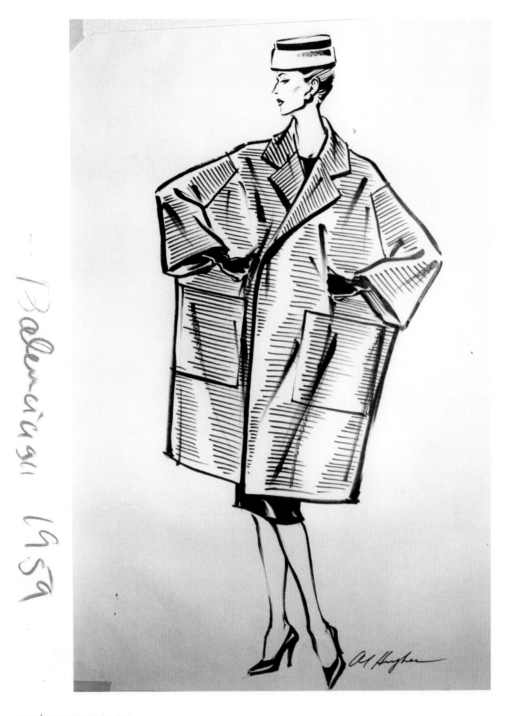

CRISTÓBAL BALENCIAGA, 1959.
Photograph of a sketch from the Nina Hyde collection, made for the US market.
The extreme shape of the coat is in great contrast with the hourglass couture
silhouettes of the day.

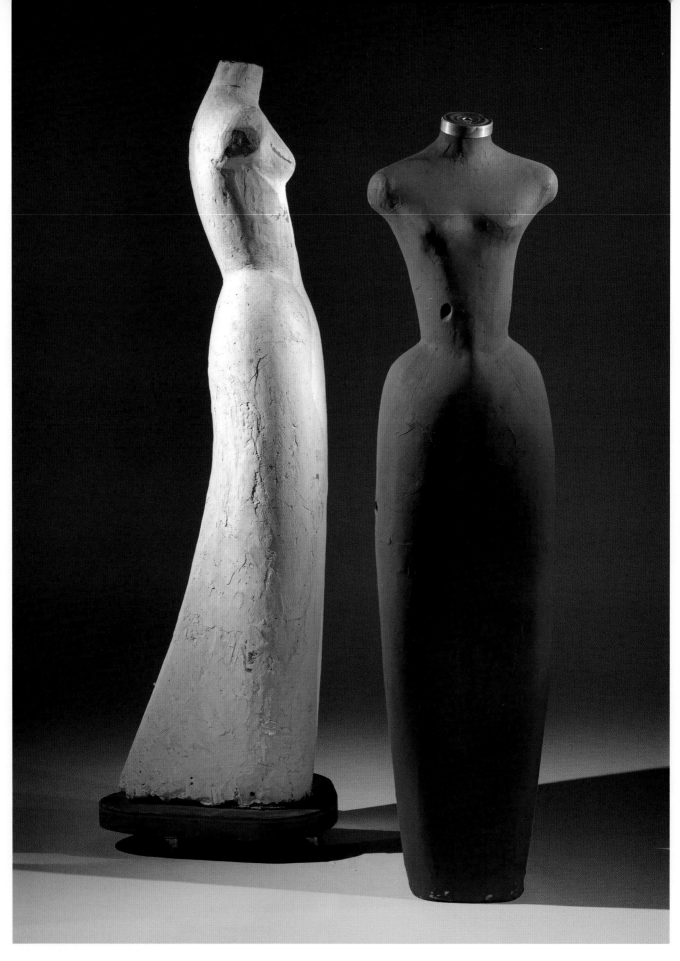

Full-length forms made to the shape of Charles James's Butterfly gown, c. 1954.
The white one is plaster-covered papier-maché, wood, and metal;
the blue form is papier-maché and metal.

This is Charles James' most abstracted depiction of his 'Cocoon' coat,
a 1967 drawing in mixed media, including shoe polish.
Subsequent silk-screen versions were titled *Meta Morphology*.

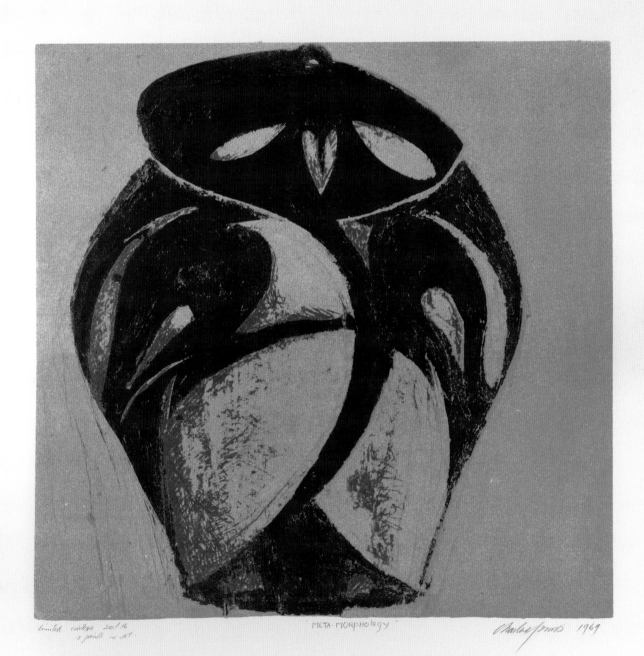

META-MORPHOLOGY

CHAPTER 3 — SELF-TAUGHT AND EXPERIMENTAL: A NEW APPROACH TO THE BODY

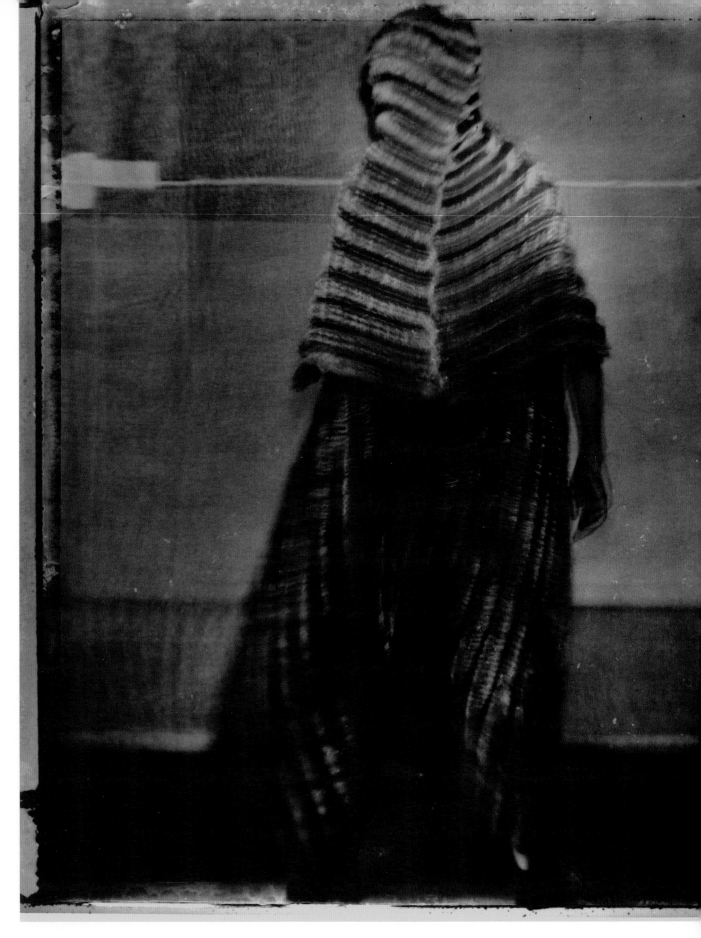

ISSEY MIYAKE, 1992.

Like Vionnet, after conceiving of a shape, James sculpted the cloth directly on a bust. Similarly, 'Miyake's designs, though highly engineered, projected a process of intuitive draping rather than tailoring.'[10] Neither does he work from sketches:

'I create by wrapping a piece of fabric around myself. It's a process of manual labour. My clothes are born out of the movement of my hands and body.'[11]

Margiela, Demeulemeester and Yamamoto, on the other hand, exemplify the idea that it takes knowledge of classical tailoring and draping principles in order to be able to deconstruct them. These designers, as masters of cut and deconstruction, show both a technically skilled as well as a highly conceptual approach toward garment design, uniting the ideas of craftsmanship and idea-led design.

Georgina Godley,[12] as a synthesis of the previously discussed designer types, combines self-taught technical knowledge (learning from over-the-counter patterns, creating her own mannequins), a conceptual design approach linked to her art school days (similar to Kawakubo, she says, 'I learned how to package an idea aesthetically'), and a later apprenticeship in a tailoring shop where she furthered her technique.

The Romantic idea of the 'natural' talent of the artist evolved in the postmodern era of the late twentieth century to a more collective vision of creativity: multiplicity, multidirectional exchanges and the 'death of the author' are properties of postmodern thinking about creation, as described by Deleuze, Barthes, Derrida and Bakhtin. The death of the author and the turn towards the collective can be seen in the anonymity of Martin Margiela, operating under the group name of the Maison Martin Margiela. This way, at the end of the twentieth century, fashion design becomes a 'heterogenesis, it is born out of many'.[13] The notion of work as unpredictable, free play is also central to this vision. Kawakubo's pattern-cutters' description of the design process, in which she posits abstract ideas, and her team reacts on it as a game of catchball,[14] is a great illustration of this anarchistic and playful way of 'birth giving' to designs. 'To be able to come up with a method like that is her creativity. She is very good at hiring assistants who know how to interpret her ideas.'[15] Nevertheless, she urges them not to work in the way they were taught pattern-cutting at school.[16] Koda confirms, 'The paradox is that Kawakubo's careful control over all aspects of the business incorporates at the core of its design process, an openness to the unpredictable.'[17]

The idea of starting from zero has been at the root of Kawakubo's design philosophy since 1979: she starts with the yarn and fibre research before all else. Both Kawakubo and Miyake have long working relationships with their fabric engineers, who are the first to hear their

GEORGINA GODLEY,
'LUMPS AND BUMPS',
AUTUMN/WINTER 1986.
Full-length rayon jersey
sheath dress with Rigilene
boning hem, worn over
asymmetric padded
underwear of cotton Lycra
with polyester filling.

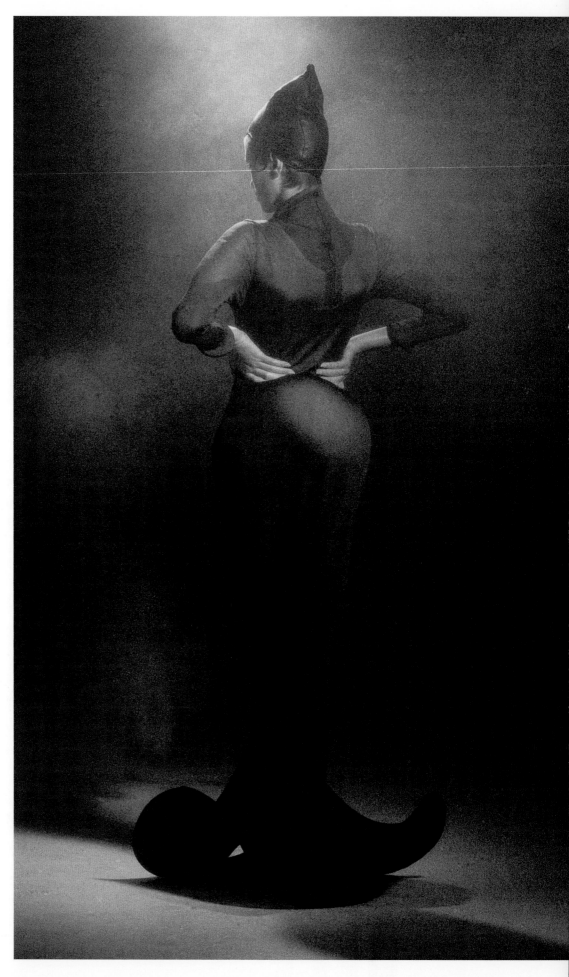

GEORGINA GODLEY,
'LUMPS AND BUMPS',
AUTUMN/WINTER 1986.
Asymmetric padded under-
wear in cotton Lycra with
polyester filling.

MAISON MARTIN MARGIELA,
AUTUMN/WINTER 1998–99.
Flat coat with collar in felted
wool with metal hook.
MUDE. M.0251 |
"Coleção Francisco Capelo"
MUDE – Museu do Design e
da Moda, Coleção Francisco
Capelo | Lisboa.

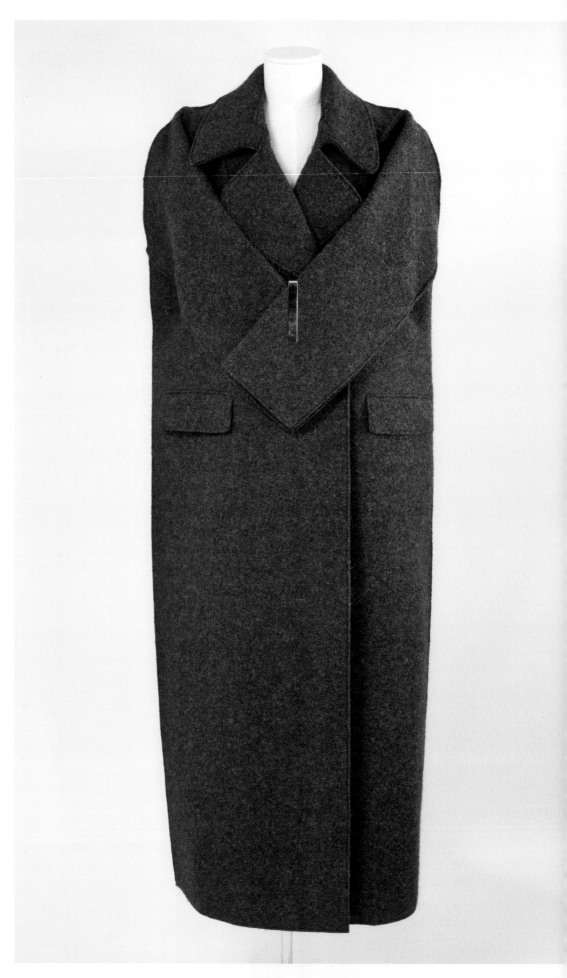

Preparation booklets with images made by Martin Margiela for the video shown at the spring/summer 1998 collection presentation. This collection was partly made out of flat garments and was shown together with the collection of Comme des Garçons in Paris.

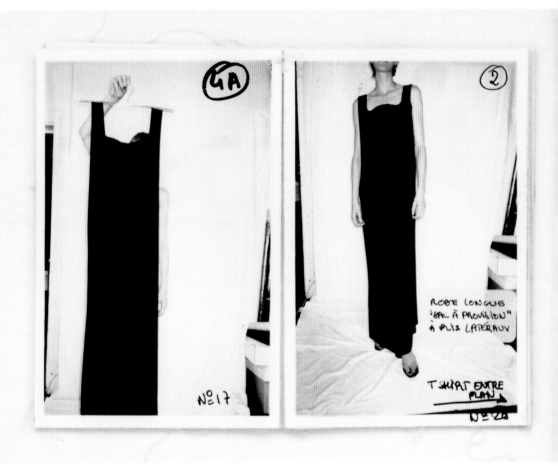

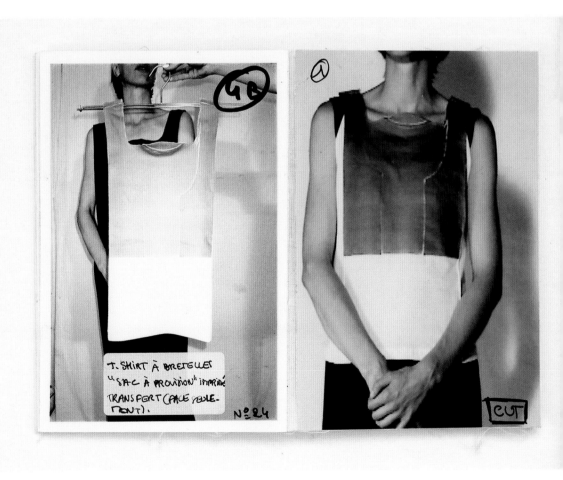

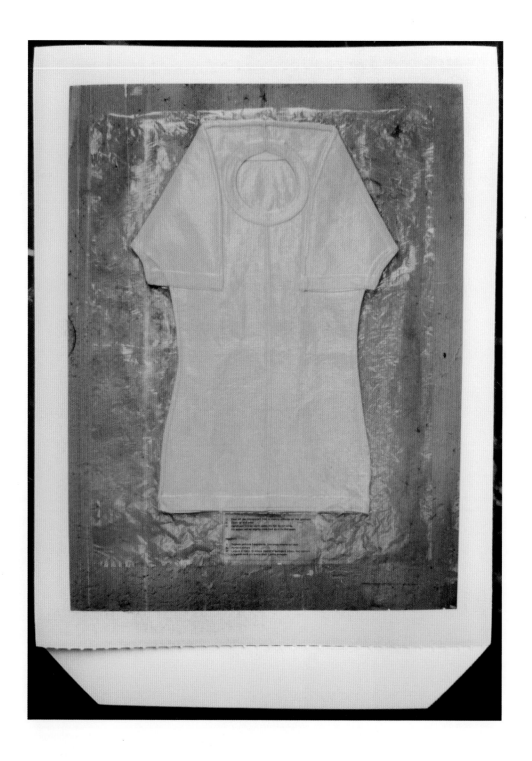

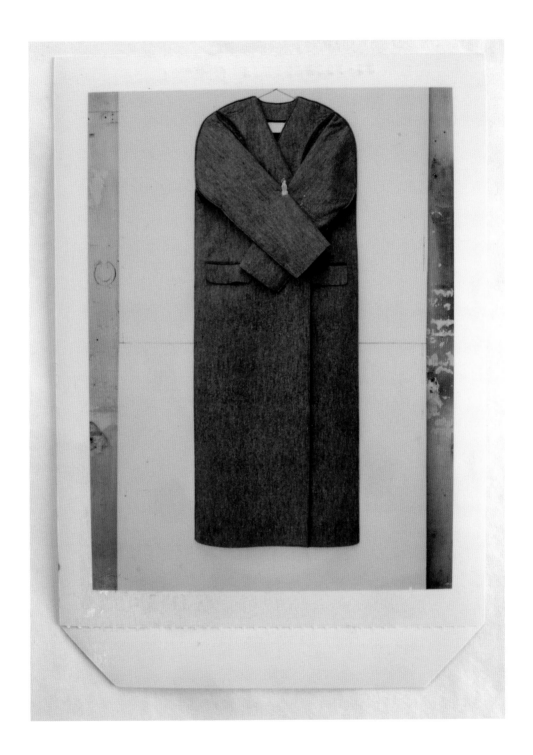

CHAPTER 3 — SELF-TAUGHT AND EXPERIMENTAL: A NEW APPROACH TO THE BODY

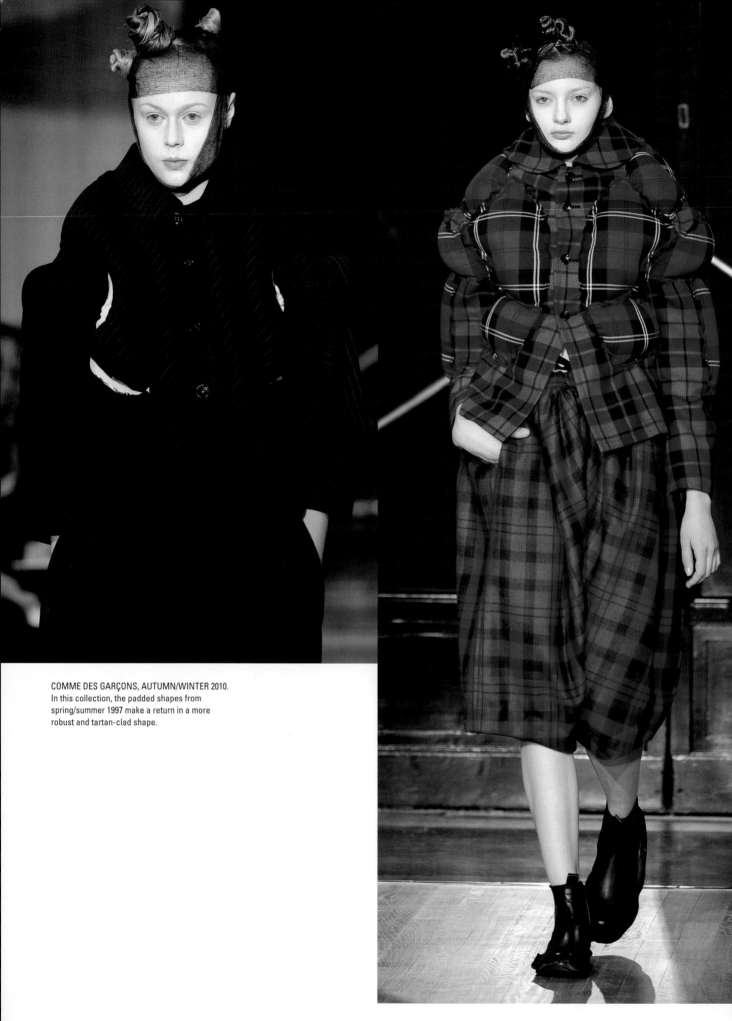

COMME DES GARÇONS, AUTUMN/WINTER 2010.
In this collection, the padded shapes from
spring/summer 1997 make a return in a more
robust and tartan-clad shape.

abstract ideas and translate them into textile.[18] Issey Miyake's work with Makiko Minagawa, who communicates his wishes to the textile mills, has led to his innovative 'A-POC' (acronym for 'a piece of cloth') and 'Pleats Please' lines. Similarly, Kawakubo's collaboration with specialty weaver Hiroshi Matsushita is at the basis of her most iconic designs, such as the holey jumper and her distressed weaves and textures. These collaborative processes confirm the cooperative creativity at the root of their creation.

I couldn't explain my creative process to you, and even if I could, why would I want to? Are there people who really wish to explain themselves? — Rei Kawakubo[19]

Design methods ranging from the direct to the conceptual inform the way these designers look upon the relationship between body and garment. Before looking at how this translates into a specific attitude towards the female body, it is important to note the strong female mentorship that runs through these designers' lives: Vionnet, for example, was trained as the 'première d'atelier' with Callot Soeurs. In her turn, she was a close friend and example to Balenciaga, who had learned the basics of tailoring from his mother, a widow who took care of her family by sewing fashionable designs. For Balenciaga, his friendship with three female designers, Vionnet, Chanel, and the lesser known Louise Boulanger, 'guided his development and emboldened him in creating ever more innovative fashions for women'.[20]

Chanel famously looked to herself for inspiration: 'I was the same age as the new century, and it was to me that it looked for sartorial expression.'[21] Yamamoto and Kawakubo were raised by strong mother figures[22] who inspired them to make clothes for working women, rather than designed for the binary 'mother/geisha' vision of women which still existed in Japan. Kawakubo explained: 'I design for strong women who attract men with their mind rather than their bodies, and for wives who are not swayed by what their husband thinks of them.'[23] Margiela and Demeulemeester were trained by female head teachers, and they have become renowned for blurring gender boundaries by combining traditional sartorial codes for men and women into one garment.[24]

A strong female mentorship in combination with Eastern approaches towards the female body,[25] where body-hugging shapes are considered vulgar[26] and the kimono flattens a woman's curves, results in a more abstracted silhouette which extends into the space around the body. The abstracted body can be found in Charles James' lengthened and flattened torsos, Vionnet's 80cm doll and Balenciaga's silk gazar structures of semi-circles, cones and cubes. It is also visible in Chanel's waist-obliterating jackets and dresses, which liberated women from the 'caged bird look'.[27]

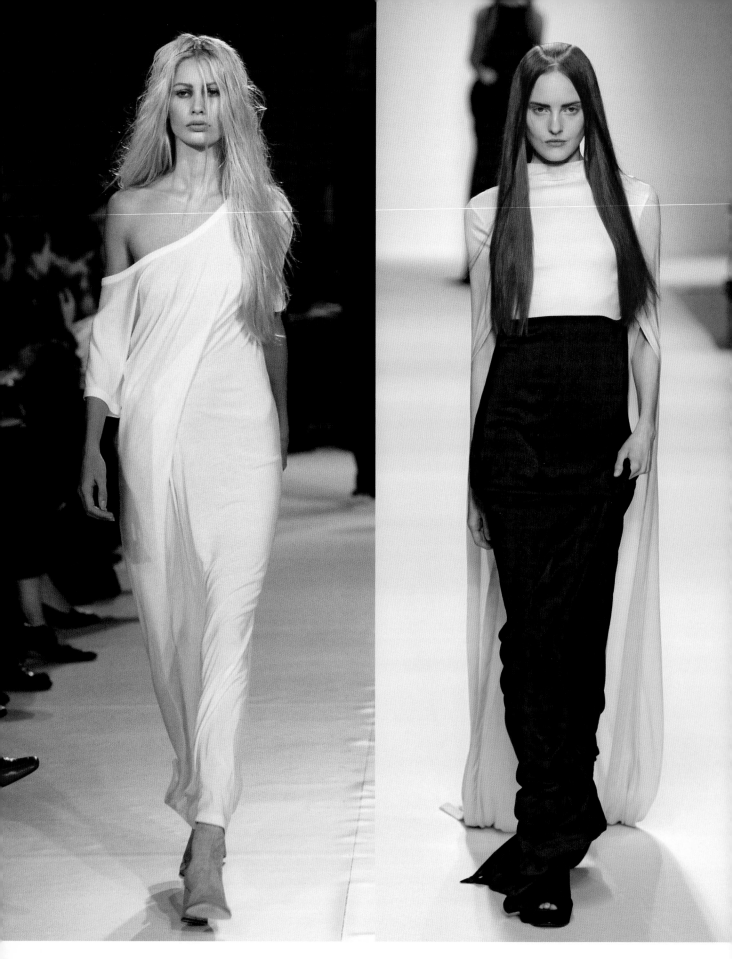

ANN DEMEULEMEESTER,
SPRING/SUMMER 1997.

ANN DEMEULEMEESTER,
SPRING/SUMMER 2013.

These waist- and bust-obliterating shapes around the body rely strongly on the shoulders, which provide the structure from which the fabric hangs loose on the body, often creating a 'decolleté' of the back. For Chanel, the back was the most important part of the body and Yamamoto even says that he designs clothes from back to front.[28] The space thus created from the shoulders downwards, between body and garment, the *ma*, is a 'rich space that possesses incalculable energy',[29] the space between the perfect and the imperfect. Vionnet used her technical innovation of working with the grain of the fabric not to create a form-fitting shell, 'but to lay the fabric effortlessly along the lines and silhouette of the body in movement.'[30] She was followed by Balenciaga, whose use of silk gazar and masterful cut made for near-weightless, autonomous volumes which obscured but also 'strangely emphasized the reality of the body'.[31] The body is liberated by being enveloped in an intimate space, not obliterated.

It was Balenciaga, and especially Vionnet, who provided the greatest inspiration for Miyake: 'Vionnet really understood the kimono, using the geometric idea to construct her clothes and this brought much freedom'.[32] Miyake's guiding principle throughout the different stages of his designs incorporates the idea of *ma*, from his early designs of one piece of fabric hung from the body to his 1983 invention of the 'Pleats Please' technique,[33] to his 'A-POC' line of universal clothing and the origami structures of his recent '132 5' line. Unlike the body-clinging Delphos pleats of Fortuny, Miyake's pleats give the wearer an embodied freedom of movement, an architecture for the body.

Yamamoto and Kawakubo show a similar conception of the relation between dress and body, bridging both into a fusion of self and surrounding: 'Clothing is thereby given the authority to extend into space and to command not only its enclosed space but also its ambient space. The unity of self and landscape [...] is discovered by Kawakubo [...] The proposition of the clothing [...] is the seamless fusion between self and world.'[34]

This fusion is not a skintight garment but a symbiosis of skin and fabric into the intimate space around the body; the body is not so much abstracted but becomes a subject instead of an object to be shown:

This fashion is indeed strongly physical, it does not, however, treat the body as an object, to be exhibited, but instead as something that is one's own, that belongs to and with the inner self. Kawakubo does not aim for a spiritualization or a concealment of the body, but rather a new mode of embodiment. The relative indeterminateness of the clothing, which leaves a great deal of freedom for the wearer, corresponds to this intention.[35]

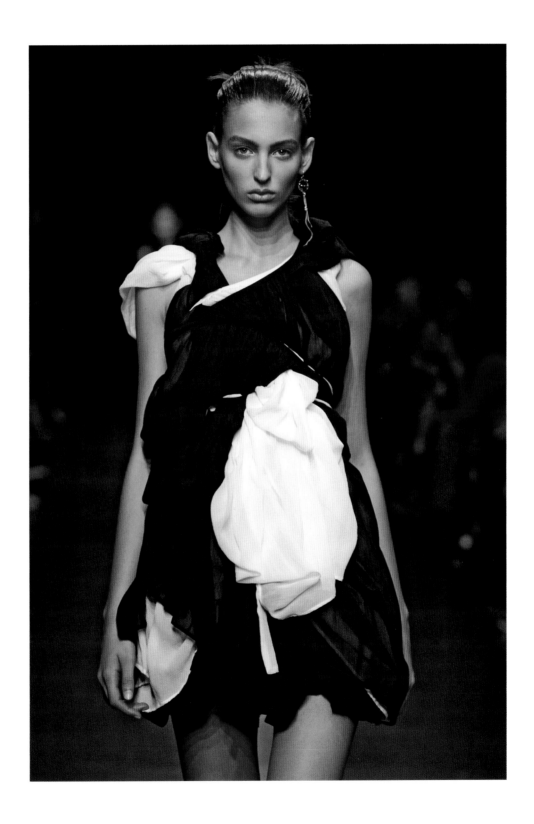

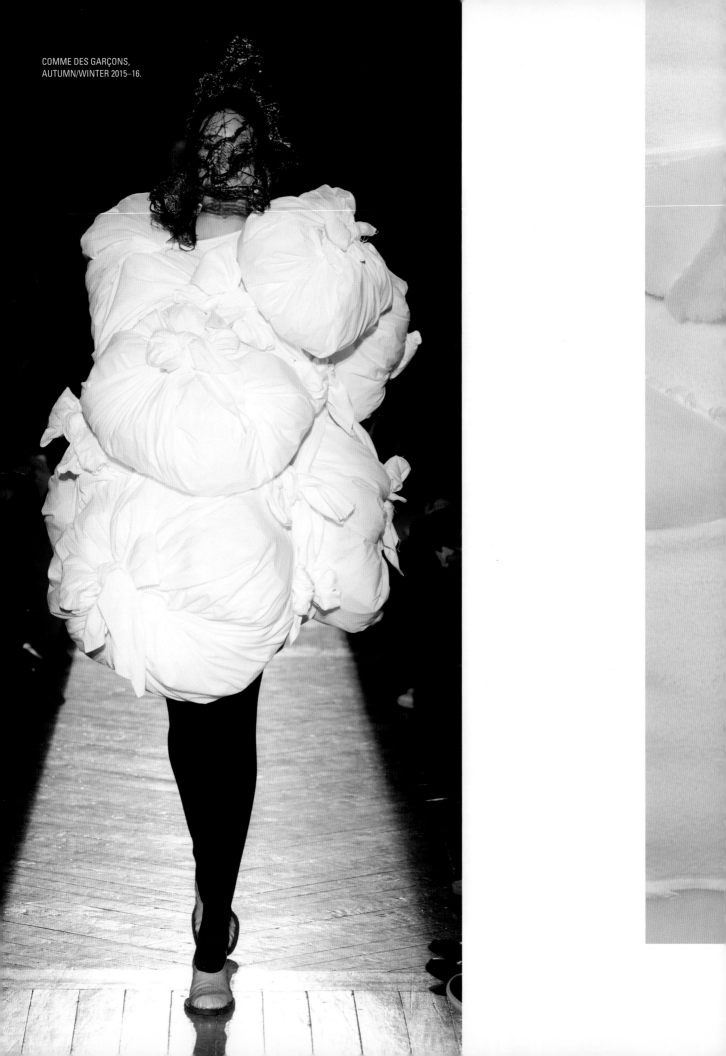

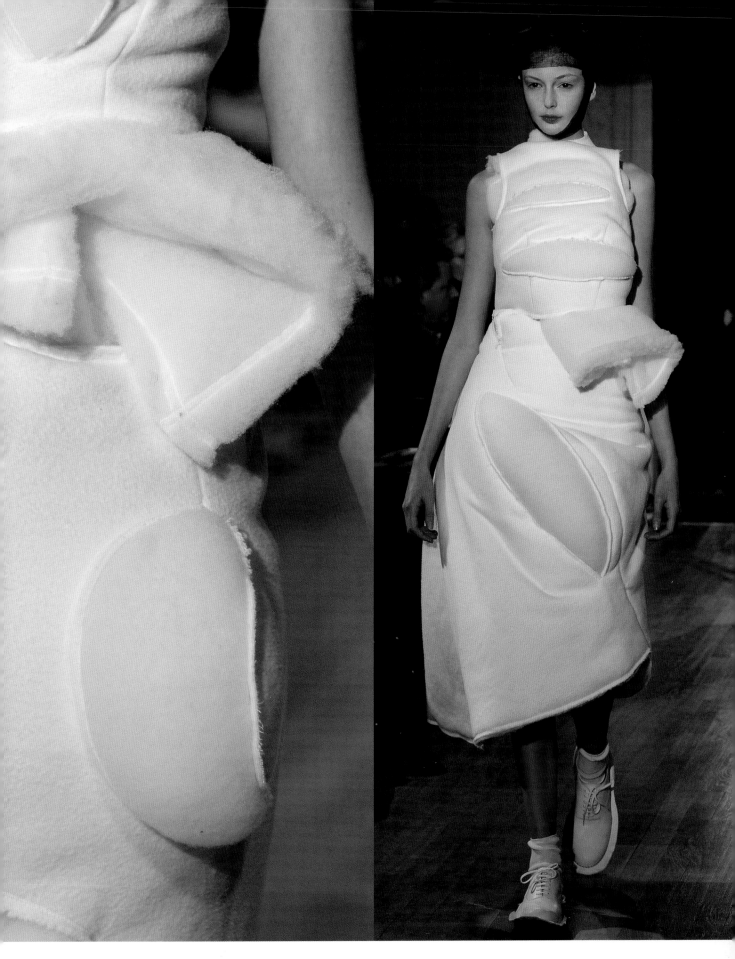

COMME DES GARÇONS, AUTUMN/WINTER 2010–11

CHAPTER 3 — SELF-TAUGHT AND EXPERIMENTAL: A NEW APPROACH TO THE BODY

Freedom of movement, lightness and embodied sensuality characterize the work of Ann Demeulemeester: 'I did not make very abstract nor body-hugging shapes, I did not want the body to disappear, I wanted to see its contours moving in the garment.'[36] Martin Margiela, too, used different techniques such as flat garments with displaced necklines, circular cuts, cantilevered dresses, perpendicular zippers and oversized volumes to allow the body beneath the clothes to come into a three-dimensional being.

Fashion celebrates not the suggestion of woman as doll, but the doll 'as woman' as the woman that women are not.[37] — Barbara Vinken

The image of woman as a living doll is central to twentieth-century Western fashion and modern ideas about femininity. Walter Benjamin stipulates in his Arcades project: 'Every fashion couples the living body to the inorganic world. Fashion claims the right of the corpse in the living. Fetishism, based on the sex appeal of the inorganic, is its vital nerve.'[38] Yamamoto confirms: 'Dolls ... this is what many men want women to be ... just dolls.'[39] Chanel was early to point out the obsession with an idealistic doll-like silhouette by her contemporaries: 'Look at them. Fools dressed by queens living out their fantasies. They dream of being women, so they make real women look like transvestites. [...] I made clothes for the new woman. She could move and live naturally in my clothes. Now look what those creatures have done.'[40] Her answer was not so much to design for the natural woman but for the modern, slim, androgynous New Woman, the *gamine*, reincarnated in the designs of Kawakubo, Demeulemeester and Yamamoto.

Martin Margiela deconstructs the idea of the doll as a more perfect version of woman: his collections featuring blown-up versions of dolls' garments (autumn/winter 1994, autumn/winter 1999), clothes moulded to an oversize tailoring dummy (spring/summer 2000, autumn/winter 2000–01, autumn/winter 2001–02), the adaptable metal wire dummy (autumn/winter 1989–90), and a tailor's dummy used as a vest (spring/summer 1997, autumn/winter 1997–98), all show a woman 'not inscribed with the fetish of femininity, but rather this fetish is presented as [...] a foreign body'.[41] Margiela uses the fetishistic association of the ideal body shape in the tailor's dummy or puppet and reverses it.[42]

In 1983, as a reaction to the power-woman silhouette of the 1980s and its counterpoint, the voluminous, abstract shapes of the Japanese designers, Godley returned to womanliness and reconsidered the female form:

I returned to dressing dolls. I took Barbie as the most abhorrent example of where we had gone. It was not interesting to merely explore the symmetrical shape that the Edwardian bustle had

HANS BELLMER, *LA POUPÉE [THE DOLL], SECONDE PARTIE*, 1937.

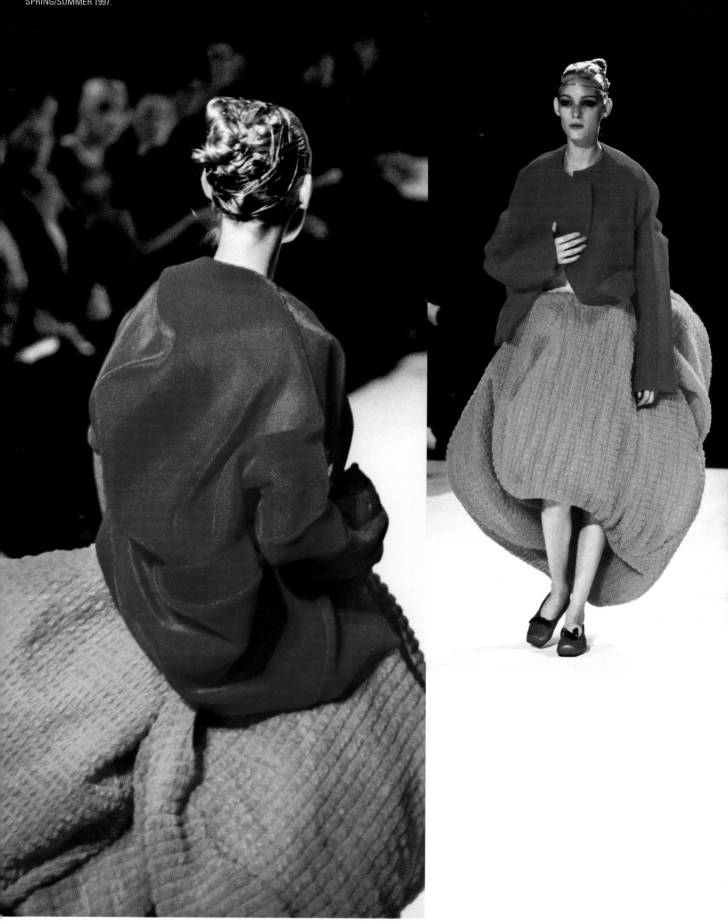

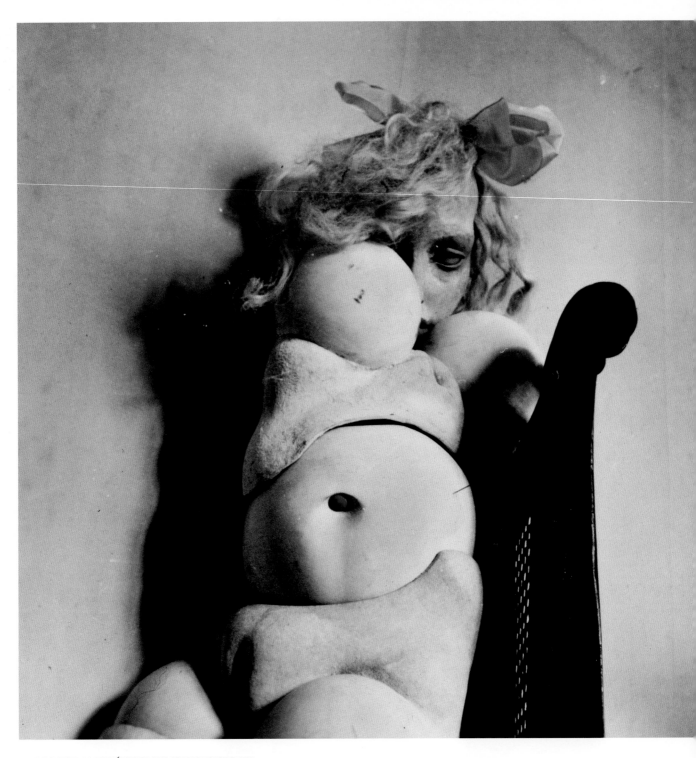

HANS BELLMER, *LA POUPÉE [THE DOLL]*, *SECONDE PARTIE*, 1937.

given us, or the pannier of the seventeenth century as these were male dominant fantasies of how women should look. I was more interested in the very feeling of inhabiting the female form as an expression of fecundity and power.[43]

She created collections called 'Body and Soul' (1983), which featured figure-hugging, romantic shapes with hooped hems, and 'Lumps and Bumps' (1986), which celebrated the female form in exaggeration, using surrealist techniques,[44] including distorting the body's curves by using padded shapes which could be slipped on and off. Similar to, but overstepping the curve-hugging fashions of Azzedine Alaïa, Godley created asymmetrical, body-enhancing structures on top of the clothes instead of stretching the fabric around the body. Her feminist stance made her turn to a lost feminine allure, inspired by African fertility goddesses, Renaissance paintings, and Vermeer.

Kawakubo used knots, twists and elephantine, organic shapes in her work, throwing the silhouette off balance and leaving room for the imagination. Different collections feature lumps incorporated into the fabric structure (see for example spring/summer 1993), but gradually the lumps are detached from the silhouette, becoming surface decorations which, counter-intuitively, look more integral to the body.

In 1997, Kawakubo presented her pivotal 'Body Meets Dress, Dress Meets Body'[45] collection, dubbed 'Lumps n Bumps'. There is a huge divergence between what people saw in the collection and what Kawakubo is reported to have said about the collection, ranging from banal to artistic, beautiful to disturbing. Since Kawakubo, in the manner of a Fluxus artist, often changes or negates her own previous stance, all of them can be taken into consideration:

Comme des Garçons press release, 1997: 'Not what has been seen before, not what has been repeated, instead, new discoveries that look towards the future, that are liberated and lively.'[46]

Kawakubo in 2011: 'inside decoration'.[47]

Adrian Joffre, quoted in 2005: '[The collection was inspired] by Rei's anger at seeing a Gap window filled with banal black clothes.'[48]

Sotheby's website: 'silhouettes referring to *Les Baigneuses* by Pablo Picasso.'[49]

Merce Cunningham, 1997, commenting on the 'Scenario' collaboration between himself and Rei Kawakubo: 'the lumps are familiar shapes we can see every day, a bike messenger with a bag over the shoulder, a tourist with fanny pack, a baby on a mother's arm.'[50]

Fashion blog, 2013: 'a woman who holds onto grief, who carries the weight of her past on her.'[51]

Y. Kawamura, 2004: 'Fashion critics christened the Comme des Garçons bump dress the ugliest dress of the year, whilst Kawakubo explained it as rethinking the body.'[52]

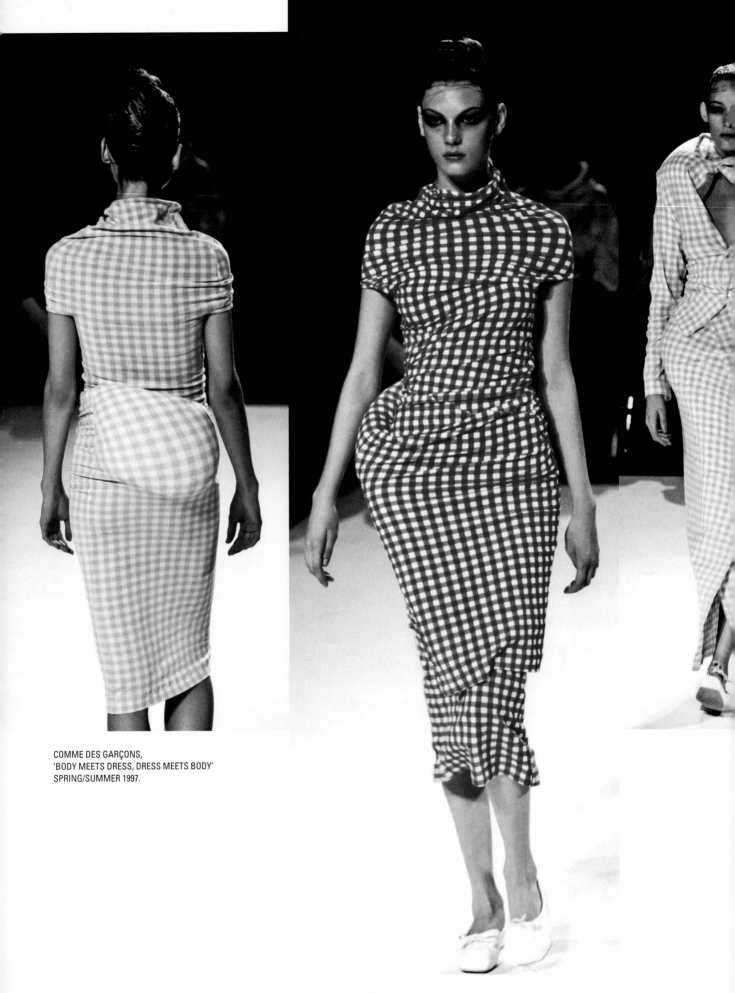

COMME DES GARÇONS,
'BODY MEETS DRESS, DRESS MEETS BODY'
SPRING/SUMMER 1997.

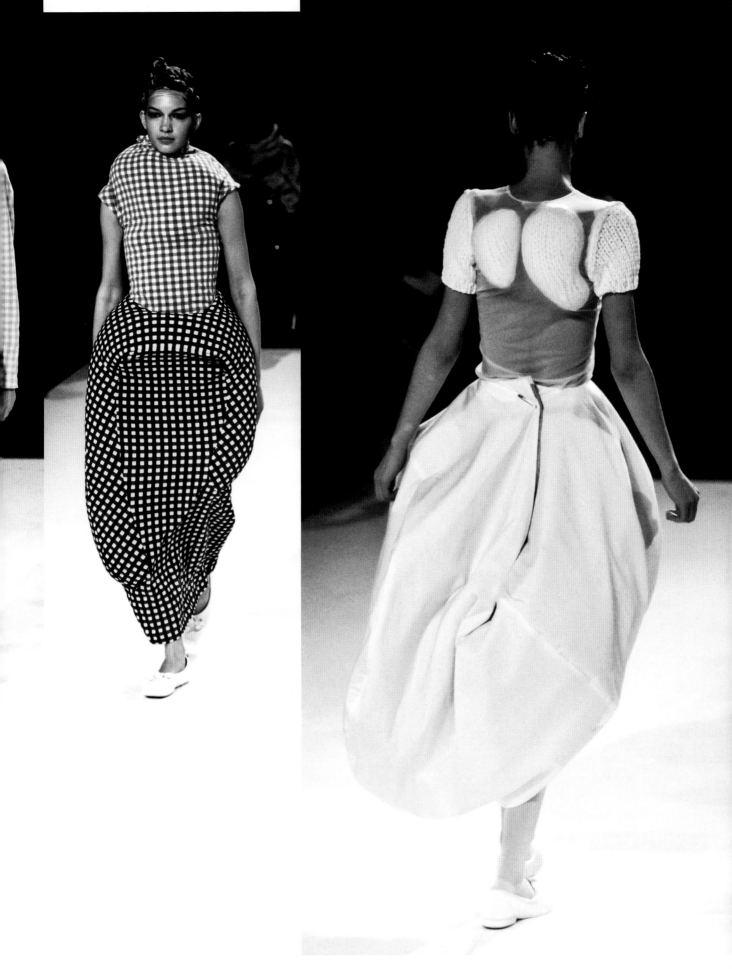

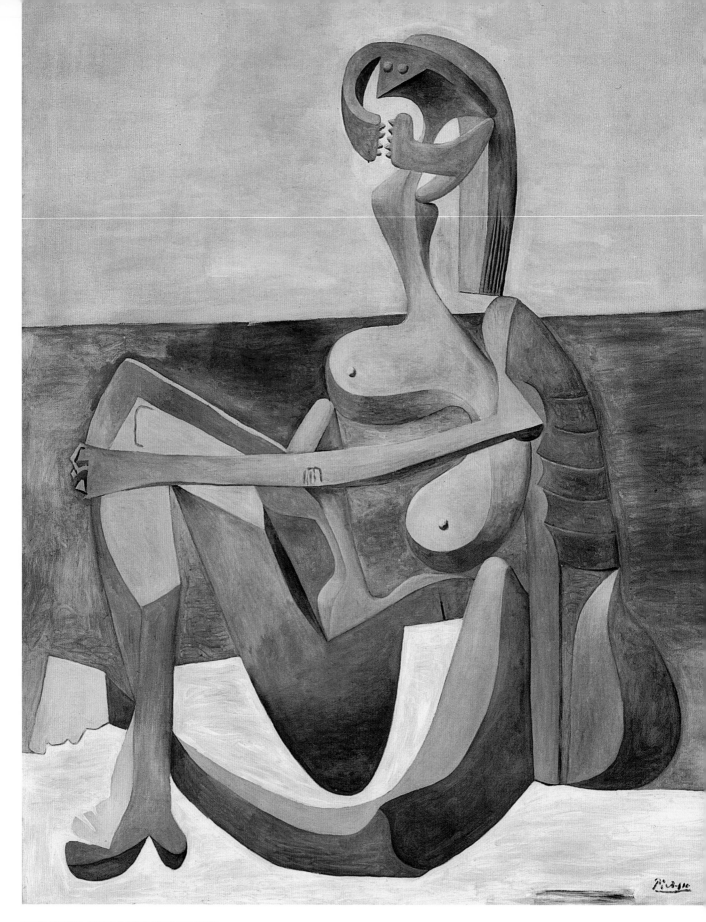

PABLO PICASSO, *SEATED BATHER*, EARLY 1930, PARIS.
The Museum of Modern Art, New York; oil on canvas, 163.2cm x 129.5cm.

Time magazine, 2004: 'Quasimodo collection.'[53]

G. Wood, 2007: 'The garments seem to derive from a symbiosis of the ideas of Bellmer, Dalí, Schiaparelli and Charles James'.[54]

Michael Stone-Richards, 2008: 'Kawakubo's exploration of the beauty of asymmetry.'[55]

Kawakubo revisited the lumps in spring/summer 2010 and autumn/winter 2015, letting them grow into huge knots and pillows, no longer an extension of the body but creating new surfaces and structures around the body. She has deconstructed and transcended the idea of the Western ideal and symmetrical female silhouette many times over, thus re-imagining not only the body but also the idea of what fashion is and the nature of clothes, 'by reconciling clothing with the "elsewhere". She bonds the individual and the world through the garment.'[56] The postmodern body she presents, like Godley's sensual forms and Margiela's oversized doll garments and displaced openings, leave room for the imagination of the body in the twenty-first century, enveloped by a structure which is not a defence against the world, but a bridge towards it. She thereby resolves the modern dilemma described by Rainer Maria Rilke:

This is what fate means: to be opposite and to be that and nothing else, opposite forever.[57]

If we consider the definition of avant-garde – redefining artistic convention; utilizing new artistic tools and techniques; and redefining the nature of the art object, including the range of objects that can be considered artworks[58] – we can apply this to the practices of all these designers and conclude that their radical rethinking of the method of designing garments and the use of material, a new interpretation of the relationship between garment and body, and a redefinition of what can be considered fashion, inevitably leads to their labeling as avant-garde designers or iconoclasts.

Since fashion exists by means of turning breaking points or anti-fashion into fashion,[59] all of them have become recognized as 'game changers' in their own right.

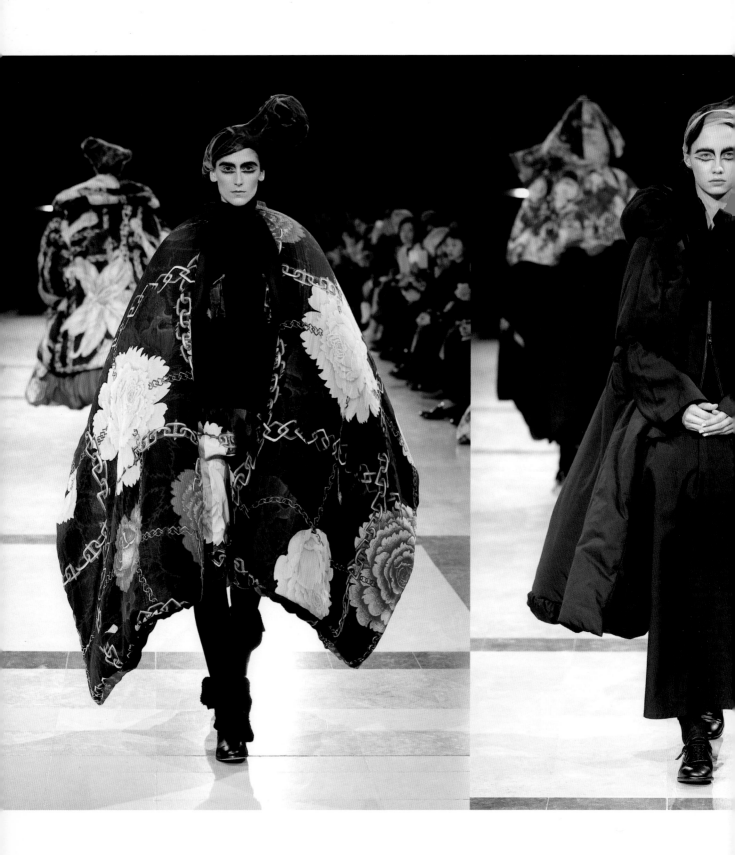

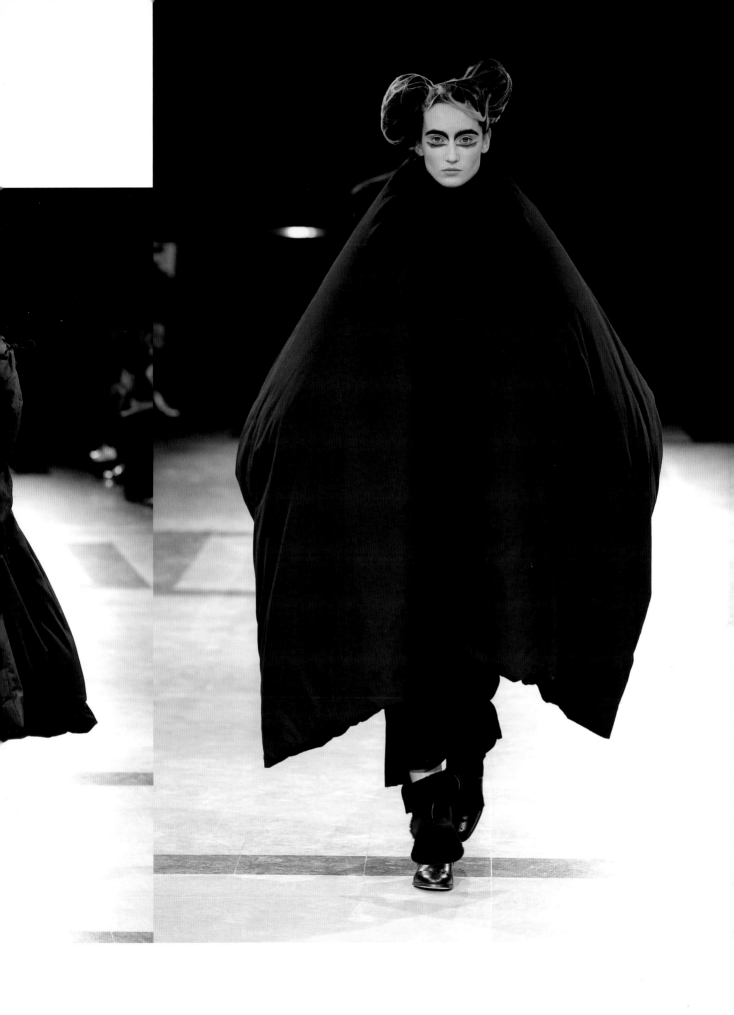

CHAPTER 3 — SELF-TAUGHT AND EXPERIMENTAL: A NEW APPROACH TO THE BODY

MAISON MARTIN MARGIELA,
AUTUMN/WINTER 1997–98.
Sleeveless linen vest
replicating a Stockmann
dummy, cotton dress,
paper pattern.
MoMu inv.nr. B02/122,
B02/127, T96/42.

MAISON MARTIN MARGIELA,
SPRING/SUMMER 2000 COLLECTION,
in which the generic garments
were enlarged by hand to size 74.

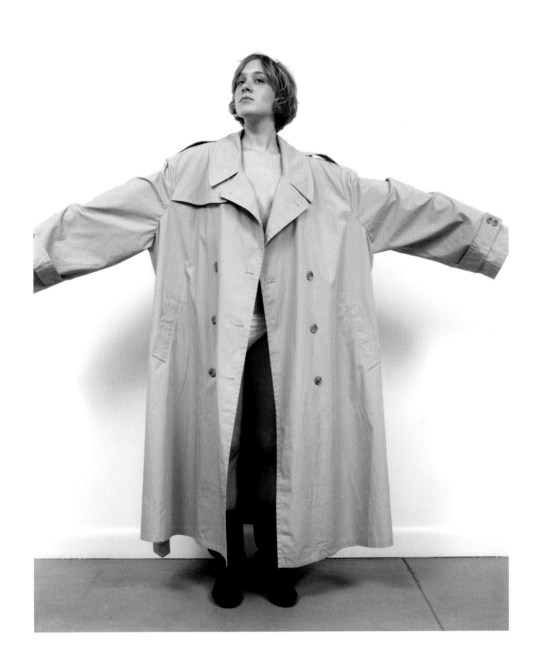

MAISON MARTIN MARGIELA,
SPRING/SUMMER 2000
COLLECTION,
in which the generic
garments were enlarged
by hand to size 74.

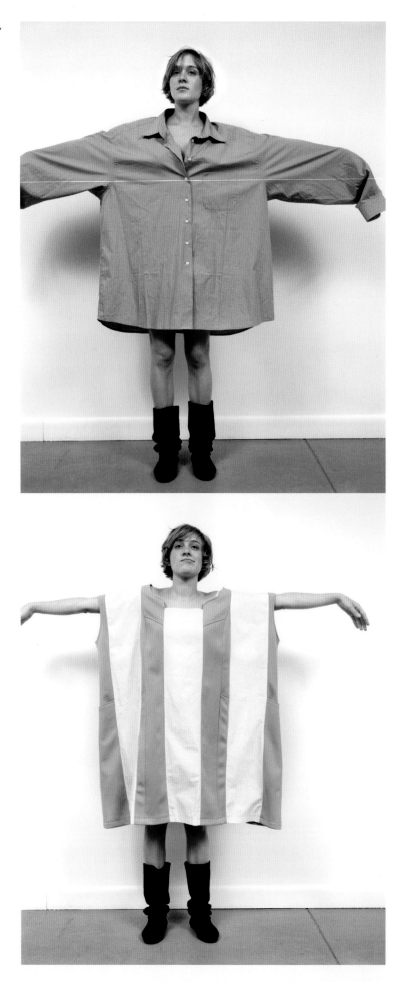

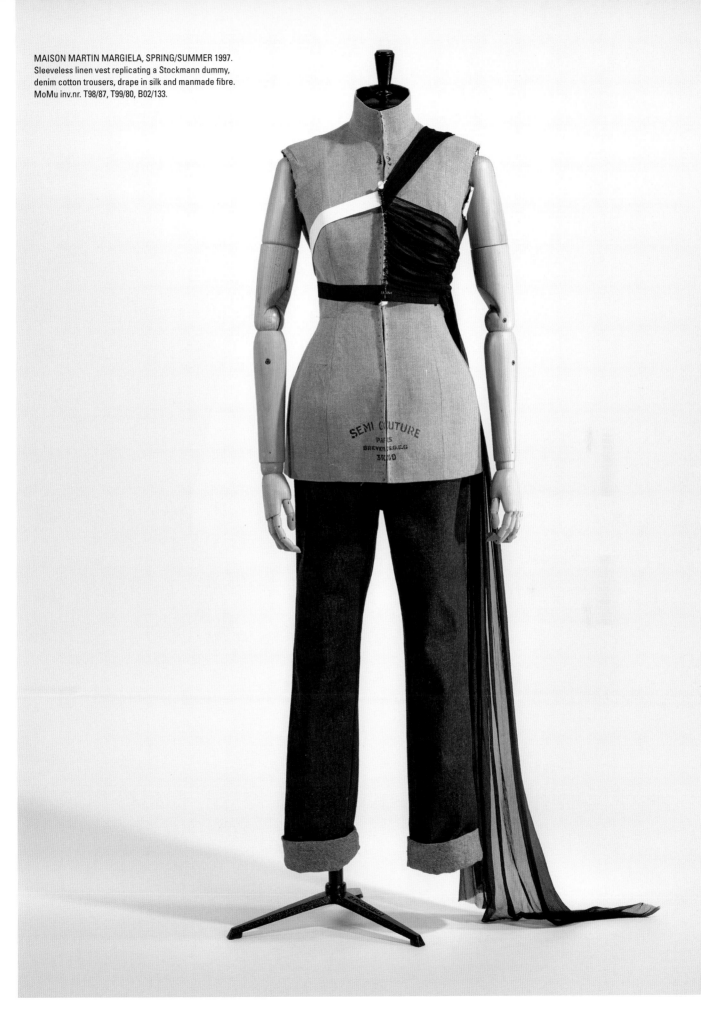

MAISON MARTIN MARGIELA, SPRING/SUMMER 1997.
Sleeveless linen vest replicating a Stockmann dummy,
denim cotton trousers, drape in silk and manmade fibre.
MoMu inv.nr. T98/87, T99/80, B02/133.

KARIN DILLEN ON WEARING MAISON MARTIN MARGIELA

— HETTIE JUDAH

I first encountered the work of Martin Margiela in 1993, just after I started work as a company doctor. My friend [the scenographer] Bob Verhelst was working closely with Margiela at the time and he told me about the clothes, how they were made, and the vision behind them. I joined Bob at some of the shows, and was allowed to see what went on behind the scenes. I became passionate about the love that went into the garments and the innovative designs of Maison Martin Margiela. On one occasion I assisted Bob backstage and loved being party to the creation of that atmosphere. I had thought fashion was inaccessible but MMM seemed to have a very relaxed atmosphere: I liked the seasonal rhythm, the excitement, the stories of how things were made, as well as the silhouette.

Bob invited me to try some things on: I was immediately in love with the pieces. I have long arms and often had difficulty finding garments that fit, but MMM was a great match since the clothes were often long. Quite quickly I acquired a lot of garments. In the beginning this was through personal orders, but after a few seasons I bought them in the store [Louis], and also ordered garments from their style sheets.

Before that I had not been into fashion: I wore 'student' clothes. Wearing Maison Martin Margiela did not make me behave or hold myself any differently: I just enjoyed wearing the emotions of the garments and the passion that was inside. One boss reprimanded me for what I was wearing. I said, 'OK, put it in the regulations', but as the garments are long and inoffensive they can't really be prohibited. To me there's no difference between a long dress and a pair of trousers, but the 'new' length of the garments was something people reacted to.

Each time that I've changed jobs I've started off wearing less 'full on' MMM, only gradually introducing some pieces after people got to know me. I don't want people to judge me immediately on my clothes: I want them to see me first. Patients have always reacted positively and when they return after a period of time they will often remember the tabi shoes or something I was wearing the previous time they saw me.

In general, men's reactions to what I wear have been positive, even fascinated, whereas women's reactions can be more negative. Although I don't care about the material status of the garments, the perception of them as a status symbol rather than as a creative act has provoked some negative reactions. In fact, I wear the garments all the time, not just for events. There is only one garment, made from recycled nightgowns, which I consider inappropriate to wear to work.

I enjoy the timelessness of the garments and the fact that you can keep combining MMM throughout the seasons and everything fits together. I don't like shopping or searching: with MMM I can just go to the store and find things that I love and in which I feel at home. Martin always appreciated the fact that I really wear his stuff in daily life.

Preparation booklets with images made by Martin Margiela for the video shown at the spring/summer 1998 collection presentation. This collection was partly made out of flat garments and was shown together with the collection of Comme des Garçons in Paris.

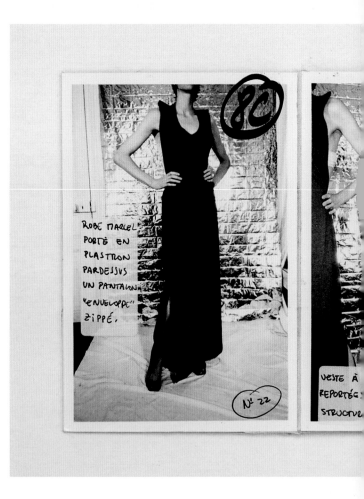

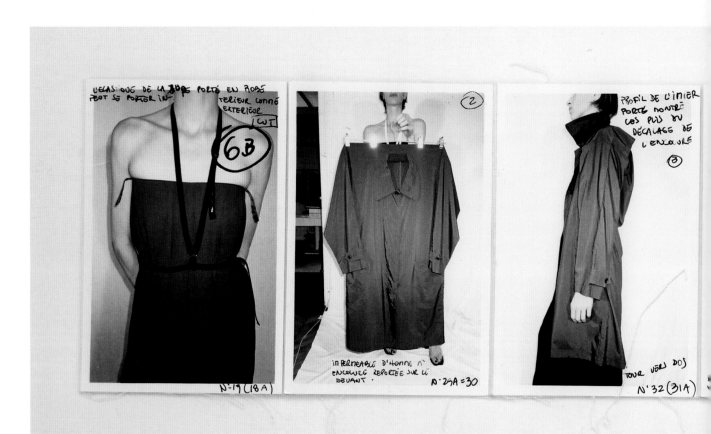

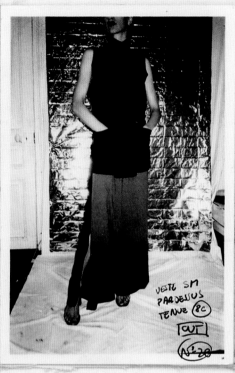

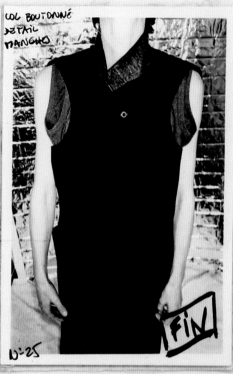

COL BOUTONNÉ
DÉTAIL
MANCHES

VESTE SM
PARDESSUS
TENUE 8C

CUT
N° 23

CUT
N° 20

N° 25

FIN

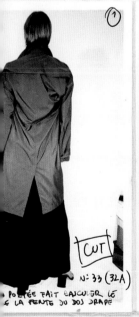

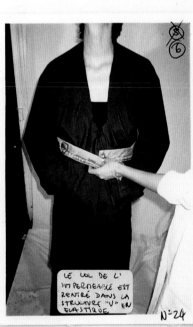

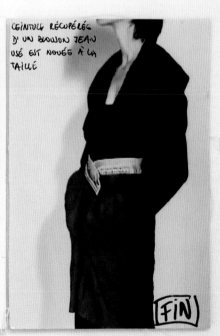

CEINTURE RÉCUPÉRÉE
D'UN BLOUSON JEAN
USÉ EST NOUÉE À LA
TAILLE

CUT
N° 33 (32A)

PORTÉE FAIT BASCULER LE
& LA FENTE DU DOS DRAPÉ

LE COL DE L'
IMPERMÉABLE EST
RENTRÉ DANS LA
STRUCTURE "V" EN
ÉLASTIQUE

N° 24

FIN

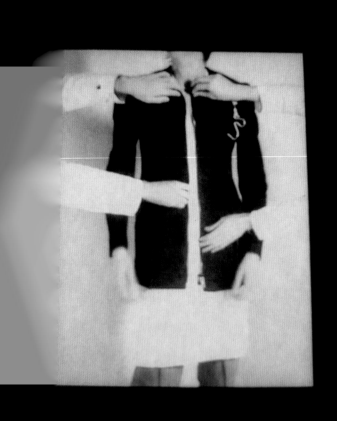
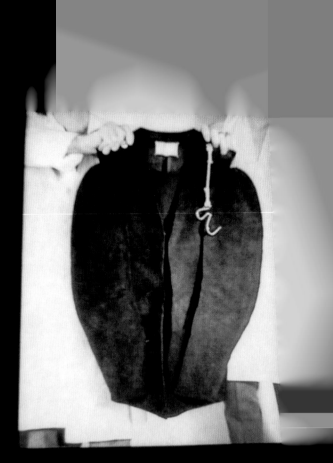
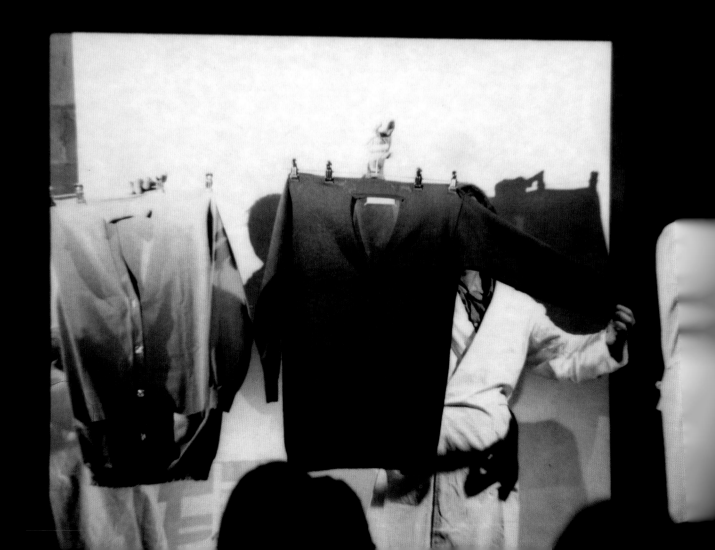

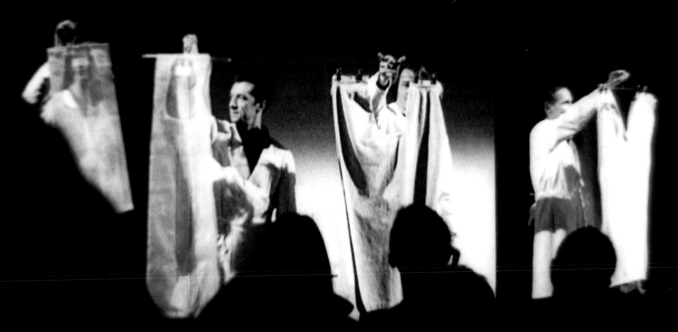

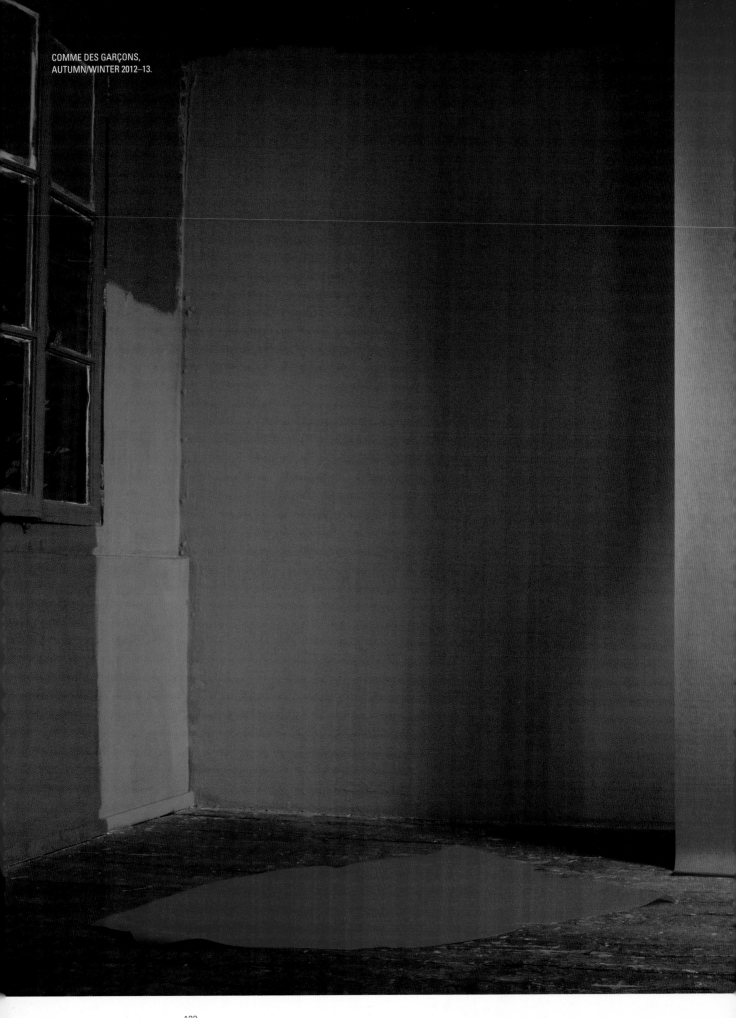

COMME DES GARÇONS,
AUTUMN/WINTER 2012–13.

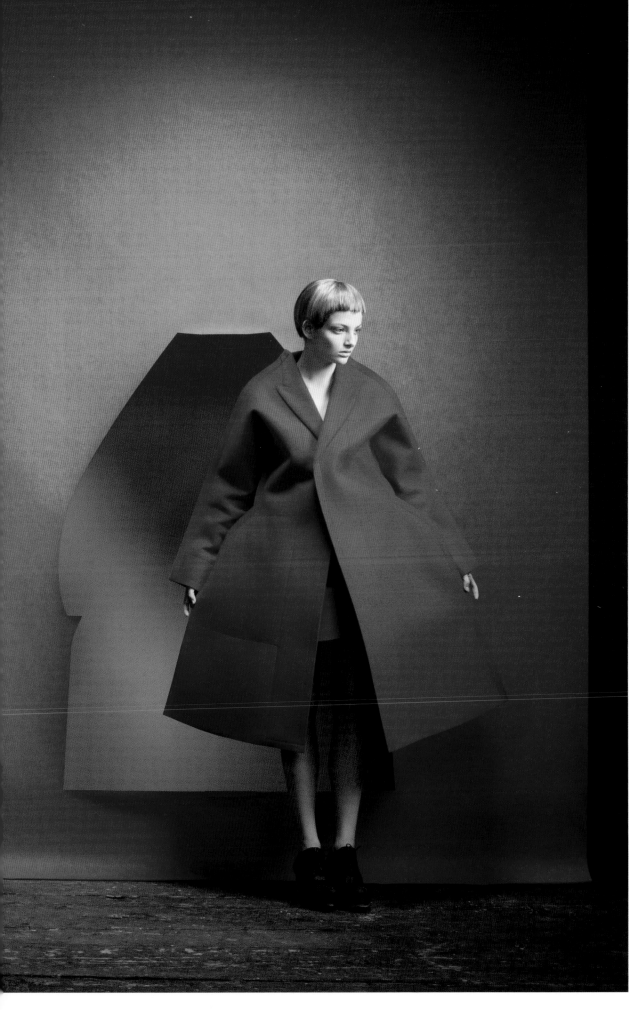

KINDRED SPIRITS: THE RADICAL POETRY OF JAPANESE AND BELGIAN DESIGNERS

— ANABELA BECHO

In the silkworm nursery,
Men and women
Are dressed
Like gods in ancient times.

— Sora[1]

FASHION THINKERS

From the moment the visionary spirit of Japanese designers was revealed to the world, in Paris in the early 1980s, it became perfectly clear that their work was much deeper than mere 'rags'. Kenzo Takada and Issey Miyake had arrived in the French capital in previous decades, but in 1981 Yohji Yamamoto and Rei Kawakubo caused a real revolution with their autumn/winter collections, which they presented together. In contrast to the glamorous image of the power-woman then in vogue, the Japanese designers presented all-black clothes, which the most conservative critics claimed looked as though they had come out of a nuclear disaster. Polly Mellen, then editor of American *Vogue*, stated, 'It is modern and free. It has given to my eyes something new and has made this first day incredible. Yamamoto and Kawakubo are showing the way to a whole new way of beauty'.[2]

A new beauty, challenging the prevailing aesthetic conventions still based on the Western Renaissance conception of symmetry, balance and perfection. In fact, this 'new' aesthetic – an anti-aesthetic, according to many commentators – had its roots in the secular legacy of Japanese culture. The concept of *wabi-sabi*[3] is symbolized in the tea ceremony and its ritual – an ode to the patina and imperfections of used objects, as the old bowls display their scars with pride. Furthermore, they resonate in the avant-garde minds of Japanese designers such as Miyake, Kawakubo and Yamamoto, and their disciples, Junya Watanabe and Dai Fujiwara. The themes of perishability, absence (always accompanied by the immense power of suggestion, as in Haiku poetry, for example, where omission of words creates a possibility of meanings), irregularity, both simplicity and complexity, deconstruction to reconstruct, and the importance of meaning have permeated

Japanese and Japanese culture for thousand of years. Aesthetically, this particular sensibility and taste for the subtle is still relevant in Japanese contemporary art and design. These new fashion thinkers bring with them these ancient concepts, confronting us with the poignant beauty of humanity through their garments. The shock they cause comes from our inability to look in the mirror and recognize that imperfection is inherent to the human condition.

IN THE SEARCH FOR A NEW (OLD) BEAUTY

I want to see scars, failures, disorder. [...]
I think perfection is ugly.[4]
— Yohji Yamamoto

This radical thinking translates into radical attires: garments reconstructed through the deconstruction of conventional patterns; monochromatic, focusing on ascetic and mysterious black; unusual volumes, sometimes over-sized proportions; asymmetry; overlapping; rips; seams and hems on the outside, taking part in the design process; unfinished garments; knots and bows as fastenings, keeping the pieces in place; faded boundaries between male and female. New lexicons of clothing were created and the essence of *wabi-sabi* present in the work of these Japanese aesthetes touched the soul of many young designers deeply. These young designers, who were looking for a new meaning to express their creativity through clothes, included the fashion students of the Royal Academy of Fine Arts in Antwerp, firmly trained in classical construction and cut. One of the Antwerp Six (together with Dries Van Noten, Walter Van Beirendonck, Dirk Bikkembergs, Dirk Van Saene and Marina Yee), Ann Demeulemeester recalls, 'I was just finishing my studies [when the Japanese designers had their European debut] and it was a brave new step in fashion – the beginning of a new freedom for me as a designer and as a woman.'[5]

Demeulemeester, in the tradition of Rei Kawakubo/Comme des Garçons' work, asserted herself with strong and steady female silhouettes, paying the greatest attention to cutting techniques, which she combined with the monochrome purity of black and white. Just like Kawakubo, Ann Demeulemeester's outfits question the stereotypes of beauty and Western gender – her women show attitude and self-esteem, attracting men with their mind rather than their body.

The work of the Japanese designers, especially Yamamoto and Kawakubo, was both a shock and a revelation to Belgian designers, who at the time were still on the periphery of the international fashion scene. Confident that there would be other, less conventional ways

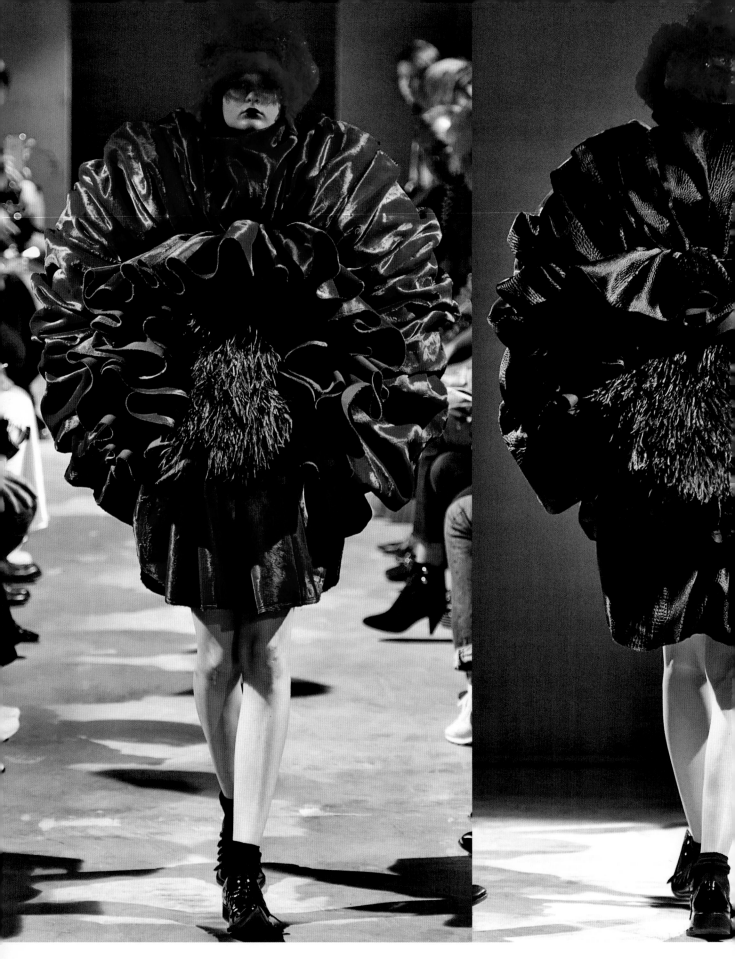

COMME DES GARÇONS, SPRING/SUMMER 2016.

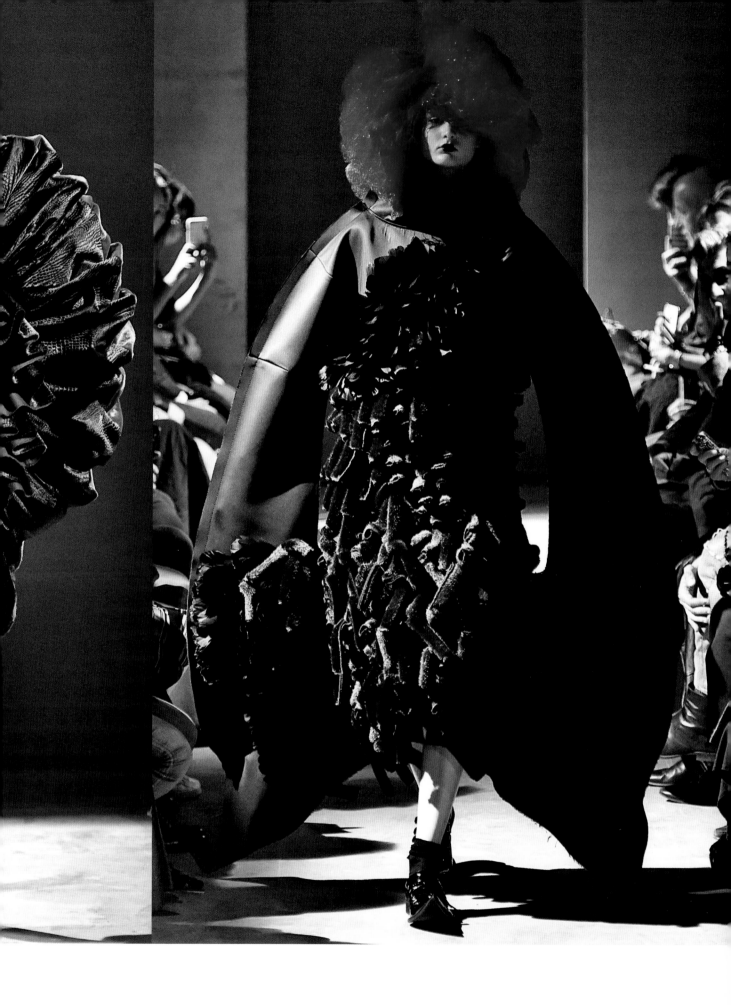

Maison Martin Margiela,
the tabi last.

Maison Martin Margiela,
different versions of
the tabi shoes.

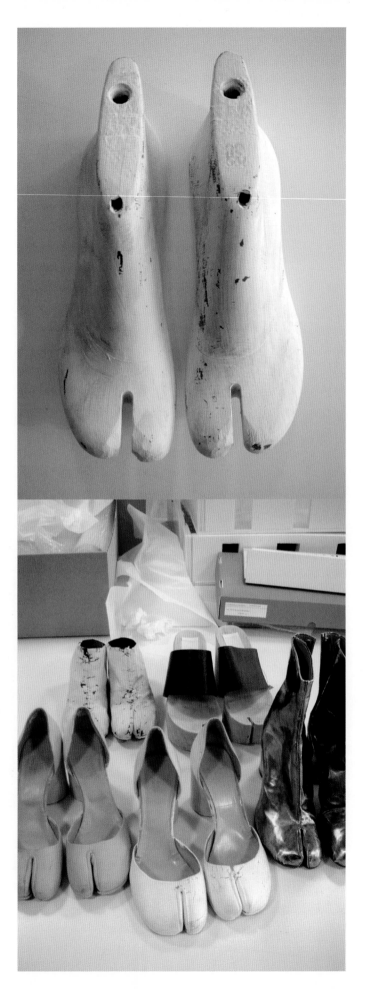

than those of the established system, the revolutionary group left Antwerp for London in search of a stage receptive to the expression of their sartorial philosophy. So began a new wave that would rock the foundations of Western fashion and paradigms established by haute couture and already shaken by the Japanese designers.

One of the Belgian school would take the poetics of deconstruction initiated by the Japanese designers even further – Martin Margiela. Far from being a clone of his forerunners, Margiela found his own voice through a radical aesthetic: he maximized deconstruction and dissection of the garments, making this process a form of reflection; he moved elements, such as sleeves or collars, from their usual location and gave them new and unusual contexts. It was not only the final result that was important but also the design process and the various stages of production. The chalk marking the fabric or the basting stitches are acknowledged in the final piece, giving prominence to the unfinished and random, as if the piece had been stopped somewhere during its production process. The memory of a garment has an active role in the design process when it is re-used and given a new life, for example if paint is applied to the fabric or if it is used in association with a new element. The *tabi* boots, for over twenty years one of the most iconic pieces to come out of Maison Martin Margiela, and produced in different variations, are inspired by Japanese *tabi* – ankle-length socks shaped with a separation between the big toe and the other toes, to be worn with traditional Japanese sandals. It is fascinating to note that the element of perishability, underlined in the early works of Yamamoto and Kawakubo through the deconstructed nature of the garments – asymmetries, tears, frayed edges, knots, and uneven hems – is very present in the work of the Belgian designers, especially Martin Margiela.

The conceptual and aesthetic proximity between these two revolutionary waves in fashion, despite originating in countries geographically so distant, was favourable to the successful export of the work of Belgian designers to Japan. Linda Loppa, for many years the head of the fashion department at the Antwerp Academy, says, 'The success of Belgian designers in Japan is, to my mind, due to the fact that the Japanese and Belgians are kindred spirits to some extent. Added to which, there's the receptiveness to creativity among young Japanese buyers.'[6] One good turn deserves another.

Glamour was replaced by uniqueness. Mass production gave place to individuality. Expressing themselves freely, these designers, from two different cultures and different generations, contributed to the emergence of a 'new' aesthetic and to consolidate the idea that fashion can be an art form in its own right. However, the 'new' when it comes to fashion is a fallacious concept, because, according to Ulrich

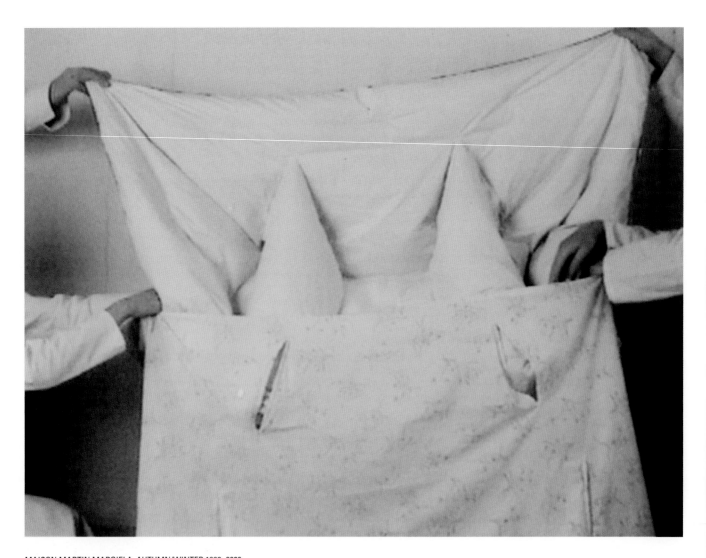

MAISON MARTIN MARGIELA, AUTUMN/WINTER 1999–2000.
Rectangular duvet coat, video still.
The rectangular duvet shape begets sculptural qualities
when worn around the body.

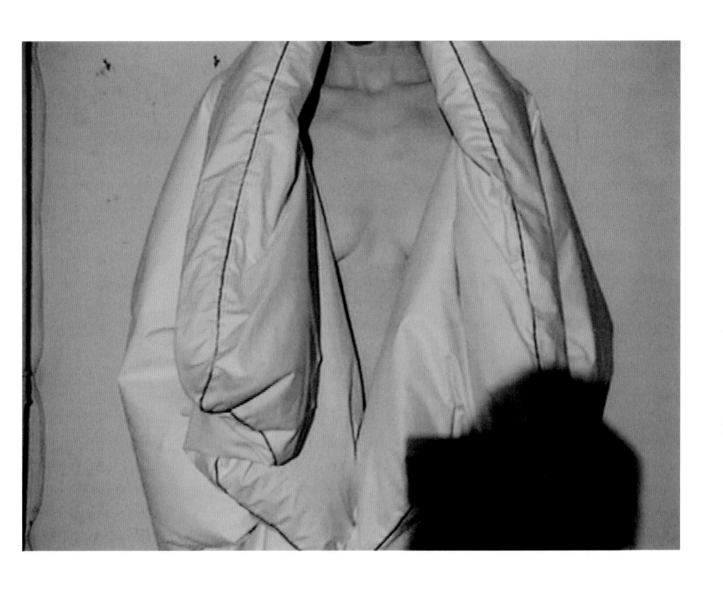

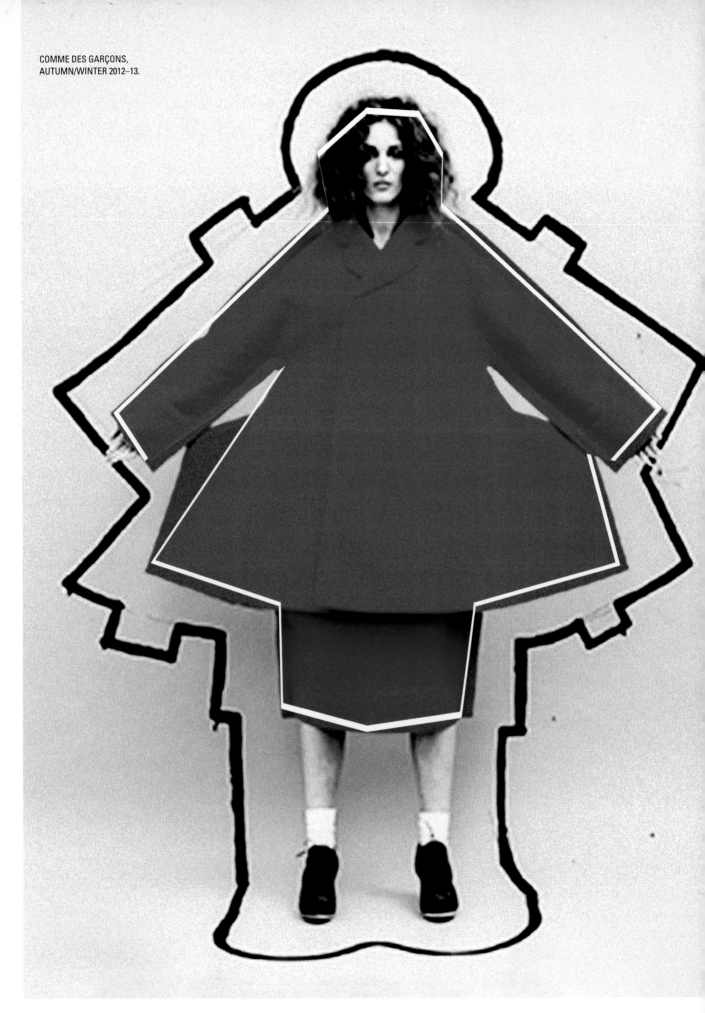

COMME DES GARÇONS,
AUTUMN/WINTER 2012–13.

Lehmann, in sartorial matters there is no progressive evolution or chronological narrative:

Fashion works erratically through its method of quotation. It wilfully cites any style from the past in a novel incarnation or present rendition. Clothing types may be retained, yet their appearance is renewed by using past elements [...].[7]

Through the *Tigersprung*[8] fashion is able to leap from the contemporary to the ancient and back again without coming to rest exclusively in one temporal or aesthetic configuration.[9]

The kimono is a perfect symbol of constant renewal based on a style from the past. Japan's distinctive garment for centuries, its construction is based on ancestral techniques – eight rectangular pieces of fabric – that have not been abandoned over time but rather adapted and updated over the years. Sometimes reluctant to accept the geographical context as a formative element of their aesthetic identity, Issey Miyake, Yohji Yamamoto and Rei Kawakubo assume the kimono as the basis of their fashion design. It is the foundation for the construction of the attire they design and a path of conceptualization of their ideas regarding form and its relation to space and the underlying body:

For good or ill, the Japanese conception of beauty is firmly rooted in the 'Kimono culture'. The body is covered just as it is with a plain piece of fabric. This is then draped to create surplus space, or *ma*, which is in no way considered irrational. Often the resulting garment – which is loose-fitting, without any real 'shape' in the Western sense of the term – is also asymmetrical, one of the specific criteria of Japanese beauty.[10]

In the first decade of the twentieth century, Western fashion was strongly seduced by the East and its aesthetics, and the next four decades represent a great leap forward in the development of the relationship between the garment and the real physicality of the body. It was through the Eastern spirit that Western avant-garde designers such as Paul Poiret,[11] Mariano Fortuny,[12] Grès,[13] Madeleine Vionnet,[14] and Cristóbal Balenciaga[15] laid the foundations of contemporary fashion. Inspired by these avant-garde mavericks and by their own tradition, Miyake, Kawakubo and Yamamoto leapt into the past and deconstructed tradition in the search for new shapes.

THE BODY WITHIN

Through the inventive use of cloth and its successive layers, Miyake developed a sartorial concept based on the very essence of clothing – to wrap the body in fabric. He created unstructured and organic clothing, with aesthetic quality and natural freedom that allows free movement, expressed through the simplicity of style, the use of new materials, and – paramount – the space between the garment and the body. His 'Pleats please' line is the perfect example: while echoing Fortuny and his emblematic Delphos dress, Issey Miyake took the pleating even further, combining traditional techniques with new tech-

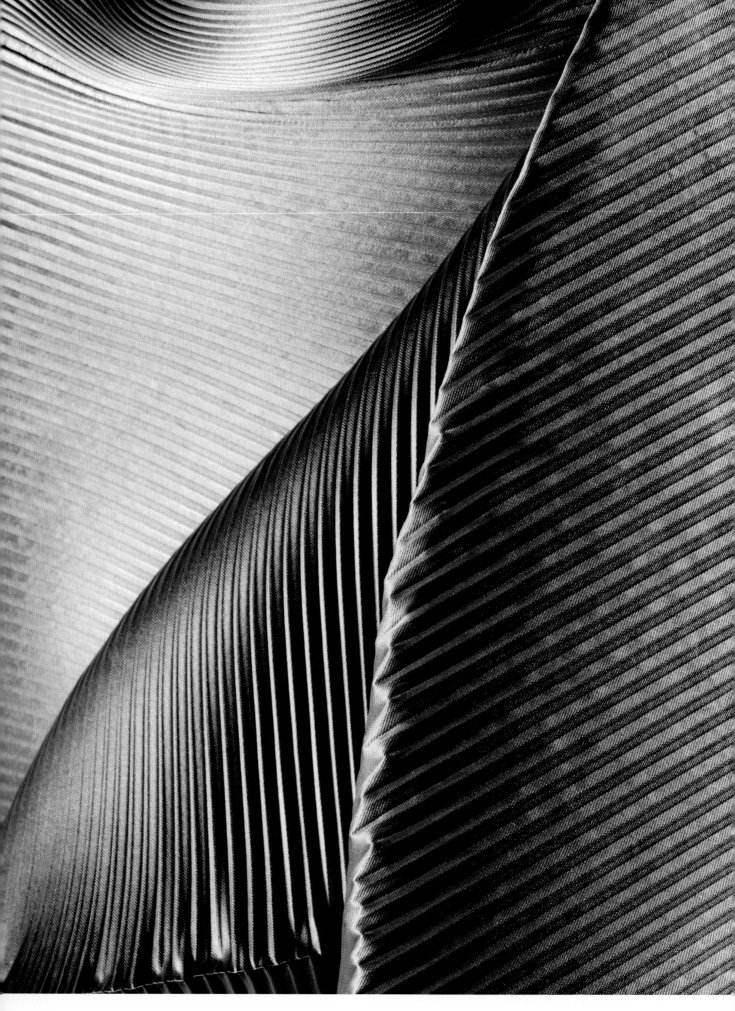

ISSEY MIYAKE,
AUTUMN/WINTER 1999.
Pleated tunic in polyester
and satin.
MUDE. M.0442 |
"Coleção Francisco Capelo"
MUDE - Museu do Design e
da Moda, Coleção Francisco
Capelo | Lisboa.

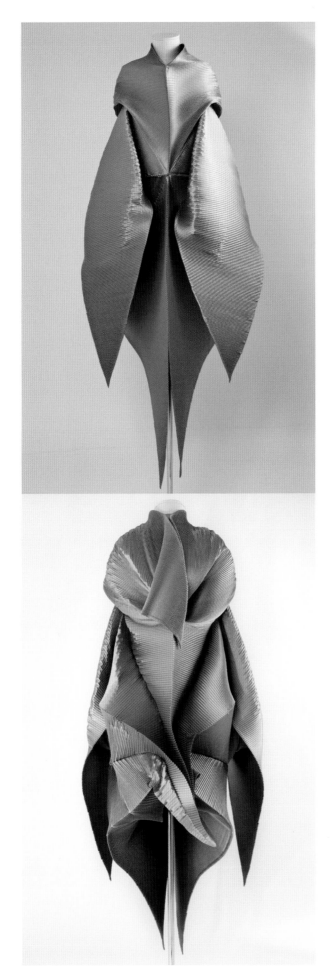

ISSEY MIYAKE, AUTUMN/WINTER 1999.
Pleated tunic in polyester and satin.
MUDE. M.0443 | "Coleção Francisco Capelo"
MUDE – Museu do Design e da Moda,
Coleção Francisco Capelo | Lisboa.

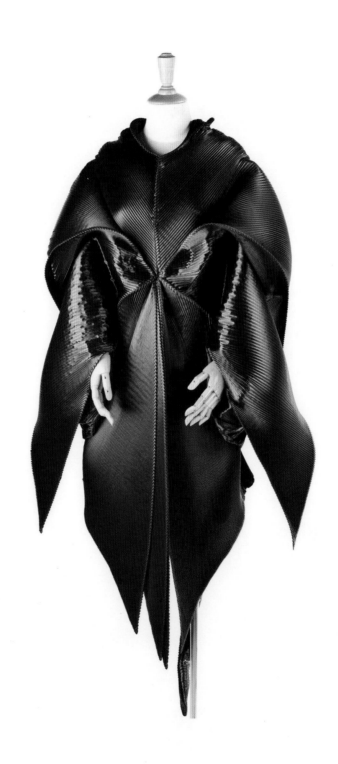

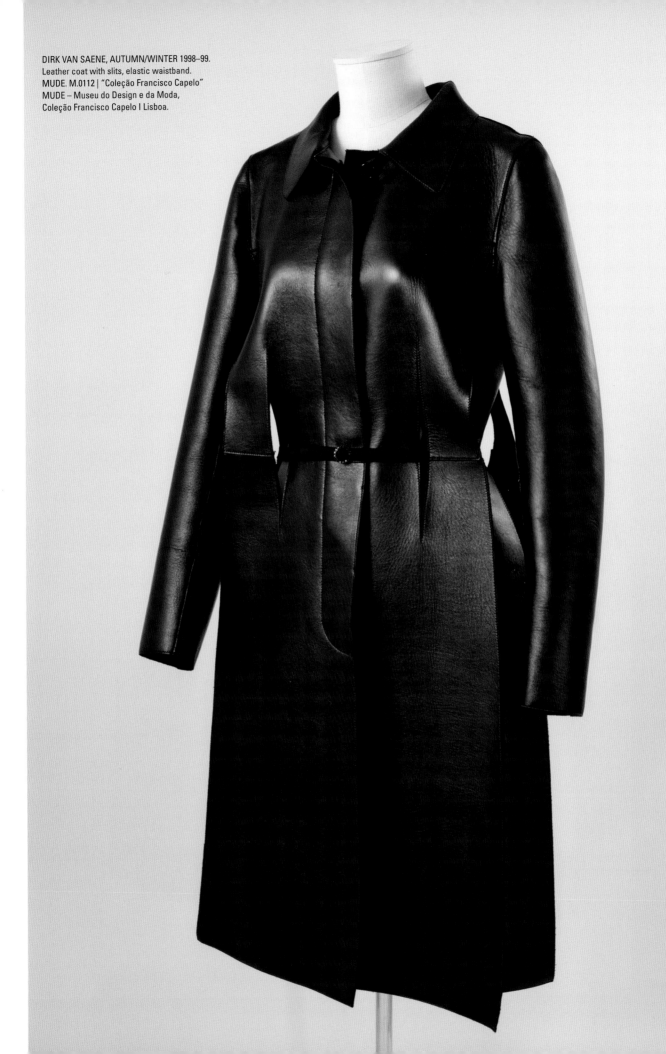

DIRK VAN SAENE, AUTUMN/WINTER 1998–99.
Leather coat with slits, elastic waistband.
MUDE. M.0112 | "Coleção Francisco Capelo"
MUDE – Museu do Design e da Moda,
Coleção Francisco Capelo I Lisboa.

YOHJI YAMAMOTO, AUTUMN/WINTER 1999–00
Long evening coat of dark green velvet and an inner side of
brown jersey with application of black pile stripes, long wide
sleeves, two velvet strips at breast height close the coat.
MUDE. M.0024 | "Coleção Francisco Capelo"
MUDE – Museu do Design e da Moda,
Coleção Francisco Capelo | Lisboa.

RIGHT:
YOHJI YAMAMOTO, AUTUMN/WINTER 1999.
Shirt and skirt in cotton poplin, woollen taffeta, and nylon.
MUDE. M.0152 | "Coleção Francisco Capelo"
MUDE – Museu do Design e da Moda,
Coleção Francisco Capelo | Lisboa.

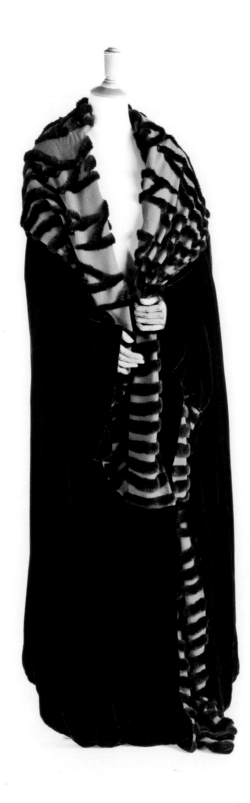

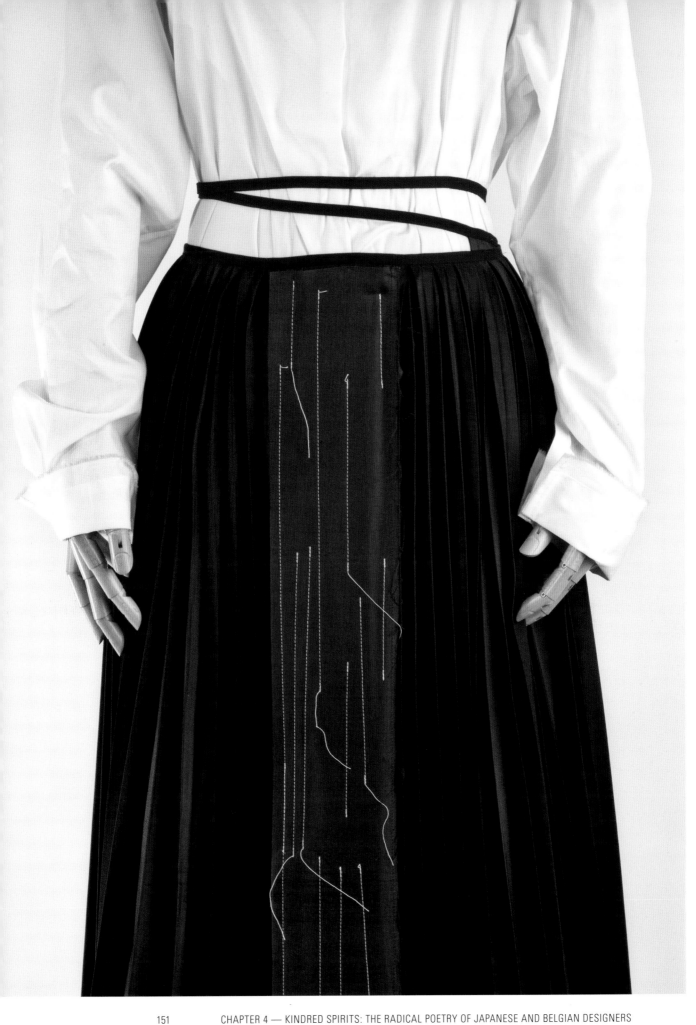

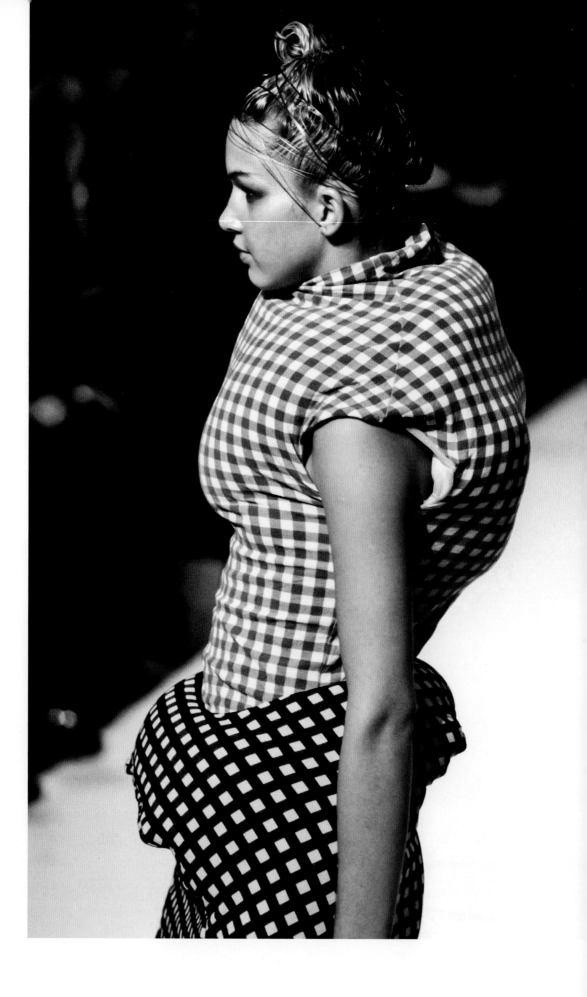

nological and synthetic fabrics. 'I learned about the space between the body and the fabric from the traditional kimono ... not the style, but the space',[16] he declared.

This notion of subtly enveloping the body without constraining it is linked to the Japanese genius for defining space and their deep respect for nature. According to the Japanese tradition, clothes are a way of wrapping the body. As in the spirit of kimono, the principle is not to cut or 'amputate' the fabric, instead respecting its integrity and using its shape to accommodate the body. A perfect example is Miyake's 'A-POC' line of clothing, in which clothes are cut all from one long high-tech knit fabric tube. The quest for freedom of shape is combined with an understanding of what can be used as raw material. Inspired by the art of origami, Dai Fujiwara created dresses made of paper for Issey Miyake; Dirk Van Saene has also used paper in his work. In ancient Japan, farmers would line their clothing with paper for protection against the cold. Boro ('ragged', meaning mended and patched) fabrics would pass from generation to generation, adding the memory of their many lives to the new forms they were given as they were re-used (this spirit is very much present in the work of Margiela). The work of the Japanese and also the Belgian designers swings between an artisanal nature and the use of new technologies – to the use of natural and traditional materials such as cotton, wool, and silk are added new textile processes, such the coating of polyester jersey with polyurethane. But, regardless of the material, the most important theme in their work is a respect for the essence of clothing: clothes are a shape to house the body.

The fundamental concept of space between the body and the fabric, *ma* in Japanese, gives the wearer natural freedom and makes the garment flexible. In his oversized pieces, Margiela increases that space, bringing it almost to the extreme of the abstract. He expands in a garment in proportion from an Italian size 42 to a size 78 or 80 – a size that does not exist on the market. All the elements of the garment – the zips, buttons, pockets – are expanded, all in proportion. The Japanese and Belgian designers actively question the concepts of clothing, but also the body and its limits, causing the wearer to question their own assumptions about what is clothing, or about the act of dressing and its physicality. Rei Kawakubo gives us a punch in the stomach with the 'new' bodies she proposes in 'Body Meets Dress, Dress Meets Body'. Using padding inserted in the most unlikely places, Kawakubo invented new silhouettes for the body, radicalizing the close relationship between it and the garment – the power of clothing in redefining a 'new' physicality. A 'new' body that – whether repulsive or attractive – makes us question the established assumptions, offering us a new understanding of the world – strong and fragile at the same time, full of humanity and poetry.

ISSEY MIYAKE, *C*. 1990.
Origami-shaped coat in satin.
MUDE. M.0139 |
"Coleção Francisco Capelo"
MUDE – Museu do Design e
da Moda, Coleção Francisco
Capelo | Lisboa.

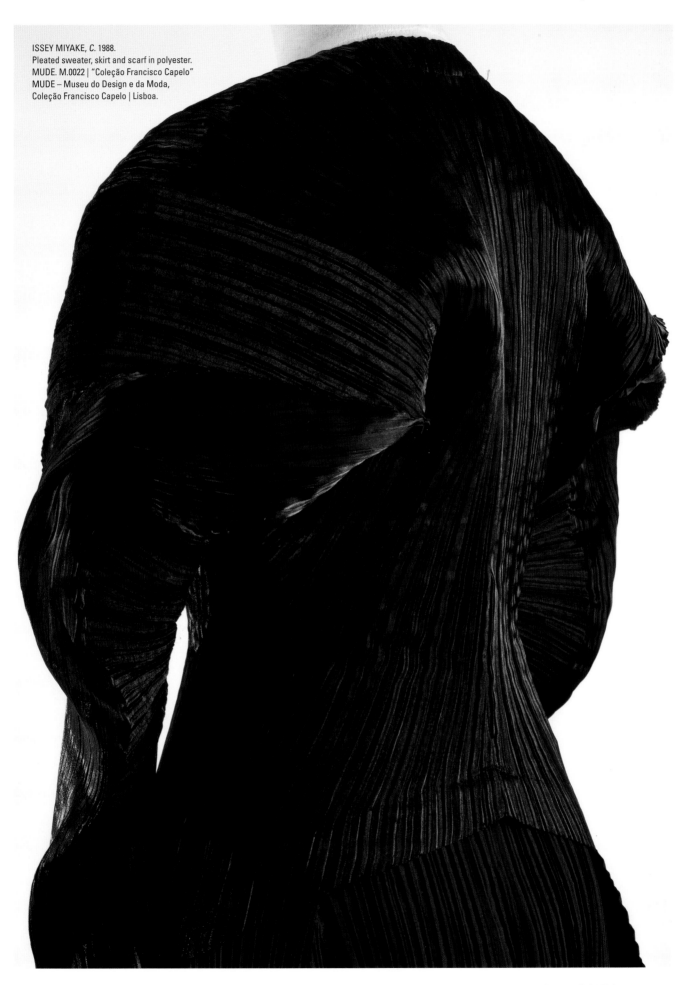

ISSEY MIYAKE, *C.* 1988.
Pleated sweater, skirt and scarf in polyester.
MUDE. M.0022 | "Coleção Francisco Capelo"
MUDE – Museu do Design e da Moda,
Coleção Francisco Capelo | Lisboa.

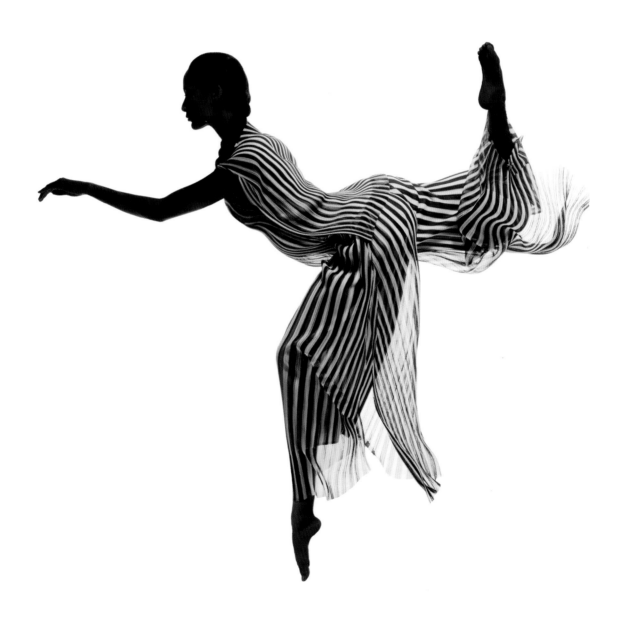

LILIANE LIJN ON WEARING ISSEY MIYAKE

— HETTIE JUDAH

I met Issey Miyake through two photographers. Jorge Lewinski and his wife Mayotte Magnus had photographed British artists over a period of years so they had a number of photographs of me. They also became very friendly with [the sculptor, Elizabeth] Frink, because they photographed her as well. She was a friend of Maureen Doherty who was Issey Miyake's manager in Britain and in Paris and it was through that chain that a photograph of me was shown to Issey Miyake. In 1987 he wanted to do a book called Permanente where he had professional women wearing his clothes, so he was looking for special faces, professional women who appealed to him I suppose. He liked the photograph that Lewinski had taken of me a lot, so Maureen got in touch with me and asked whether I'd be willing to wear his clothes in a photoshoot.

It was supposed to be an hour of my time, maybe maximum two hours. Lord Snowdon was doing the shoot with a number of professional women, none of whom were models. I've never modelled for anything before, but I don't know what happened — maybe they liked the way I wore his clothes? But I was there the whole day and they use me for postcards; for their Christmas card; I was in Japanese fashion magazines: all kinds of things that I didn't expect to happen. Issey was very generous — he gave me one of the gorgeous outfits I wore for the shoot.

At that time I tended to wear jeans, trousers or other kinds of easy, comfortable clothes and being an artist I wasn't really dressing up all that much. On occasion I would wear a dress — I certainly did when I was younger — but by 1980 I wanted to wear clothes I felt good in, not what was fashionable.

When I wore Miyake's clothes I felt very comfortable and at the same time very elegant and beautiful. The clothes I wore on that day weren't all that feminine, they were kind of severe — there was one outfit that was black and white, high necked and very Japanese but not necessarily feminine, and I liked that — they didn't subscribe to the conventional notions of what a woman should look like — but Issey also doesn't subscribe to what the conventional male should look like. Jeremy Fry came on the same day that I was modelling and he wore the exact same outfit I was wearing.

I still have them — they don't age, those clothes: when you wear them you look great in them. It doesn't matter if it's ten or twenty years later.

'Permanente' was a line of clothes that were designed for women of all ages and body types. That's why he used professional women of all ages — the famous ceramicist Lucie Rie was then in her eighties — he wanted so much for her to model his clothes, he made them especially for her. He wanted to go beyond age discrimination as well as body shapes and size.

That's a very important issue, what the body is made to look like — there has been a fashion to make women look like little girls, which I find really demeaning. Women want to grow up just as men want to grow up, they don't want to be little girls.

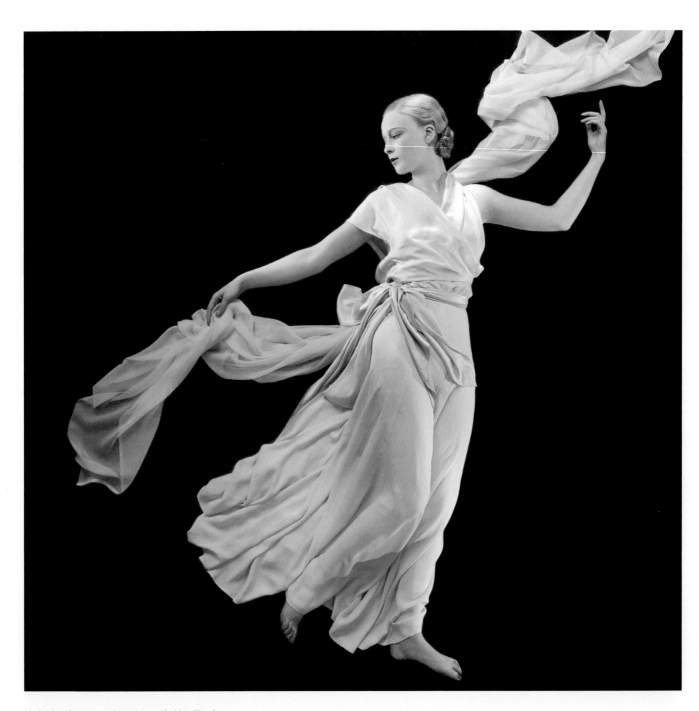

Madeleine Vionnet, evening pajamas of white silk crêpe
with matching scarves, worn by Sonia Colmer.

THE DISCOVERY OF ABSTRACTION IN TWENTIETH-CENTURY FASHION

— AKIKO FUKAI

PROLOGUE

In my work with Western fashion collections, I often come across Japanese concepts, such as kimono, used in fashionable Western clothing. Examination of Western clothing has led me to wonder about the 'exceptional' flatness of fashions in the 1920s. Why did 1920s fashion move away from the principles of traditional Western fashion that had endured since the Renaissance – in which clothes were three-dimensionally tailored to fit the body – and become a linear composition like kimono? Of course, kimono is not the only type of clothing with a linear composition. However, the development of new linear fashions that freed the body, and a fundamental switch from the customary outfit of a body-moulding bodice and skirt to a garment made from two pieces of cloth came at a time of keen Western interest in all things 'Japan'. This chapter will discuss the relationship between the birth of modern clothing and the Japanese concept of kimono.

JAPONISM AND FASHION

It is well known that the encounter between mid-nineteenth-century Western Europe and Japan began in France, where it flourished and developed into a wave of Japonism that covered the Western world until the beginning of the twentieth century. Japan had maintained a policy of isolationism for over two hundred years before it opened its ports in 1854, the year after the American 'Black Ships' arrived in Edo Bay. Westerners who visited Japan after it opened up brought home with them Japanese arts and crafts and everyday objects. Interest in Japanese products and style then became far more widespread with the advent of world fairs: international exhibitions that showcased manufactured products, gathering knowledge on a worldwide scale to satisfy Western curiosity. Beginning with the Great Exhibition in London in 1851, 'expos' were huge events held in different parts of the West every few years and attracting a large number of spectators. From the expos, interest in Japan, a country generally unknown to most of the European population, spread.

G. Desbrosses, 1912,
dinner gown with Japanese
motifs and kimono sleeves.

Callot Sœurs, *c.* 1908,
evening dress in silk
charmeuse with chinoiserie
floral embroidery,
The Kyoto Costume Institute,
Inv. nr. 7708-93-2-IAB.

Shops that sold Japanese products appeared in Paris and London in around 1860 and various Japanese items could be found in English and French paintings from the 1860s.[1] Japan officially joined the Paris Exposition of 1867, in which, as the French art critic Ernest Chesneau later said, 'Japan was completely enthralling'.[2] This 'Japan fever' continued in the West until the beginning of the twentieth century.

Meanwhile, contemporary Western artists were seeking new forms of expression. Progressive artists were moving away from academic painting, a style established during the Renaissance which emphasized realism. These impressionist artists, following Édouard Manet, were adopting innovative techniques, and in this context they encountered Japanese aesthetics. In addition to its unfamiliar and exotic rarity, Japanese art captured their hearts. Chesneau pointed out that it was unique in its 'unpredictable composition, subtle forms, vibrant colors, picturesque originality and the simplicity in the methods it used to obtain those effects'.[3] Japanese aesthetic sense, with its two-dimensional planes, stood in striking contrast to post-Renaissance art, which endeavoured to reproduce three-dimensional space and the reality of objects using perspective and shading.

Western artists discovered these exotic new concepts in the work of Hiroshige and Hokusai and other Japanese artists, and were inspired by them, with brilliant results, such as Monet's *The Water-Lilies*. According to art critic Shuji Takashina, Monet had 'an awareness of the problems in the "aesthetics" of screen composition, in addition to painting itself and not toward Japanese motifs, such as *uchiwa* or *kimono*'.[4]

The importance of the Western 'discovery' of Japan was not simply the novelty factor but a recognition of the distinctive features of Japanese art. Japonism was a powerful inspiration for the constitutive and modelling principles in Western art.

The influence of Japonism extended to every corner of Western life, including clothing fashions. Western fashion designs were inspired by images and real objects such as kimonos drawn in ukiyo-e ('pictures of the floating world'), by kimonos themselves, and by textiles. Even before Japan opened up, 'kimono' was known in the West. Kimonos first arrived in Holland through trade with the Dutch East India Company and were worn as luxurious housecoats by Western men during the seventeenth and eighteenth centuries.[5] Kimonos received renewed attention in the West in the 1860s when artists used models wearing kimono to represent the new image of 'Japan'.[6] Japanese influence first appeared in Paris fashion in the 1867 Paris Expo. The Japanese government (*Tokugawa shogunate*) set up a Japanese

CLAUDE MONET, *WATERLILIES: MORNING WITH WEEPING WILLOWS* (DETAIL), 1914–18.
Musée de l'Orangerie, Paris.

CHAPTER 5 — THE DISCOVERY OF ABSTRACTION IN TWENTIETH-CENTURY FASHION

EISEN KEISAI,
Unryu Uchikake no Oiran.

A LA COMÉDIE

Manteau de Théâtre, par Paquin

Gazette du Bon Ton Nº 1. — Pl. VII

tea house at the venue where three Japanese women, clad in kimono, served tea. The Japanese style of clothing first appeared in Paris fashion magazines that year, in an illustration in the October issue of *Journal des Demoiselles*.[7]

Later, clothes made with late Edo period kimono fabric (kimono referred to as *kosode* in the Edo period) appeared during the 1870s and 1880s in Paris and London.[8] Kimonos were made of large rectangles of fabric, which could be used to make clothing if the kimono was taken apart.

Furthermore, Japanese designs appeared on Lyon textiles from the 1880s. Famous Paris-based designers such as Charles Frederick Worth and Jacques Doucet decorated women's clothing with Japanese patterns including chrysanthemums, irises, flowing water lines, sparrows, and sea spray. Later, kimono, family crests and other Japanese asymmetrical patterns became an established style for textile designs in the West.

Moreover, kimono, with its characteristic 'looseness' in comparison to contemporary Western clothing, became a luxurious housedress for affluent women.[9] Initially such a loose garment was only acceptable for wear inside the home, but the concept of more comfortable clothing was beginning to take hold, and articles introducing the kimono appeared with increasing regularity in women's magazines around the end of the nineteenth century. According to *Le Grand Robert*, kimono was first seen in France in 1876 but the word didn't become common until the end of the nineteenth century.

'Kimono Sada Yacco', an affordable housedress, was sold at 'Au Mikado', riding on the popularity of the Japanese actress, Sadayakko Kawakami, at the 1900 Paris Expo. Soon after, it gained broader popularity in Italy and the surrounding countries as it was frequently advertised in *Fémina* from around 1903, as well as being sold at shops and through mail-order catalogues.[10] A few years later, Babani, a fashion house in Paris, extensively advertised kimono in *Figaro-Modes*,[11] a woman's magazine that targeted affluent women, marketing it as 'robe-japonaise', an elegant housedress and clearly asserting its unique 'looseness'.[12]

POIRET: LOOSENESS

Thus the kimono was part of Paris fashion at the beginning of the twentieth century; its influence can be seen in the fashionable silhouettes of the time and played a part in the creation of new fashions. Paul Poiret (1879–1944) created a relaxed 'kimono coat' which was

MADELEINE VIONNET.
Dress pattern.

Below:
Kimono pattern.

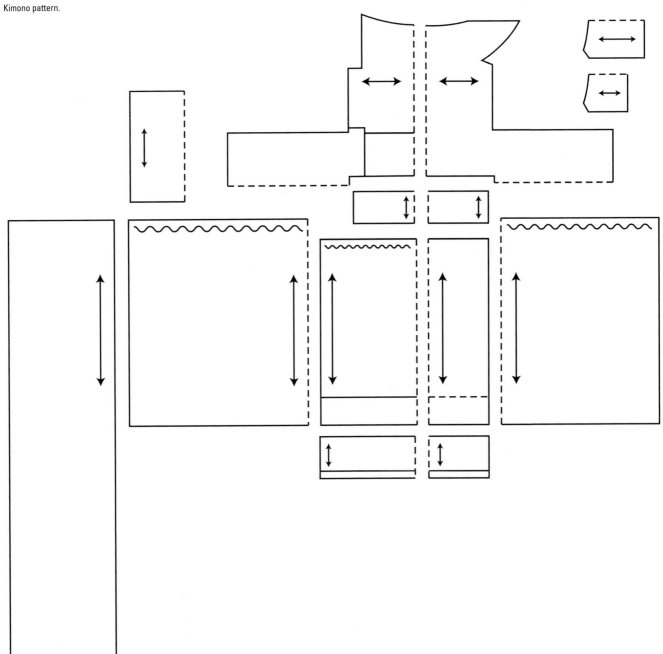

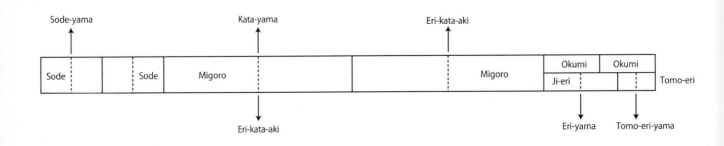

Sode-yama

Kata-yama

Eri-kata-aki

Sode	Sode	Migoro		Migoro	Okumi	Okumi	
					Ji-eri		Tomo-eri

Eri-kata-aki

Eri-yama

Tomo-eri-yama

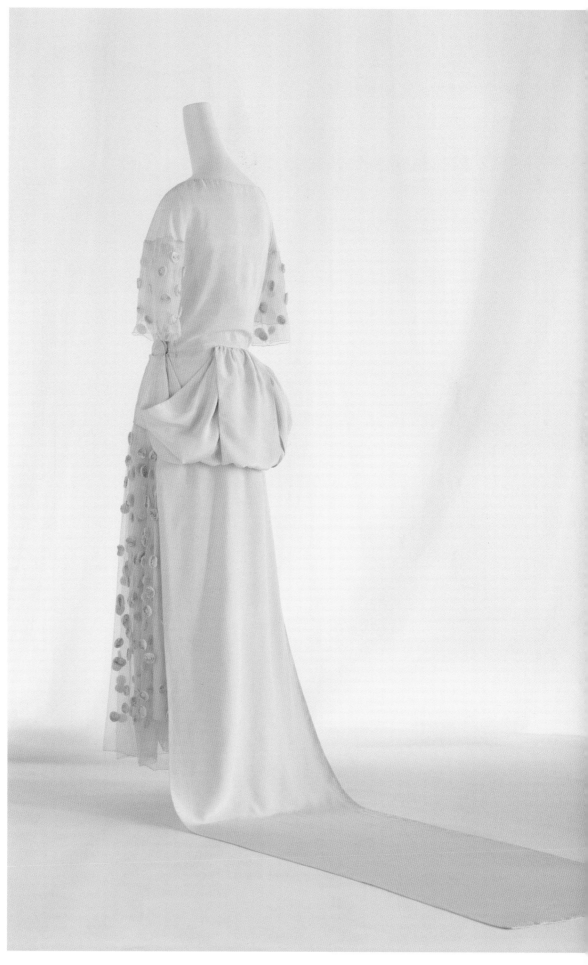

MADELEINE VIONNET,
C. 1930.
Silk muslin cocktail dress.
MUDE. M.0679 |
"Coleção Francisco Capelo"
MUDE – Museu do Design e
da Moda, Coleção Francisco
Capelo | Lisboa.

rejected by a client when he worked at the House of Worth in 1903. Poiret had begun his career at Jacques Doucet in 1896, before moving to Worth in 1900. His 1903 'kimono coat' no longer exists but his 'Confucius coat' (autumn/winter 1904), held at the Musée de la Ville de Paris, is considered to be similar. According to Poiret's autobiography, it was a 'large, square broadcloth kimono, hemmed of black satin'[13] but aspects of the Japanese *jinbaori* (battle surcoat) can also be seen in this coat. East Asia, for him, was an extremely ambiguous concept, as it was for many contemporary Westerners and the differences between Japanese garments, and even between Japan and China, were obscure. As pointed out by Yvonne Deslandres, in order to design flat composition clothes Poiret had to work out how to create the looseness of fit and liberate the body – the linear-cut, loose kimono was the source of ideas in his endeavour.[14]

Ultimately, in 1906, Poiret proposed a dress to be worn without a corset. Since the end of the nineteenth century, there had been a movement towards the rejection of the corset but Poiret's designs provoked Paris fashion to take a big step towards clothing that freed the body.

Until this time, women's fashionable clothing had exaggerated the slenderness of the wearer's waist – creating an extreme and unnatural silhouette – and often fell into the trap of overly embellishing the surface of garments. In contrast, kimono consisted of a natural drape of lithe cloth flowing down from the shoulders, enveloping the body and creating a gentle outfit. When wearing kimono, the supporting point was not the waist but the shoulders. This was essentially different from Western clothing that was cut to fit faithfully around the curvature of the body. Kimono was an abstract form of clothing that gave the body independence, while propping it up.

Mariano Fortuny (active from 1906–46) also closely studied kimono. Influenced by his father, a Spanish painter who was immersed in Japonism in Paris, he became familiar with kimono from his childhood. The influence of kimono can be seen in many aspects of Fortuny's clothing, including the composition of placing a supporting point on the shoulders, and the citing of patterns.

Kimono was not the only influence on Western fashions. At this time designers were also gaining inspiration from linear-cut clothing from ancient Greece, from clothing worn in Muslim countries and even from rustic ethnic-wear. The methods of cutting observed in these types of clothing influenced fashion designers: Poiret and Vionnet both focused on clothing from ancient Greece and Poiret also paid attention to rustic folkloric wear with linear composition. Even so, it cannot be denied that twentieth-century Paris fashion used kimono

MADELEINE VIONNET, C. 1925.
Silk crêpe dress with boat neck,
all-over wavy pattern in pin-tucks.
The Kyoto Costume Institute,
Inv. AC8947 93-23-5

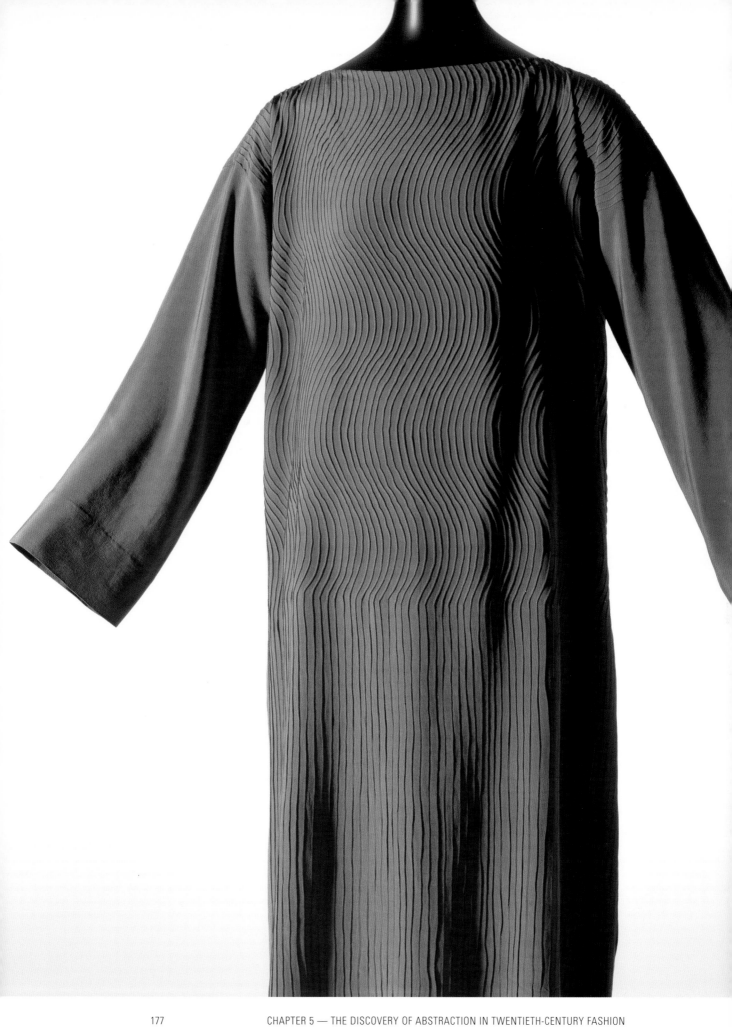

CHAPTER 5 — THE DISCOVERY OF ABSTRACTION IN TWENTIETH-CENTURY FASHION

MADELEINE VIONNET, WINTER 1920, MODÈLE 675.
Dress in silk crêpe marocain with vertical panels,
Les Arts Décoratifs, collection UFAC,
gift of Madame Lamberjack, 1976, inv. UF 76-38-3.

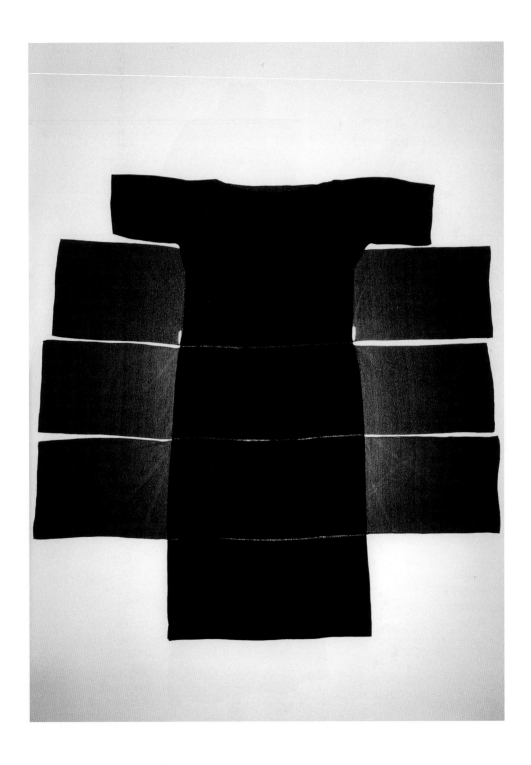

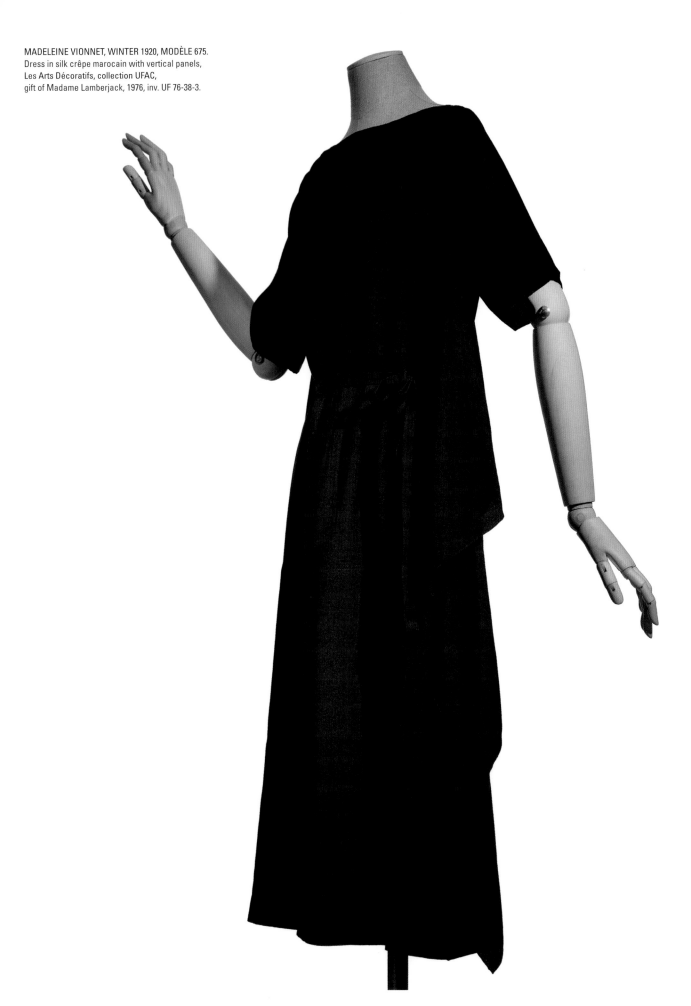

MADELEINE VIONNET, WINTER 1920, MODÈLE 675.
Dress in silk crêpe marocain with vertical panels,
Les Arts Décoratifs, collection UFAC,
gift of Madame Lamberjack, 1976, inv. UF 76-38-3.

Katsura Rikyu (Villa Katsura), Kyoto.

Villa Savoye, Le Corbusier, 1931.

as a source of inspiration because by this time Japonism was broadly absorbed into people's daily lives. At the end of the nineteenth century, *ukiyo-e* exhibitions were often held in Paris and Japan fever had spread to the masses, following the sensation that Sadayakko had caused at the 1900 Paris Expo. Moreover, when Japan was victorious in the Russo-Japanese war in 1905, it caught the attention of the French. The fever rose to such a level that newspapers and magazines labelled it the 'yellow peril', and in 1909 Paris, where previously Japan-themed dramas had been frequently performed, became wildly enthusiastic over Ballets Russes.[15] Against this backdrop, a writer in the French women's magazine *La Mode* noted that kimono 'needed to be scrutinized since it's an extremely creative item'.[16]

Between 1907 and 1913, the famous Parisian fashion houses, including Callot Soeurs, Paquin, Beer, Lucile, and Poiret, presented items inspired by kimono, and by the features of kimono as illustrated in *ukiyo-e*, such as the kimono-like overlapping closure; the kimono sleeve ('manche kimono');[17] the risqué, *nukiemon*-style neckline; the 'forme japonaise' silhouette; and the cocoon shape ('manteaux Japonais'). Fashionable women seen in women's magazines and in photos of the Hippodrome de Longchamp look just like *ukiyo-e* beauties. However attention at this time was still fixed on the silhouette and details of the kimono and not necessarily on the cutting method.

VIONNET: MODERN CLOTHING

Following the First World War, the role of women in society changed dramatically. They gained suffrage and became more prominent in society; the new women were active, cut their hair short and played sport. Skirts became knee-length, women showed their legs and modern underwear became popular. Victor Margueritte described a sexy, uninhibited image of the modern woman in his shocking 1922 novel *La Garçonne* (*The Tomboy* or *Bachelor Girl*): she had short hair, masculine clothing and lived as she liked in an ambiguous realm between accepted male and female roles.

The demands of the new society meant that a fundamental review of women's functional clothing naturally occurred. Coco Chanel set up a new style that introduced men's clothing for women and Madeleine Vionnet set the direction of fashion in the 1920s with her innovations in garment construction. Women's clothing took on concise, rectangular silhouettes, and superfluous, flounced frills disappeared. They were linear-cut compositions fundamentally different from the previous styles that had used curves and darts to shape garments to the body.

Madeleine Vionnet's studio,
decorated with *ukiyo-e* prints,
1924.

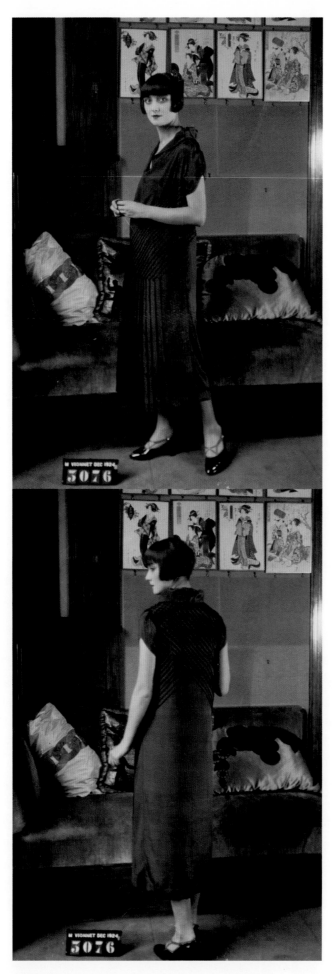

Poiret had previously worked to create a garment that was independent from the body, however Madeleine Vionnet (1876–1975) was the one to bring that concept into fruition in modern clothing. Vionnet worked independently from 1912 but, before that, she had accumulated experience at Jacques Doucet and Callot Soeurs. One of the Callot sisters was Madame Gerber, a friend of Edmond de Goncourt, who was an advocate of Japonism at the end of the nineteenth century. In that environment, Vionnet discovered Japanese works and later collected *ukiyo-e* and kimono. Part of her *ukiyo-e* collection was displayed on her atelier walls.

Vionnet never used curves and darts in her early work; her clothes were a composition of rectangular parts. Vionnet researcher Betty Kirke points out that Vionnet further developed 'garments with rectangular-based forms such as kimono' and transferred the kimono principle from the law of composition into Western clothing.[18] The strong influence of kimono, such as the linear kimono composition, and the effect of the *obi* sash is clear in a 1922 Vionnet dress now held at The Kyoto Costume Institute. Kirke further infers the link between 1920s clothing and the kimono from various features such as the diagonal cut with the triangular gore, the halter-neck backless dress and the draped collar opening that is wound around.[19] The 1924 'Japonica' illustration by Ernest Thayaht, a renowned futurist artist who worked for Vionnet, as the title indicates, reflects a direct interest in Japan.

A 1924 Vionnet dress now held at The Kyoto Costume Institute is likely to represent the culmination of Vionnet's linear composition experiments. This extremely simple cylindrical dress is formed from a rectangular bodice and sleeves in a moss green crêpe de Chine. The curves of the body are absorbed by running fine pin-tucking in gentle parallel waves down the entire upper body, a refined design reminiscent of Japanese Zen gardens. The function in this dress is changed brilliantly into decoration and the fashion design of the twentieth century is displayed at its zenith.

Vionnet was keen on contemporary art movements such as Futurism and Cubism but the thinking that is echoed most strongly in this dress is that of Le Corbusier and Ludwig Mies Van der Rohe. Le Corbusier emphasized clear lines and shapes, concise screen composition and refined the moulding of language. Van der Rohe, known for the saying 'Less is more' was also inspired by the Katsura Imperial Villa. Both these designers were also greatly inspired by Japanese aesthetics. Moreover, the feminine curves are not faithfully sculpted in this dress: the female body is perfectly abstract, as it is in a kimono. It can be said that the clothing of the 1920s was reflective of the kimono, which was characterized by unisex forms.

MADELEINE VIONNET, 1921,
SUMMER COLLECTION (HAUTE COUTURE).
Silk crêpe romain, length 126cm. Gift of Madeleine Vionnet to
the Collection mode et textile (UFAC), July 1952, Inv. UF 52-18-25.

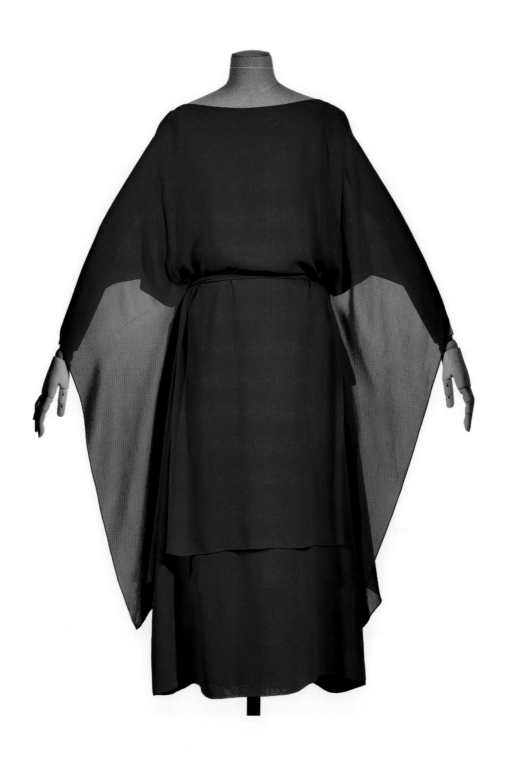

The expression of 'femininity' in fashion stepped into a new horizon. Let's consider it further from the perspective of the flow of cloth. Vionnet is known for the 'bias cut', her epoch-making cutting method, but Kirke points out that one of the foundations of the bias cut was the linear cutting of kimono.[20] The bias cut was made from a 45 degree use of cloth in a rectangular form. When cloth is used on the diagonal it follows the shape of the body and the beautiful drape created by the cloth emphasizes the lines of the body. In addition, when the wearer moves, the cloth moves away from the body creating an unpredictable dynamic beauty – a sensuality which becomes clearer in 1930s clothing.

As Harold Koda said, 'The West didn't try to imitate the cumbersome *obi* sash-like scroll but learned the principle of the planar form of winding around the body instead',[21] a point that forms the pillar of composition in Vionnet's designs is a play on the body, latitude, or space (the concept of 'ma' in Japanese), and which is likewise found in kimono. In Vionnet's cutting method, twentieth-century clothing became free from the body while respecting its existence, obtained abstractness and expanded the possibilities for fashion design.

Moreover, in addition to bringing a new sensuality to clothing, these clothes awakened the sensitivity of the wearer's skin. According to the early-nineteenth-century philosopher G. W. F. Hegel, Western clothing covered the imperfect part of the body, the 'skin'.[22] Until the end of the nineteenth century, clothing was recognized as an item that covered the imperfect skin. 'Clothes as covering' created the surface as a visual cover with sequences of gorgeous embroidery and lace, continuing to stimulate tactile sensation even while visually appealing to different modelling forms.

The view of skin became more complicated in the twentieth century. In order to reconsider the ambiguous placement of the skin as the boundary between outer and inner, various images that were not seen until the nineteenth century were revived of the skin as the body's outer layer and the inner surface of the outer skin. In particular the sense of touch was seen in a new light, and fashion's interest in it was enhanced, in a way that has continued to the modern day. Consequently a novel approach can be said to have been brought to creativity regarding skin. There has also been a re-examination of the meaning of clothing itself and we have entered a realm of clothing possibilities and fashion previously unseen: the desire to bring the human skin inherent to our bodies closer to clothes as a variable skin has coincided with the development of synthetic materials.

Skin liberated from the corset was no longer under pressure from layers of clothing. Wearers of the new linear-cut clothes were aware of the gentle sensation of cloth stroking the skin as the body

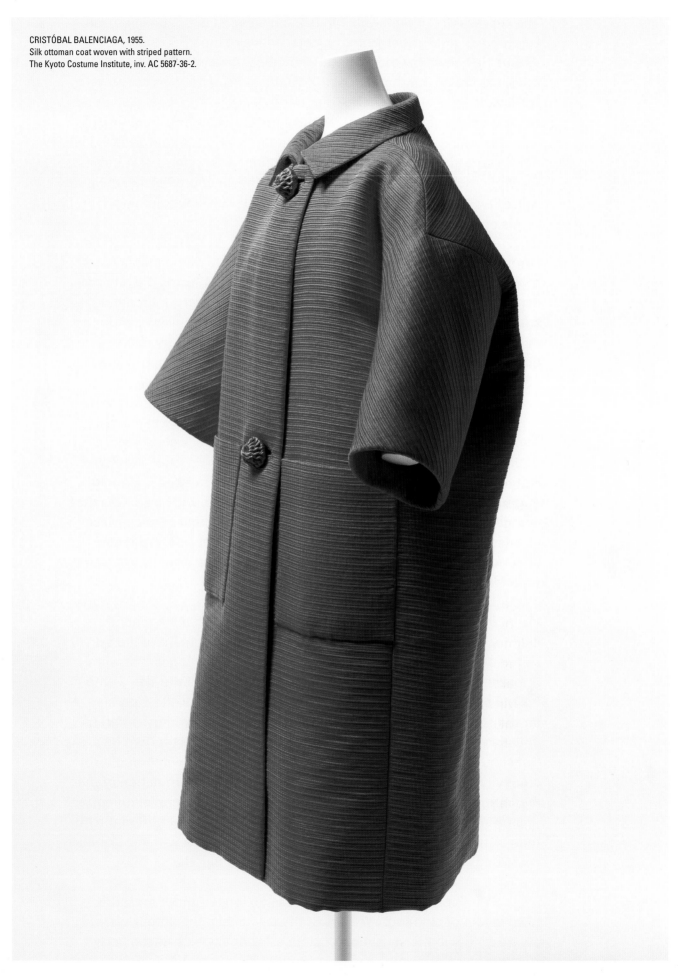

CRISTÓBAL BALENCIAGA, 1955.
Silk ottoman coat woven with striped pattern.
The Kyoto Costume Institute, inv. AC 5687-36-2.

moved. Interest in the tactile sensation in fashion finally began to take on importance when the soft silky texture of cylindrical clothing flowed down from the shoulders and gently and sensually stroked the body. The affectionate caress between cloth and skin and the attributes displayed in Vionnet and Fortuny's clothing were the same as those in kimono.

The modern clothing developed in the 1920s marked a clear divergence from previous fashion trends. Awareness of a different conceptual form of clothing – kimono – cannot be ignored as a factor in this divergence.

CONCLUSION

At the beginning of the twentieth century, as Parisian fashion was experiencing an internal transformation, kimono, and therefore Japonism, acted as the impetus for a new fashion. Ultimately, the design and clothing that was generated in this unique context led to a transformation in the concept of Western clothing. The constitutive principle of linear-cut kimono was absorbed into Western clothing in the 1920s and, even while this clothing model propped up the body from a graphic form, it split the garment away from dependence on the body and moved it toward an abstract and independent form. This led to the establishment of modern clothing. Modern clothing reinterpreted femininity and rediscovered the tactile sensation of garments, but connections to the characteristics of kimono could still be recognized.

The clothing form that obtained abstractness was further enhanced artistically by Cristóbal Balenciaga in the 1950s and afterwards reached new heights – Miren Arzalluz points out the close ties between Balenciaga and Vionnet.[23] Yves Saint Laurent broadly universalized abstract forms in the concise A-line, along with André Courrèges. Towards the end of the twentieth century, the world focused on the imagination of Japanese designers such as Issey Miyake and Rei Kawakubo. Undoubtedly, the independence and abstractness of clothing are the underlying concepts of their creations.

Finally, how does the awakened sense of tactile change the relationship between fashion and the body? I would like to examine this in the future.

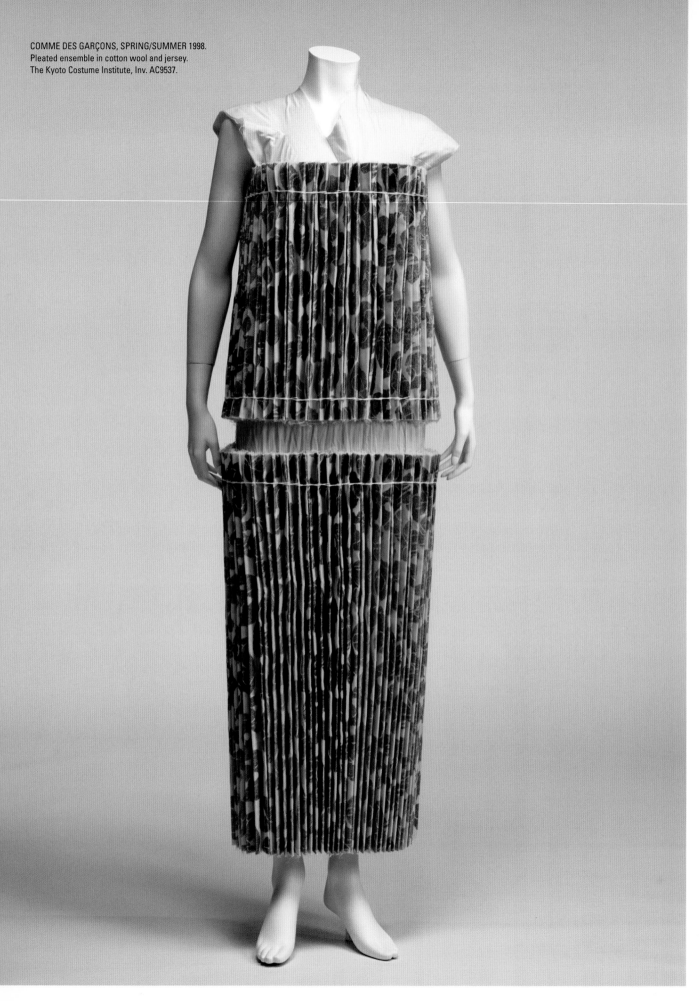

COMME DES GARÇONS, SPRING/SUMMER 1998.
Pleated ensemble in cotton wool and jersey.
The Kyoto Costume Institute, Inv. AC9537.

COMME DES GARÇONS, SPRING/SUMMER 1998.
Pleated ensemble in cotton wool and jersey.
The Kyoto Costume Institute, Inv. AC9537.

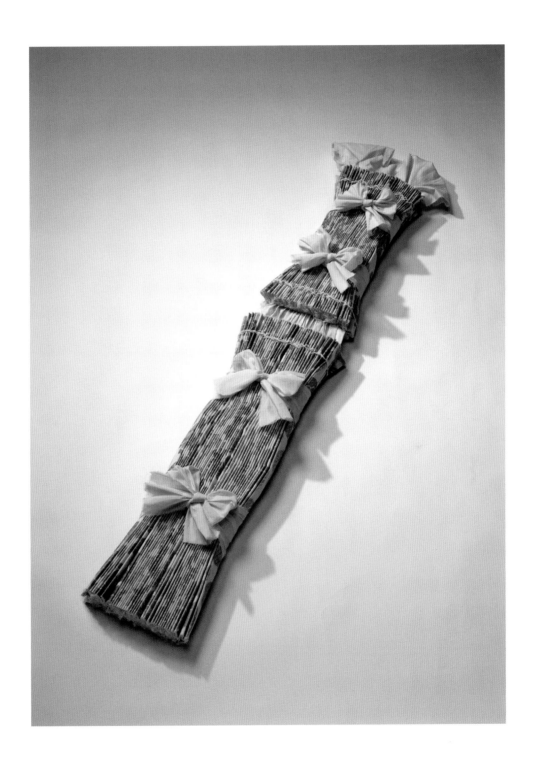

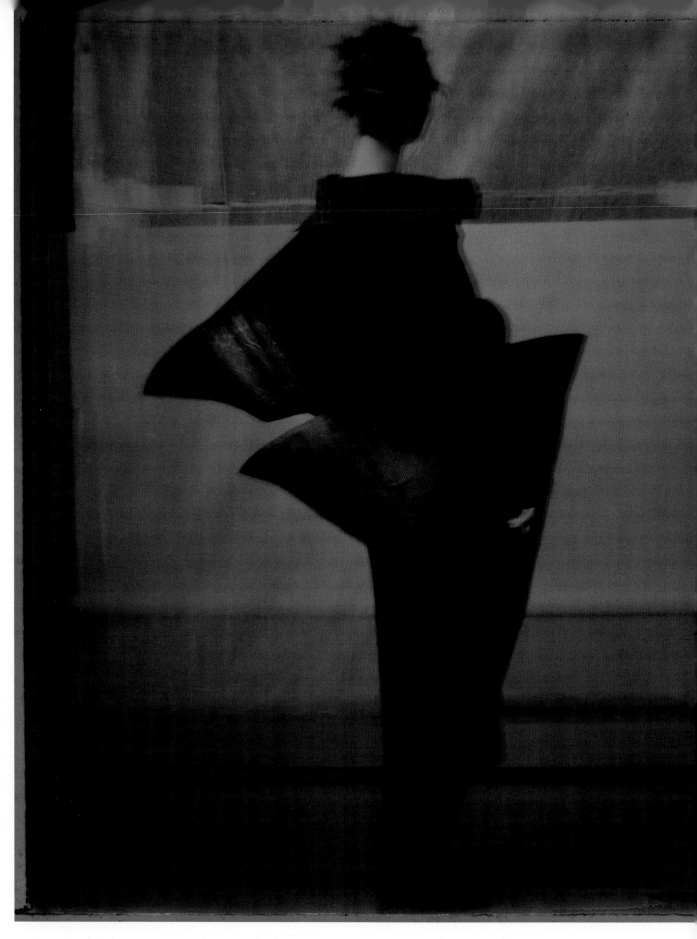

ISSEY MIYAKE, 1992.

SHADOWS OF THE BODY

— OLIVIER SAILLARD

When trends go out of fashion and clothes are resigned to hangers, locked up in silent wardrobes behind mirrored doors, when garments coloured by entire lives end up in a museum, trousers, jackets, bespoke suits, day and evening dresses arrive, alone and without hope – only a memory remains of the body they once had the honour of serving. The sediments of repeated gestures are deposited up a sleeve, at the bottom of a crumpled pocket, between the pleats of a skirt. The negatives of moving images appear in shiny linings. Beyond this singular civil state which ensures clothes populate fashion museums, a history of the figure and of body shape is also preserved. It suddenly reappears in the fabric of a half-slip or in the shoulders of a coat, asserts itself in the circumference of a waist, proclaims its origins in the length of a hem. This corporal existence from which costumes in a museum are apparently worn out is personified by the wooden mannequins that serve as fiction to the fickle natural body, the workshop busts on which designers pound out their collections, the great osier army in shop windows restoring the curves and variations of the passing decades. Mannequins in the nineteenth century adopt an S shape, evocatively recalling the corset. In the 1950s, waists are strangled and seem constricted inside the once-again fashionable corset. The resin models of the 1980s boast a sporty silhouette whose broad shoulders and high hips define the decade. Today, after years of androgynous and anonymous shapes, busts are, once again, busty. At some boutiques specializing in lingerie, for example, the showcased designs replicate the surgically enhanced and enlarged breasts that became commonplace in the late twentieth and early twenty-first centuries. Behind these changes lie couturiers and fashion designers. With the exception of a few decades that kick-started women's emancipation movements and drove changes to the body and to society (1914, 1940, 1970), it is couturiers and fashion designers that have run with or pre-empted the way in which bodies are put together.

In getting rid of the corset, Paul Poiret enables the silhouette of the 1910s to be natural and liberated. Madeleine Vionnet parades her 'living' mannequins into a scandal off the back of so much suggestion. Her tailored dresses, with soft crêpe or muslin hem, highlight woman's harmonious and unencumbered curves. With the tomboy era, the

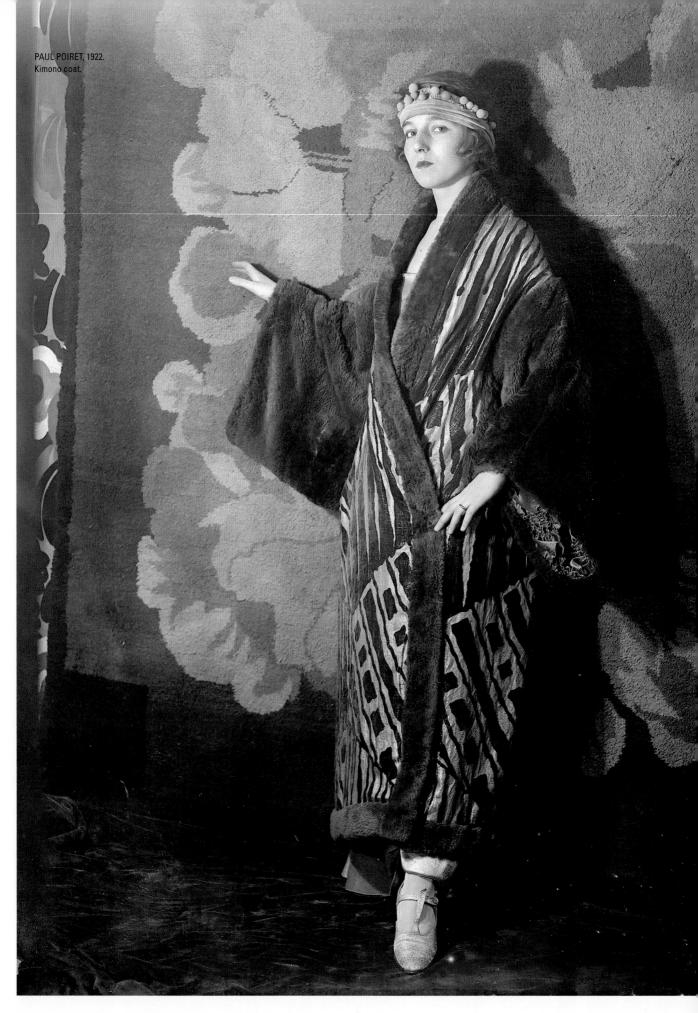

PAUL POIRET, 1922.
Kimono coat.

chest disappears. Mademoiselle Chanel is responsible for stripping back so-called modern bodies. Her black dress, as all her tailoring would become in the 1950s, is a prophetic reduction that acts as a guideline throughout the twentieth century.

Christian Dior invents the New Look by re-establishing the sinuous forms of the Belle Époque, revolutionizing fashion and his industry. Under his influence, women go back to corrective corsets. Their hips develop under yards of fabric and half-slips; their immaculate faces rest on petite shoulders. Dior corrupts the body. He moulds it around his vision of a woman bound to the demands of seduction. Not one woman would complain. Balenciaga, on the other hand, turns his flaws (the arched back, the casual approach, the lack of focus on appearance) into the supreme evidence of his art and his fashion. The 'Courrèges bomb' of the 1960s not only sanctions an androgynous youth, but standardizes it. Under trapezoid dresses – short, white, visual – and slim-fit suits, long legs make their first appearance. Yves Saint Laurent stirs excitement by cladding them in trousers before orchestrating, in 1971, the sexual return of the woman whose self-confidence and triumphant lines of oneupmanship cause a scandal. The spring/summer 1971 collection is a homage to wartime, with shoulders broadened by men's jackets, dresses draped arrogantly over the hips and wedges that elongate garishly coloured legs. This Yves Saint Laurent collection would become an essential reference point for the rest of twentieth-century fashion. The disproportionate build developed by Thierry Mugler and Claude Montana in the 1980s is indebted to him. The voluptuous, sensual fashion of Azzedine Alaïa also mirrors it during the same period.

The first move away from this body image, based definitively on the intensification of female attributes, is made by the different waves of Japanese designers, with Issey Miyake at the forefront. It swings between the celebration of an elevated body, amplified under light fabric, and the celebration of a silhouette that rips up Western notions of beauty. In both cases clothes are unencumbered and sing the praises of a flexible, slender and natural body.

The work of Yohji Yamamoto and Rei Kawakubo for Comme des Garçons is different. Going against all expectations, their clothes challenge the norm. With an awkward elegance, they retort by volumes and countervolumes that open multiple possible stylistic schools of which Rei Kawakubo remains the sole monarch. For them, clothes are the body. This is also what seems to drive the Belgian designers, especially Martin Margiela. For the first time, a broken-up, questioned, folded, souvenir or pioneering body is at the heart of conceptual collections. Jackets support themselves and become giant, and skirts are stretched out, whereas faces are erased under the veil of anonymity.

JEANNE LANVIN COUTURE, *C*. 1930.
Silk crêpe dress with silk satin kimono sleeves.
MUDE. M.0596 | "Coleção Francisco Capelo"
MUDE – Museu do Design e da Moda,
Coleção Francisco Capelo | Lisboa.

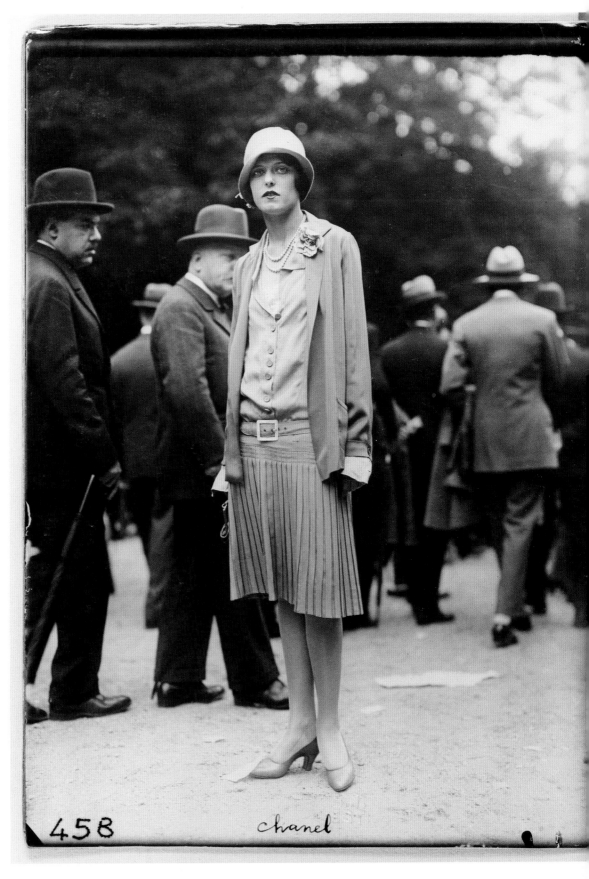

458 Chanel

Chanel's gamine silhouette, 1920s.

CHAPTER 6 — SHADOWS OF THE BODY

JEAN PATOU, 1925–27.
Silk dress with chain stitch embroidery.
The straight and flat silhouette of this dress
shows the changing couture silhouette
at the beginning of the twentieth century,
which went from a curved S-shape
into a tubular, straight silhouette.
MoMu inv.nr. S78/373.

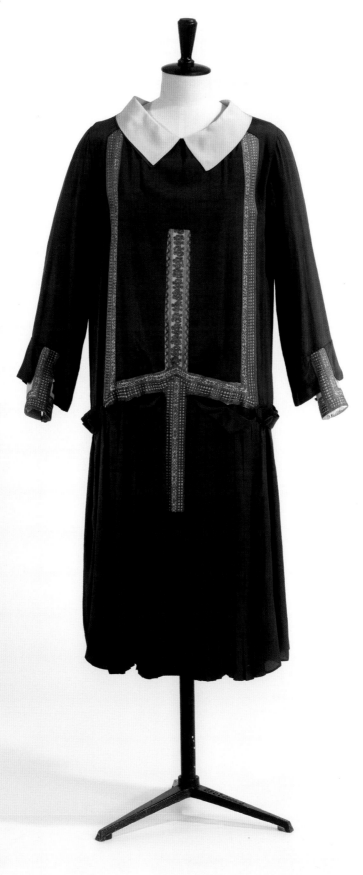

CHAPTER 6 — SHADOWS OF THE BODY

MADAME GRÈS, *C.* 1950.
Pleated silk jersey evening dress.
MUDE. M.0082 | "Coleção Francisco Capelo"
MUDE – Museu do Design e da Moda,
Coleção Francisco Capelo | Lisboa.

In the late twentieth and early twenty-first century, the fashion of Hedi Slimane and Nicolas Ghesquière is cracking the whip. The silhouette they impose on men and women is startling. Surprised shoulders, spindly legs and tapered waists make for a contemporary archetype.

Curiously, bodies modified by the widespread practices of plastic surgery are not promoted in fashion. Generous breasts (sometimes too generous), swollen lips, high cheekbones, a waist sharpened by rib removal and prominent backsides are all taking over the main industries, particularly cinema. However, on catwalks as in fashion photography, this model – widely adopted by women of all ages – is unheard of. More worryingly, girls themselves seem to be idealizing this faint femininity, something to be consumed just like a piece of clothing. It is from this body shape, something truly imprisoning in this, the early twenty-first century, that the next fashion designer should be moving away. If not, this body becomes a garment in itself that a woman seeks through the advice of a plastic surgeon or a personal trainer, when at one time she would have preferred the advice of her tailor. Most probably, for all the other bodies, those who work out how to escape the gym or the operating table, the challenge of how to dress will be taken on by exercising the right to be unique.

RUDI GERNREICH, 1967.
Two short dresses in wool jersey and vinyl.
MUDE. M.0353/MUDE. M.0354 | "Coleção Francisco Capelo"
MUDE – Museu do Design e da Moda,
Coleção Francisco Capelo | Lisboa.

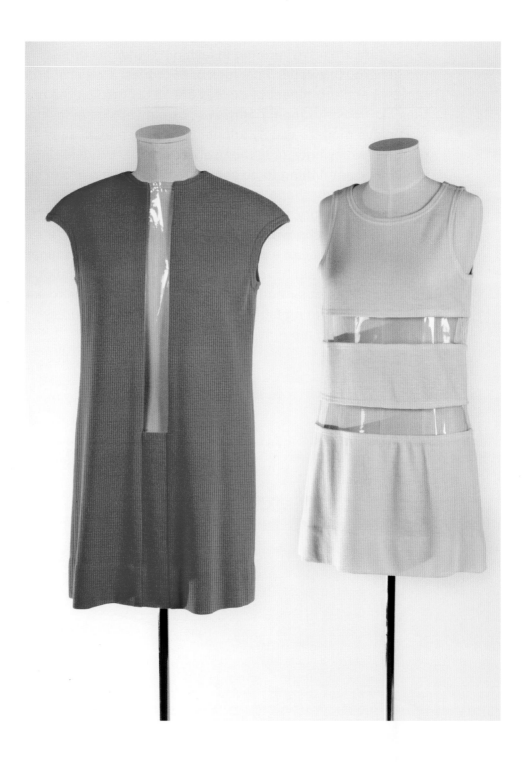

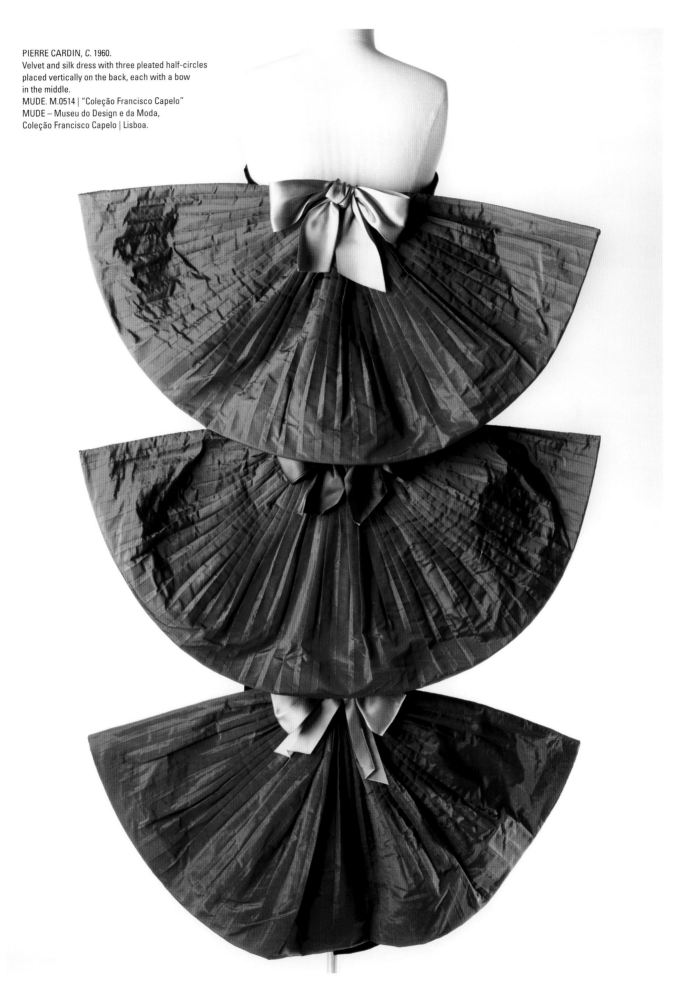

PIERRE CARDIN, *C.* 1960.
Velvet and silk dress with three pleated half-circles placed vertically on the back, each with a bow in the middle.
MUDE. M.0514 | "Coleção Francisco Capelo"
MUDE – Museu do Design e da Moda,
Coleção Francisco Capelo | Lisboa.

MAISON MARTIN MARGIELA,
AUTUMN/WINTER 2008–09.
Woollen and silk blazer.
MoMu inv.nr. T09/660.

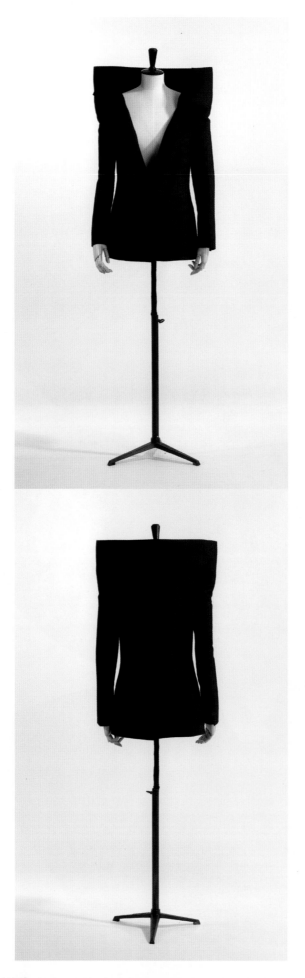

MAISON MARTIN MARGIELA, AUTUMN/WINTER 1998–99.
Flat sleeveless vest in felt with displaced armholes.
MoMu inv.nr. B02/138.

Drawings by Martin Margiela showing the evolution
of shoulder outlines in his work from narrow to wide
and conical, 2007.

AH 06 07
CARRURE "FAUTEUIL"

AH 07.08 CARRURE X LARGE POINTUE (SOUPLE)

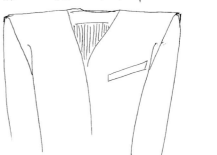

PE 07 CARRURE ÉPAULÉ + PANNEAU

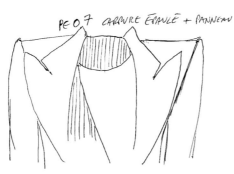

PE 08 CARRURE X LARGE POINTUE (CINTRÉE)

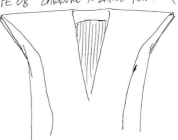

AH 08 09 CARRURE "CÔNE"

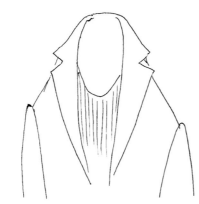

AH. 05-06
VESTE CARRURE "CAPUCHE"

CHAPTER 6 — SHADOWS OF THE BODY

MAISON MARTIN MARGIELA,
'FLAT' COLLECTION, AUTUMN/WINTER 1998–99.
Dress in manmade silk, woollen jumper with covering
in manmade fibre. Both jumper and dress have
displaced armholes which are tilted to the front.
MoMu inv.nr. T06/1139, B02/123.

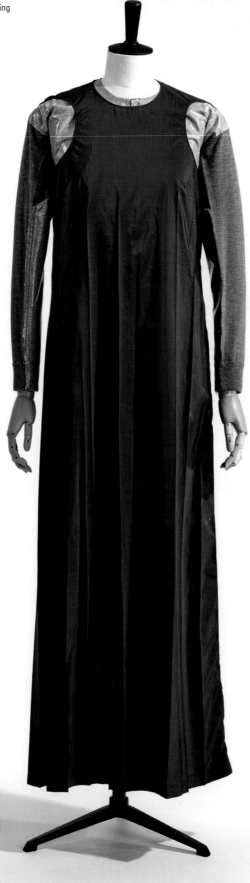

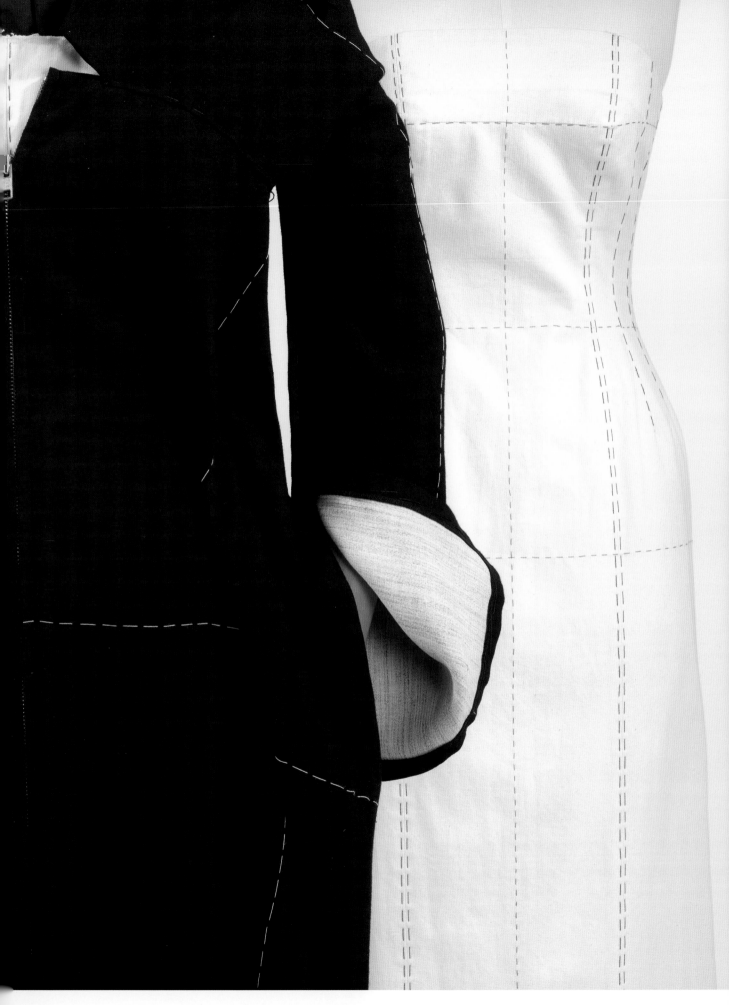

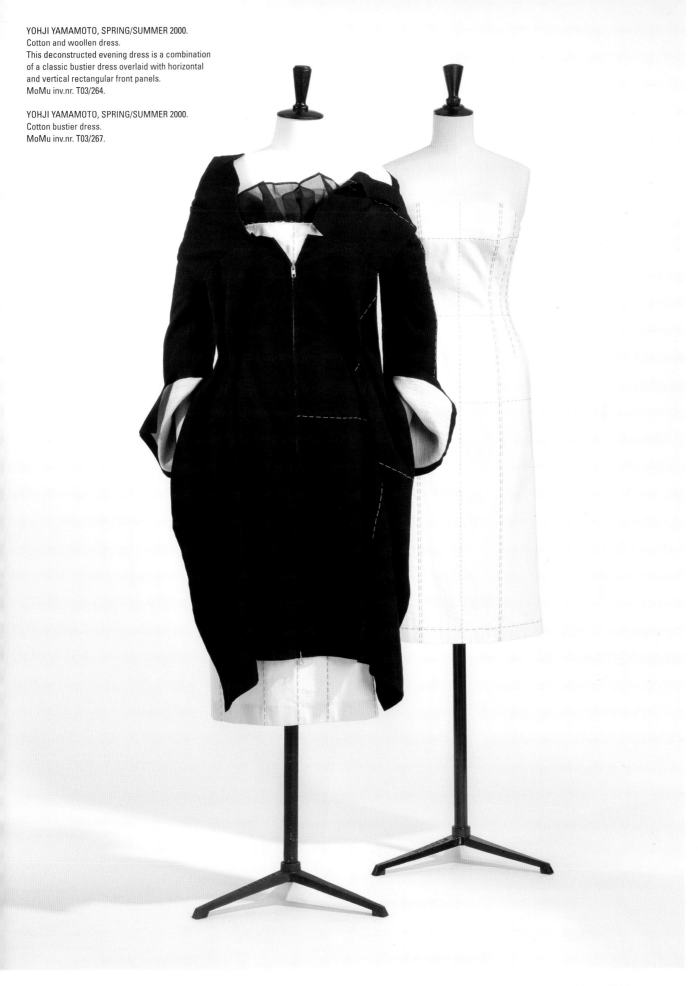

YOHJI YAMAMOTO, SPRING/SUMMER 2000.
Cotton and woollen dress.
This deconstructed evening dress is a combination
of a classic bustier dress overlaid with horizontal
and vertical rectangular front panels.
MoMu inv.nr. T03/264.

YOHJI YAMAMOTO, SPRING/SUMMER 2000.
Cotton bustier dress.
MoMu inv.nr. T03/267.

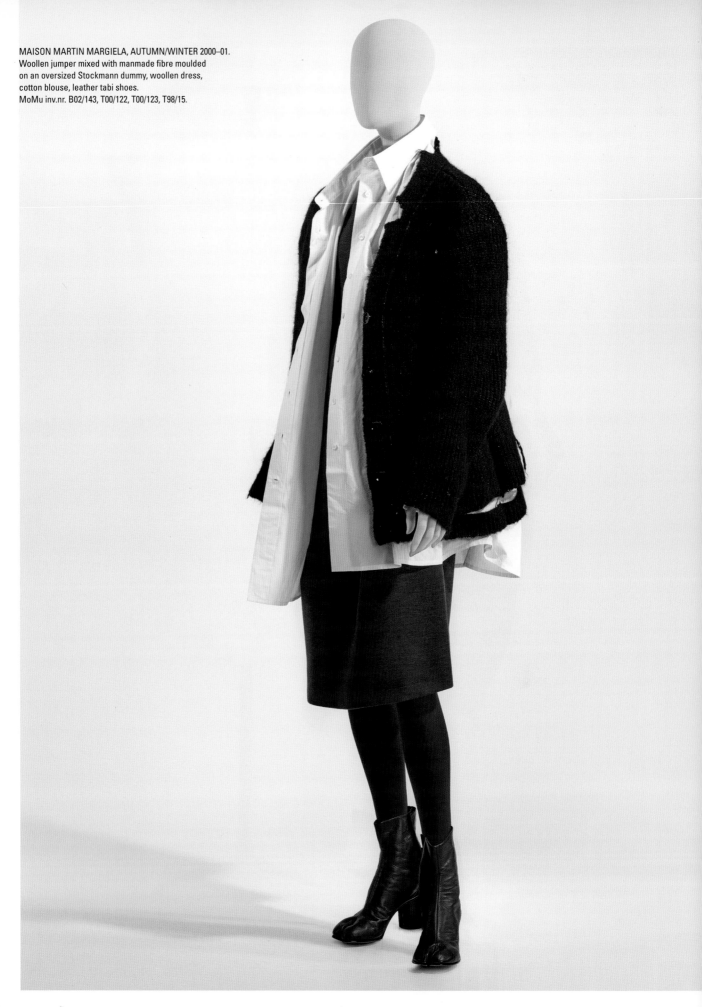

MAISON MARTIN MARGIELA, AUTUMN/WINTER 2000–01.
Woollen jumper mixed with manmade fibre moulded
on an oversized Stockmann dummy, woollen dress,
cotton blouse, leather tabi shoes.
MoMu inv.nr. B02/143, T00/122, T00/123, T98/15.

MAISON MARTIN MARGIELA, AUTUMN/WINTER 2000–01.
This oversized collection was moulded on a mannequin of Italian size 78.
The oversized garments retained their shape when worn by a regular model.

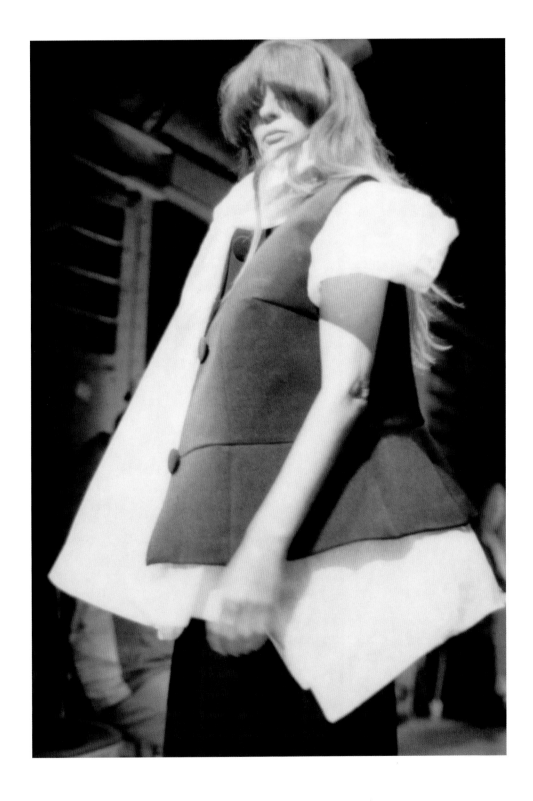

MAISON MARTIN MARGIELA,
AUTUMN/WINTER 1994–95.
Stock room view.

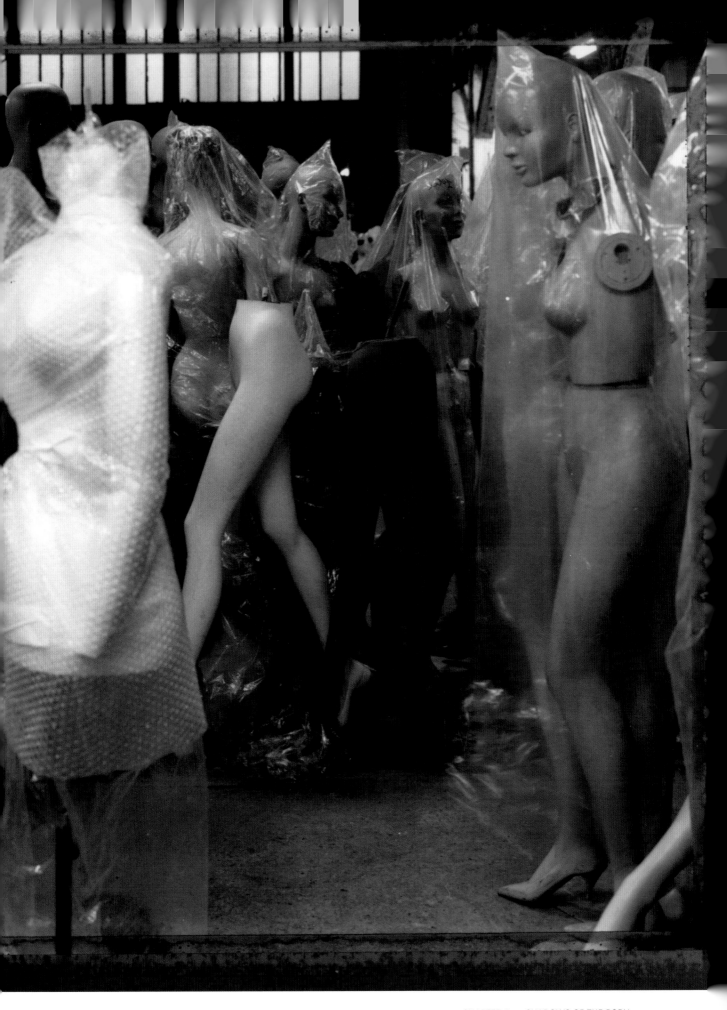

CHAPTER 6 — SHADOWS OF THE BODY

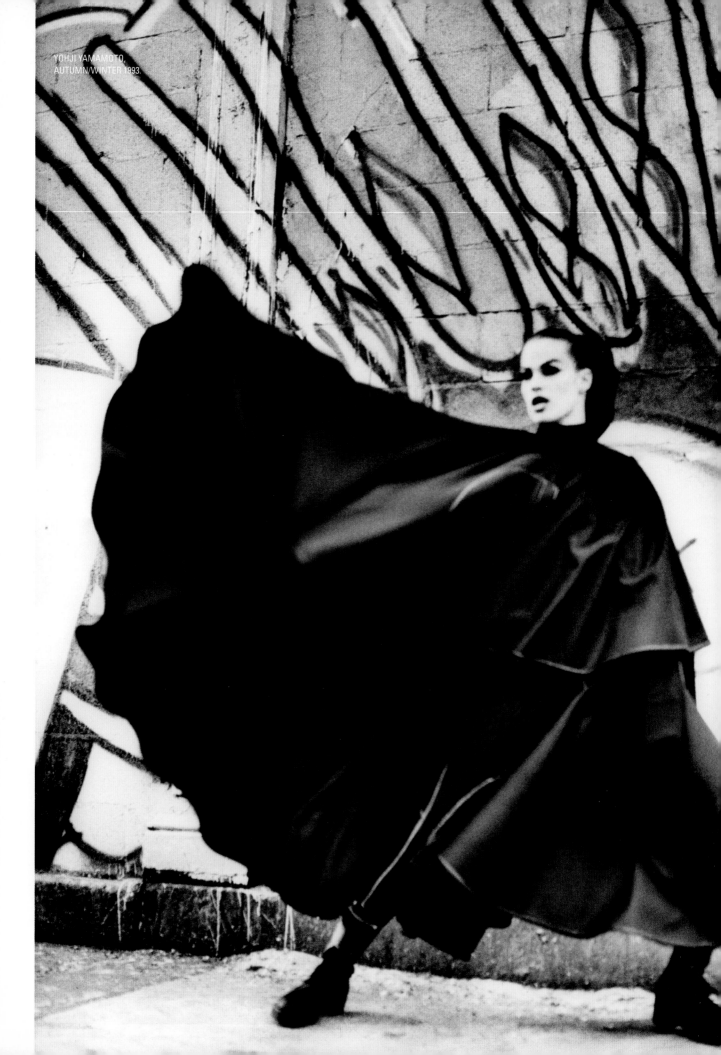

YOHJI YAMAMOTO,
AUTUMN/WINTER 1993.

CULTURAL LIBERATION SPRINGING FROM PHYSICAL LIBERATION: RECEPTION STUDY OF THE 1980s AVANT-GARDE

— HETTIE JUDAH

The divergent fashions of the early and mid-1980s were close-coupled to widespread social and political changes in the era. While styles that are now iconic of earlier decades of the twentieth century in truth represent the sartorial choices of only a small, turned-on zeitgeist – be that the hippies of Haight-Ashbury or the swinging Londoners of Carnaby Street – the 1980s ushered in the contemporary era of mass, global fashion trends.

Paris's status as the home of fashion may have been challenged by styles emerging from the US and UK in the 1960s and 1970s, but these represented waves of influence from youth and counter-culture, rather than high fashion. A more serious blow to Paris's crown came from Italy in the late 1970s, where a new generation of ready-to-wear designers – notably Giorgio Armani and Gianni Versace – started showing innovative collections that in their deployment, respectively, of masculine tailoring and powerful sexuality, held strong appeal for the emerging class of independent working women. The woman's body as a sexual weapon was likewise suggested by the ultra body-conscious designs of Paris-based designers Azzedine Alaïa and Thierry Mugler.

Just the other side of the English Channel, but spiritually far divorced from the lusty glamour of the Parisian catwalks, the UK was suffering both from the long tail of the global economic crisis of the late 1970s and the impact of political turmoil, the combination of which led to mass unemployment. London's fashion culture revolved around a post-punk DIY ethos rooted in squatter culture and characterized by the zine-like street-centric aesthetic of *i-D* magazine, which launched in 1980.

It was into this sociocultural milieu that Yohji Yamamoto and Rei Kawakubo of Comme des Garçons launched themselves when they presented their work for the first time in Paris in 1981. Both were well established in Japan – Kawakubo had founded her company in the late 1960s following stints in advertising and styling; Yamamoto established Y's in 1972 a few years after graduating from Bunka fashion

Linda Evangelista modelling Yohji Yamamoto, 1992.

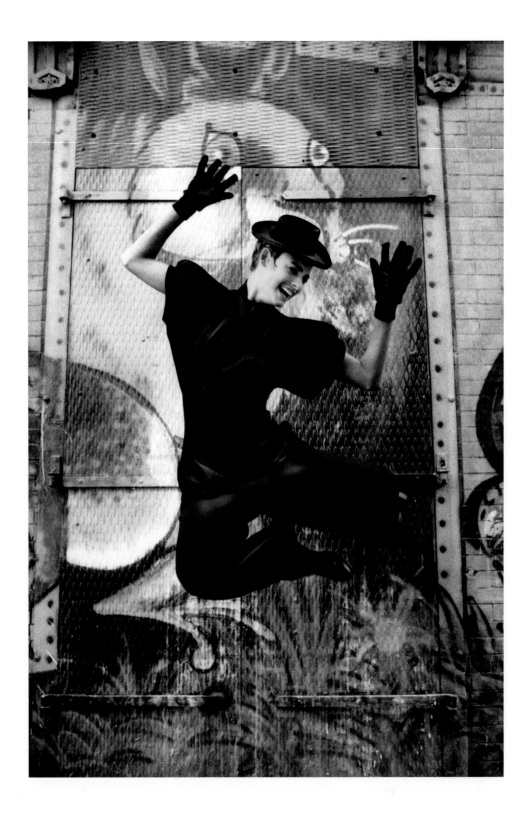

college in Tokyo – and together they presented a fully realized vision of the female wardrobe strongly at odds with the form-flattering femininity associated with Parisian high fashion. Their first – joint – presentation, shown to an audience of some hundred or so press and buyers, was composed of loose, layered, voluminous garments in black, abraded fabrics which were knotted or wrapped around the body, creating layers, contours, lumps and folds in unconventional positions.

Issey Miyake, who had been showing collections of formally and technically experimental clothing in Paris since 1973, has referred to the approximate contact between the body and the garment in his designs as *ma* – the concept of space between body and cloth that allows flexibility and movement. While the frayed and loosely stitched designs of their early Paris presentations were aesthetically far removed from Miyake's at this stage, Yamamoto and Kawakubo's designs shared this interest in volume and of creating garments for the body in motion. Shown with flat shoes, and (as some journalists remember it) combat boots, on pale, minimally made-up models who strode rather than sauntered, they represented a forceful antidote both to the traditions of Parisian high fashion and to the more exuberant, sexy styles of the time.

The new shapes demanded a new vocabulary and a new mode of fashion photography of those who sought to celebrate them. It is notable that Jeff Weinstein[1] and Deyan Sudjic,[2] two of the most eloquent champions of the work of Japanese fashion designers in the 1980s, both come from the field of art and architecture rather than that of fashion journalism, and analysed the garments using terms such as 'displacement' which were more commonly deployed in the discourse of postmodernist building design. In photography, too, the structural, object-like aspect of the garments was brought to the fore, either with black and white imagery that emphasized the outline,[3] or by presenting the clothes against strongly textured surfaces such as worn brickwork, which balanced the subtlety of the fabrics.[4]

In the wider press, response to the early collections was sharply divided. Writing in the *New York Times* in 1985,[5] Bernadine Morris noted that 'at the vanguard of the naysayers are the French, who have never understood the Japanese designs,' but it wasn't just the fashion establishment of Paris that had their reservations. In her essay 'The Aesthetics and Politics of "Japanese" Identity in the Fashion Industry' (1992), Dorinne Kondo recalls that '*Women's Wear Daily* is notorious for its publication of a large two-page spread of Japanese avant-garde clothing with Xs dramatically splashed across the page,' and notes the preponderance of martial and xenophobic imagery used in describing a Japanese 'invasion' in the following years.[6] In her summation of the styles of the previous decade published in the early 1990s, Vicky

Christine Bolster in Comme des Garçons, Deauville, 1983.

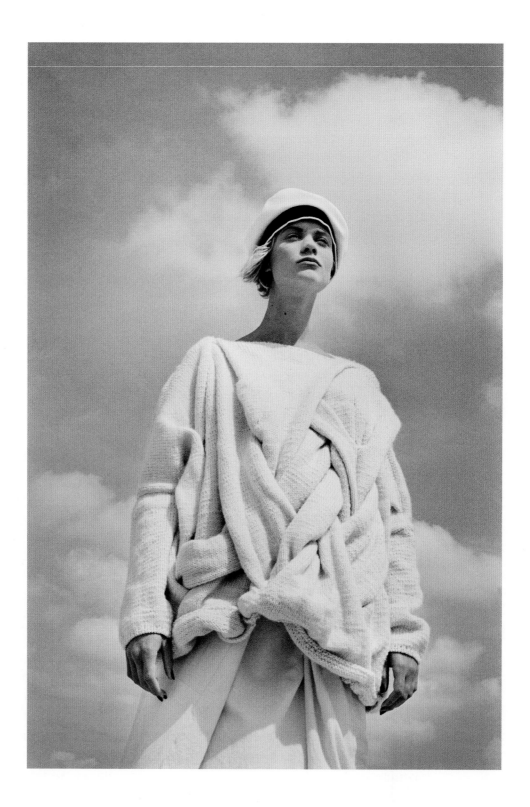

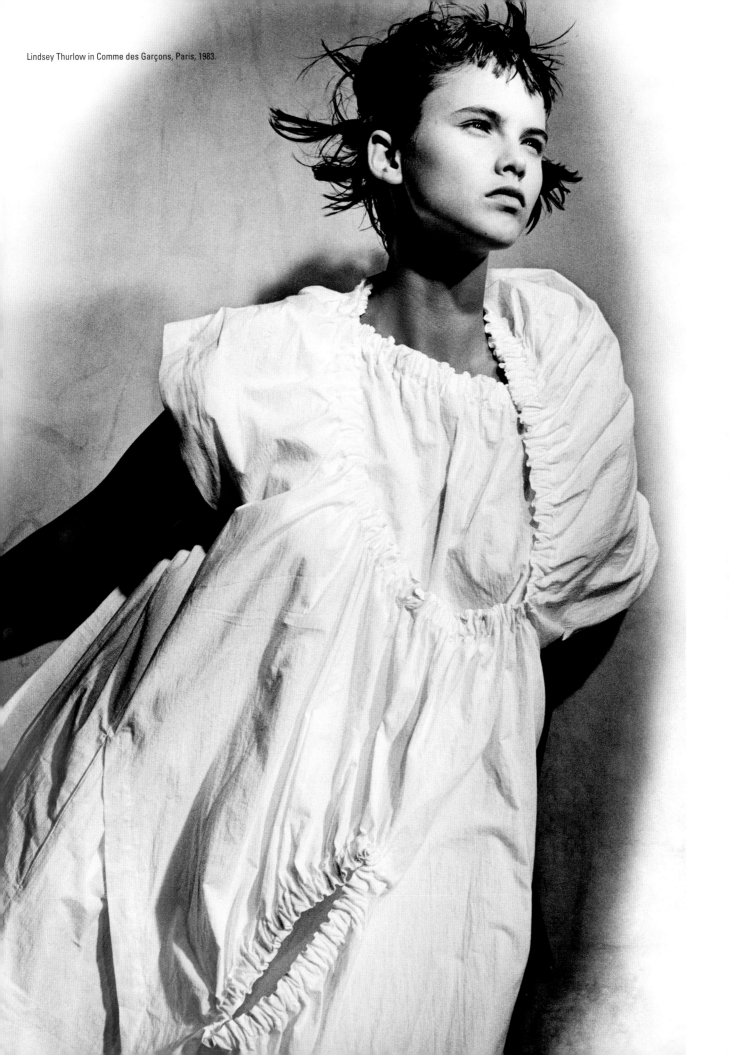

Lindsey Thurlow in Comme des Garçons, Paris, 1983.

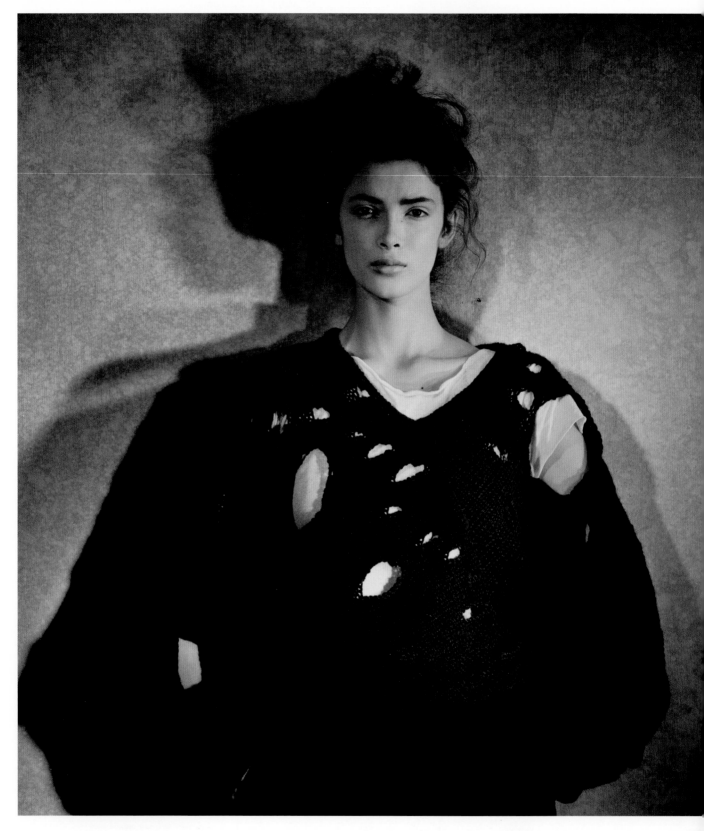

Linda Spierings in Comme des Garçons, Paris, 1982.

Carnegie recalls *WWD* labelling their work 'The Hiroshima bag-lady look'.[7] In 1983, Joan Kaner, the vice president and fashion director of Bergdorf Goodman in New York, was quoted in *The Village Voice*:

Rei's clothes are interesting to look at, difficult to wear. How much do people want to look tattered? You have to have a large pair of shoulders and the right attitude to wear them. Most are bulky layers. They do nothing for the figure, and for all the money going into health and fitness, why look like a shopping bag lady?[8]

The question of the female figure and its exhibited fitness was one central to concerns of female and feminist discourse in the era. The idealized 'New Woman' of the 1980s was immersed in the world of work, she signalled her status, discipline and power through her athletic, gym-toned frame. She wore clothes that emphasized her hard-won shape through the cling of Lycra, and accentuated her ambitions to succeed in business through padded shoulders that aped the contours of a man's business suit. Aggressive ambition was celebrated, as was the display of status through expensive clothing and accoutrements. As for sex? Gym-buffed 'New Woman' was available and up for it: as in control of her sexuality as she was her career.[9] What she was perhaps not, explicitly, was a feminist. Thanks to what became known as the 'sex wars', feminism was becoming a troubled term. As the 'second wave' of feminism fragmented into disputes about sexuality and body politics, the word was increasingly associated with hostile attitudes toward men, socialist ideologies and 'political' lesbianism, all of which was gleefully transformed by the mainstream press into a portrait of humourless militancy.

Writing in British *Elle* in 1986, the women's editor (and former fashion editor) of left-wing newspaper *The Guardian* described the troubled relationship socially and politically engaged women of the era had with the fashion industry. '…[M]y morning mail would contain disquieting little nuggets like "Guardian women have better things to do with £26 than spend it on a pair of sunglasses…" and "Guardian women despise fashion as a tool of patriarchal expression. If Brenda Polen is too stupid to realise that, she should be sacked instantly."'[10] Polen noted that studies made by the newspaper into its readership suggested that in fact the 'vast majority' were interested in fashion, and went on to caution that 'unsightliness was not next to political purity.'

The work of Yamamoto and Kawakubo struck an interesting fresh route through the hubbub surrounding the presentation of the female body and the feminist's relationship to a fashion industry that in every level of its structure, from conception to retail, seemed wedded to reinforcing the gender binary. With their voluminous shapes and androgynous forms, their clothes of the early 1980s obscured

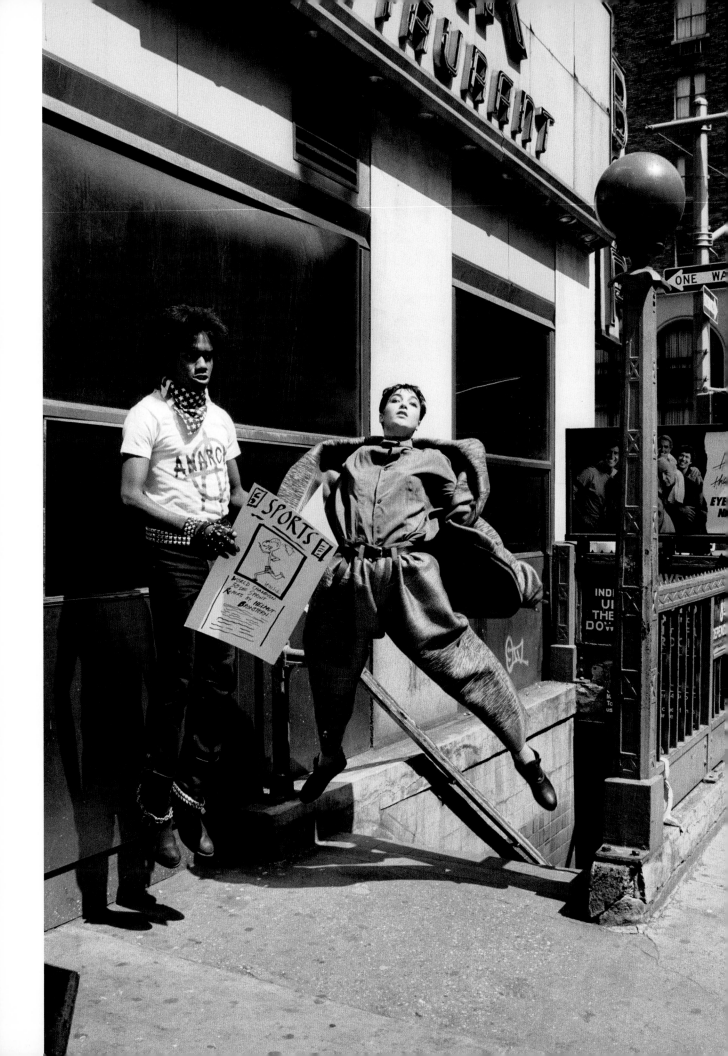

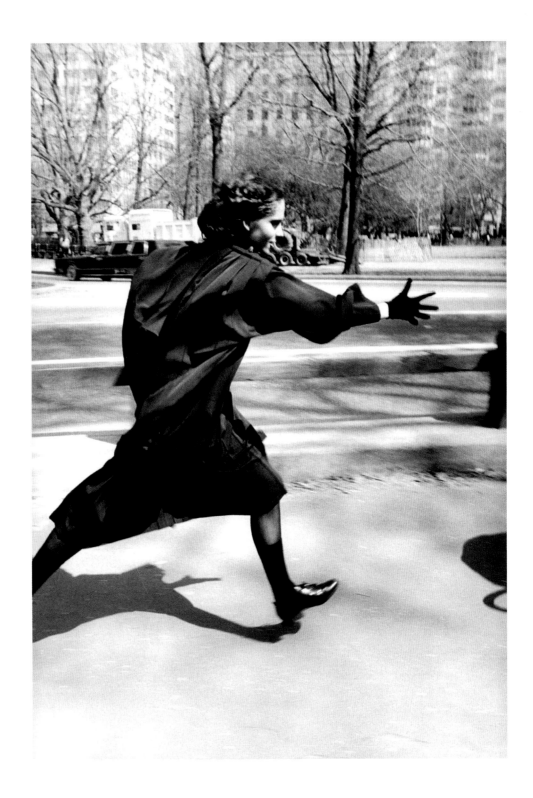

CHAPTER 7 — CULTURAL LIBERATION SPRINGING FROM PHYSICAL LIBERATION

YOHJI YAMAMOTO,
SPRING/SUMMER 1996.

the gendered body and, particularly in the first few collections shown in Paris, concealed it almost totally. As with blue jeans or traditional workwear, these were, to a greater or lesser extent, ungendered garments. Yamamoto spoke publicly about what he considered to be an arbitrary division between men's and women's wear, and how the divide was becoming blurred: '[...] when I started designing, I wanted to make men's clothes for women. But there were no buyers for it. Now there are. I always wonder who decided that there should be a difference in the clothes of men and women. Perhaps men have decided this.'[11]

Kawakubo for her part was outspoken in her dedication to provide clothes for hardworking women:

'The goal for all women should be to make her own living and support herself, to be self-sufficient. That is the philosophy of her clothes. They are working for modern women. Women who do not need to assure their happiness by looking sexy to men, by emphasizing their figures, but who attract them with their minds.'[12]

The emphasis on independence extended from the underlying philosophy right through to the clothes themselves – the layering of garments, the wrapping and knotting of cloth, all emphasized the act of dressing as a participatory experience (a practice that was extended with the launch of Issey Miyake's 'A-POC' line of fine knit clothing punched from a single, continuous, tube of cloth in 1999). Even in the literal act of clothing the body, this was individual rather than conformist dress – clothing that worked for the wearer rather than vice versa.

Mobility was a strong part of the message that enfolded the garments of Kawukobo, Yamamoto and Miyake – there is a pervasive sense of motion in the catalogue imagery used by the latter two, with models portrayed leaping and dancing in the air, a visual symbol of emancipation from restraining dress and painful high-heeled shoes. This sense of the clothes as enabling movement was further reinforced by the designers' collaborations with prominent choreographers – notably William Forsythe with Issey Miyake (*The Loss of Small Detail*, 1991), Pina Bausch with Yohji Yamamoto (his 1990 collection was dedicated to the dancer, and they formally collaborated in 1998) and Merce Cunningham with Rei Kawakubo (*Scenario*, 1997).

Both the collaborative mode of dressing and the new way of moving constituted part of a necessary re-education described by devotees of the three designers. One devotee described their garments as being like a 'prix-fixe dinner': you could not pick and choose, you had to go all in. 'To buy Japanese-designed clothing only demands money. To wear it demands a complete re-evaluation of your wardrobe.'[13]

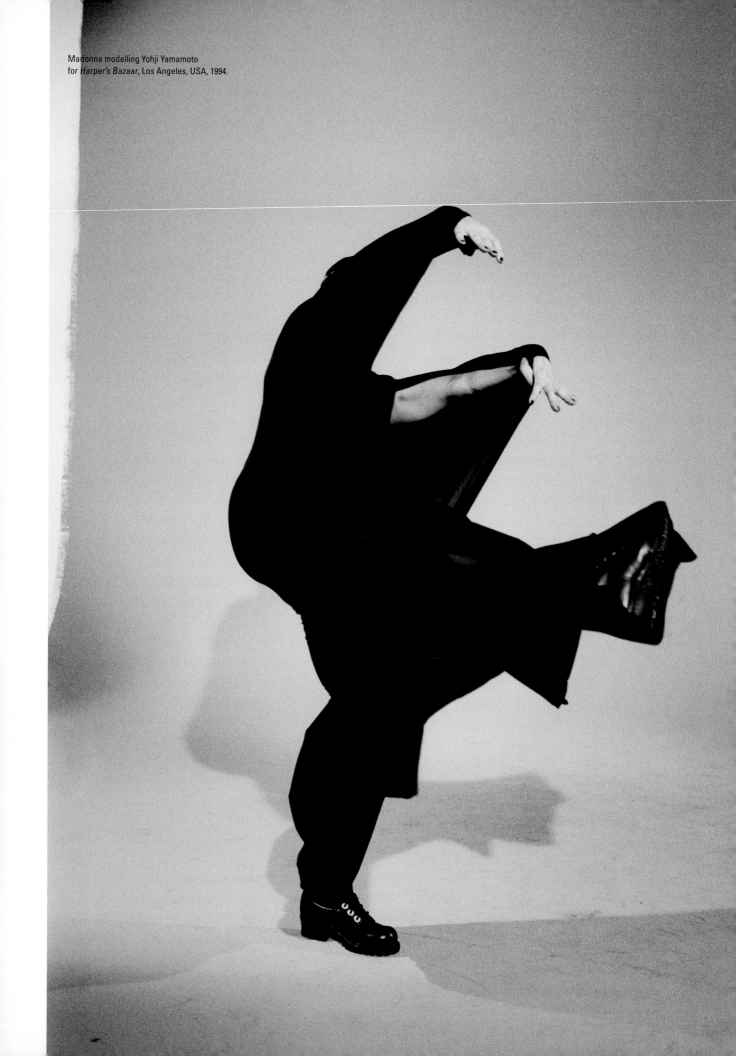

Madonna modelling Yohji Yamamoto
for *Harper's Bazaar*, Los Angeles, USA, 1994.

This re-examination of the shibboleths of dress accompanied a new cosmopolitanism among fashion consumers. Between the latter years of the 1970s and the early 1980s, a specific interest in the culture of Japan emerged where a few years earlier there might have been ambivalence or even hostility. In London in 1981 David Claridge started the short-lived post-Blitz club The Great Wall, which (somewhat confusingly, given the name) was 'propelled with a soundtrack of Japanese New Wave music.'[14] Many issues before the names of the Japanese designers appeared in its pages, Claridge penned a report on Japanese street fashion and pop music for *i-D*. That same year Leslie Bennetts wrote a feature in the *New York Times* on the 'Culture of Japan Blossoming in America' in which the vogue for Japanese-designed fashion was seen to accompany an interest in Japanese cinema, architecture, and cuisine. Sushi had even made it to Paris by 1986, where the hip dining spot during March fashion week was the recently opened Shogun.

Japanophilia aside, the impact of the Yamamoto and Kawakubo collections was as much a matter of timing as it was innovation. By the end of the decade *i-D* credited the designers with letting slip the tidal wave of black clothing that became a uniform not only within the fashion world but also for the wider creative industries. But already in 1981, the magazine's more avant-garde interviewees were expressing a preference for the colour.[15] The magazine also carried a number of DIY clothing patterns largely based on wrapping and knotting techniques, and loose geometric shapes that a short while later would become closely associated with the Japanese designers. Writing in 1984, Colin McDowell noted that 'In the first three years of this decade the strongest development has been the desire to look poor',[16] situating both Yamamoto's expressed interest in the worn clothes of working people, and Kawakubo's 'bag ladies' within a wider tendency.

Most significant of all, however, was that the emergence of these designers coincided with the rise of a new generation of independent women who were ready for an alternative to the formal dress of establishment power figures such as Margaret Thatcher, to the aggressive shoulder pads and hard-bodied image of the New York working girl, to the sexually predatory bodycon of the cosmopolitan Parisienne, and to the anti-fashion prescribed for a sex-wars-era feminist. Yamamoto's and Kawakubo's customers were successful and independent women, but as depicted in the press of the time, they were perhaps art critics or gallerists, people who travelled and engaged in cultural activities.

They were also, notably, physically diverse. Fat is a feminist issue,[17] as Susie Orbach memorably explained in 1978, but so is age, and the clothes offered by Yamamoto and Kawakubo were blind to both, as they were too to divergence from the Western European

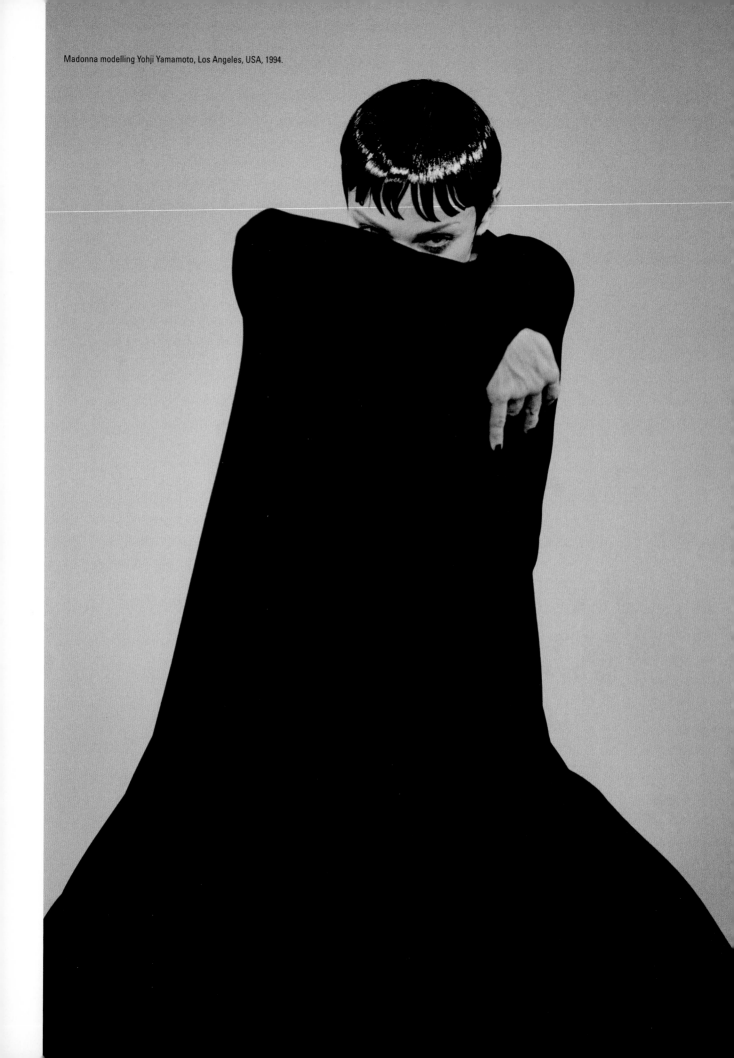

Madonna modelling Yohji Yamamoto, Los Angeles, USA, 1994.

beauty ideal. This was an inclusive avant-garde – one in which you could be fat, or old, or both and still chic. It is perhaps for this reason that so many of the aspects of dress that made this possible – volume, lack of structure, draped fabrics, soft surface texture and ripped edges – endured as defining aspects in the look of the decade overall.

This re-definition of chic was importantly extended by some of the Belgian designers who emerged onto the scene later in the decade – the garment-centric anti-pretty, anti-gloss of Martin Margiela; the embracing of different body typologies of Walter Van Beirendonck; the flat-shoed force of Ann Demeulemeester; and the all-ages appropriate garments of Dries Van Noten. While many commentators have reductively referred to the work of all of these designers as 'cerebral' or 'intellectual',[18] the unifying element within their work is an investigation of garments that don't define a woman by sexual allure and youthful appeal alone, but which explore other sensualities,[19] and a vision of strength that is rooted in independent spirit rather than status dressing.

In rethinking the gender binaries, and the passive relationship to clothing that demanded that you conform to it rather than it to you; in breaking with fashion conventions that prioritized youth, athleticism, and a narrow ideal of beauty; in making fashion that presented a body ready for action rather than a body inviting sex; in permitting soft, collaborative power rather than hard ambition, the designs of Yohji Yamamoto and Rei Kawakubo in the early 1980s questioned not only what a woman should look like and how she should dress, but also why, and for whom.

Madonna modelling Yohji Yamamoto, Los Angeles, USA, 1994.

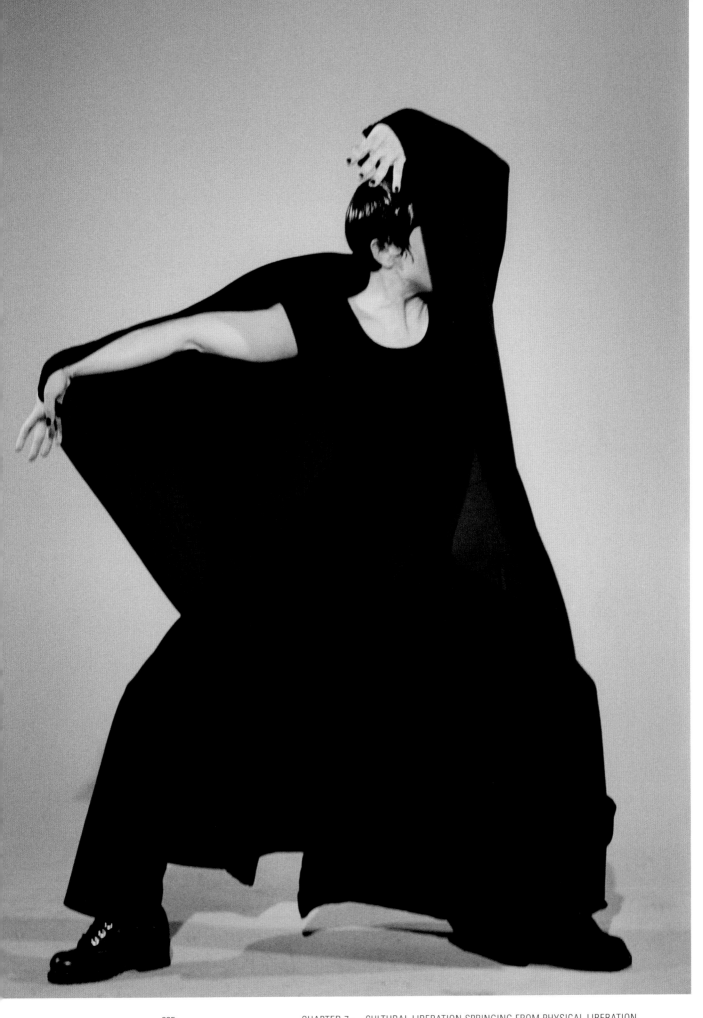

CHAPTER 7 — CULTURAL LIBERATION SPRINGING FROM PHYSICAL LIBERATION

YOHJI YAMAMOTO, SPRING/SUMMER 2000.
Linen cotton dress.
This deconstructed evening dress is a combination
of a classic bustier dress overlaid with horizontal
and vertical rectangular front panels.
MoMu inv.nr. T03/263.

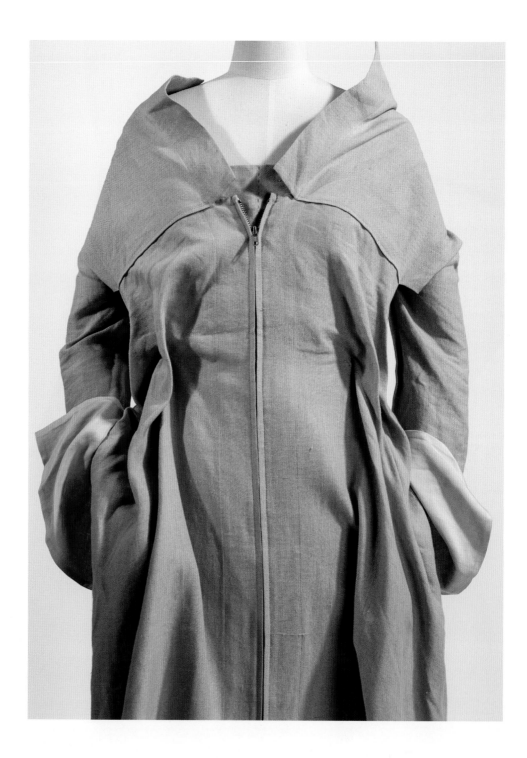

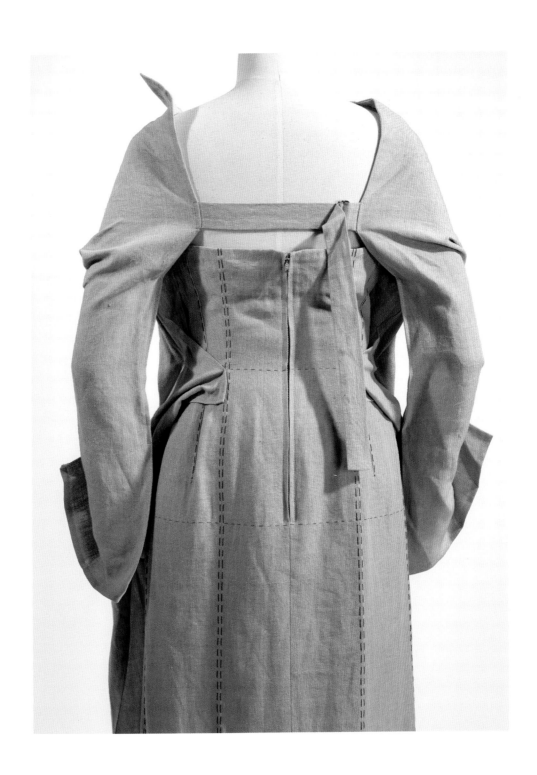

CHAPTER 7 — CULTURAL LIBERATION SPRINGING FROM PHYSICAL LIBERATION

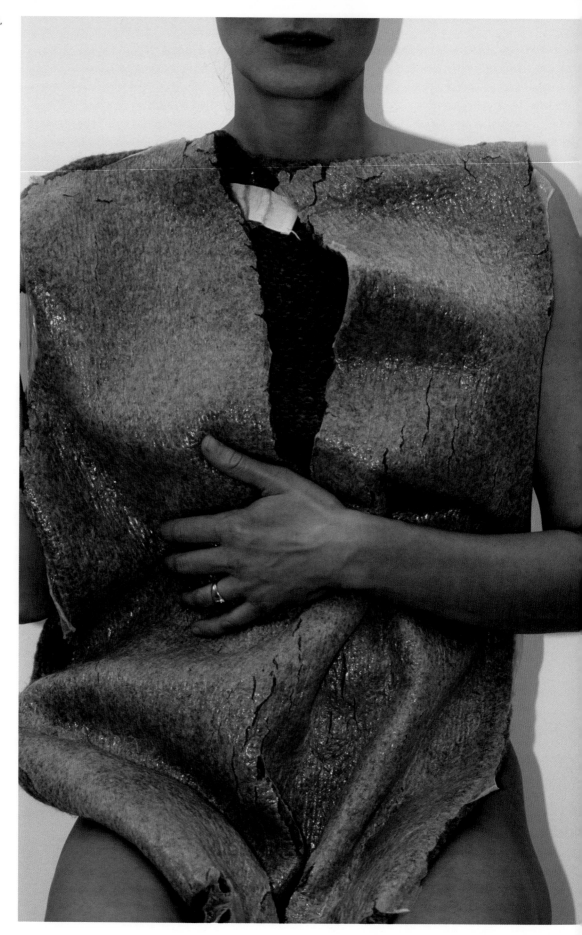

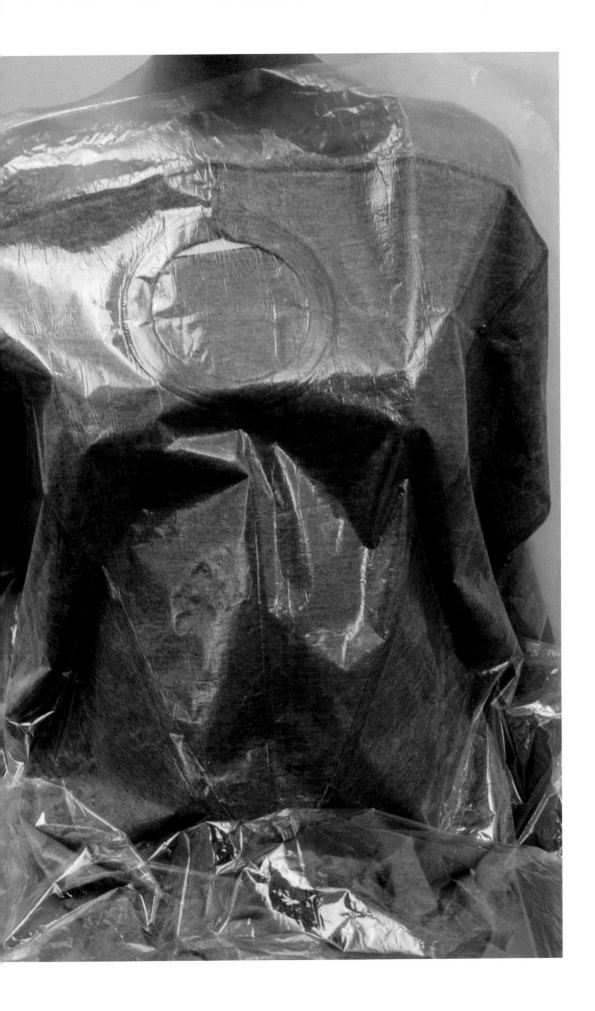

CHAPTER 7 — CULTURAL LIBERATION SPRINGING FROM PHYSICAL LIBERATION

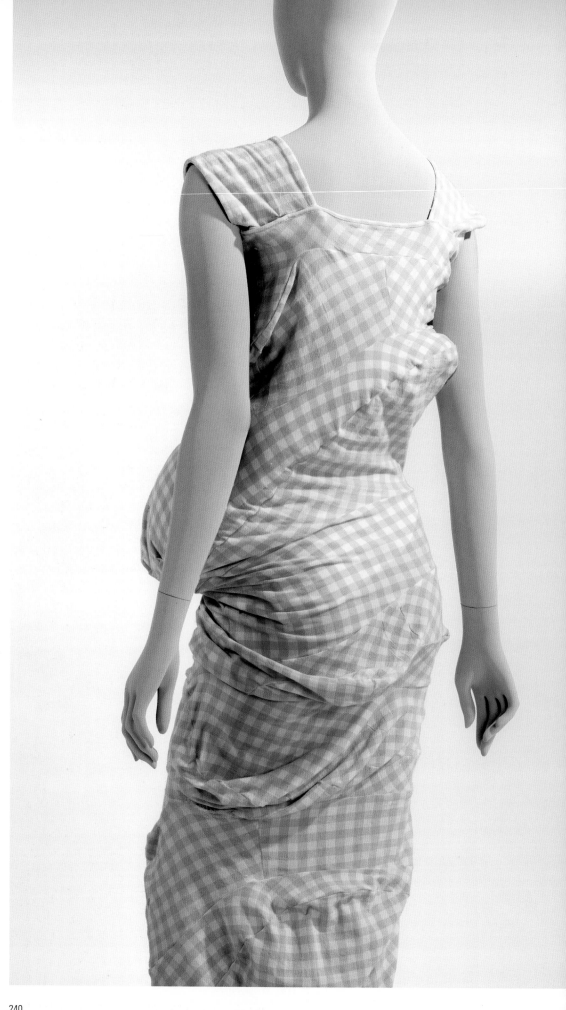

COMME DES GARÇONS,
'BODY MEETS DRESS,
DRESS MEETS BODY,
PROTOTYPE,
SPRING/SUMMER 1997
Dress in jersey, manmade
fibre.
MoMu inv.nr. T15/729.

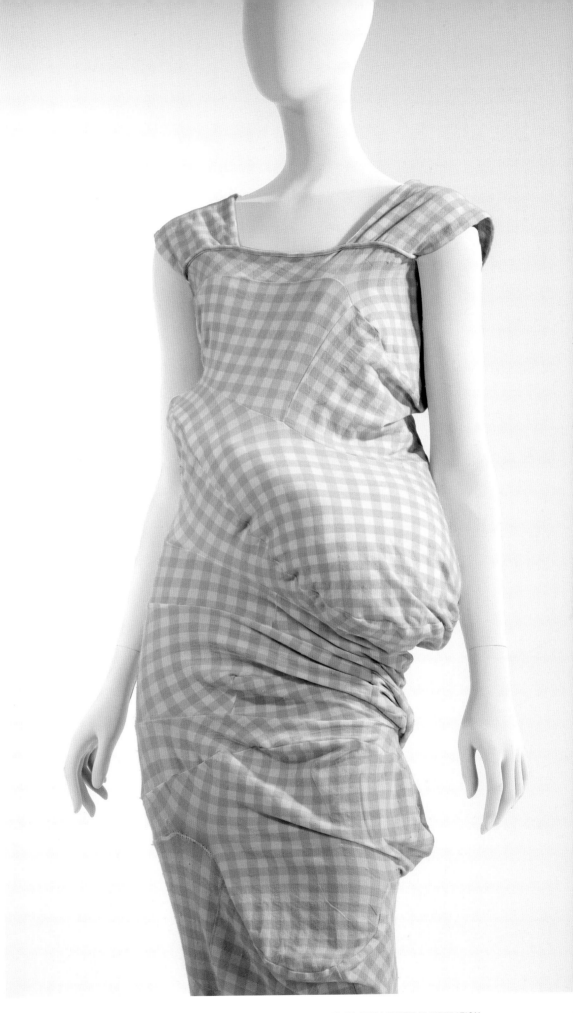

CHAPTER 7 — CULTURAL LIBERATION SPRINGING FROM PHYSICAL LIBERATION

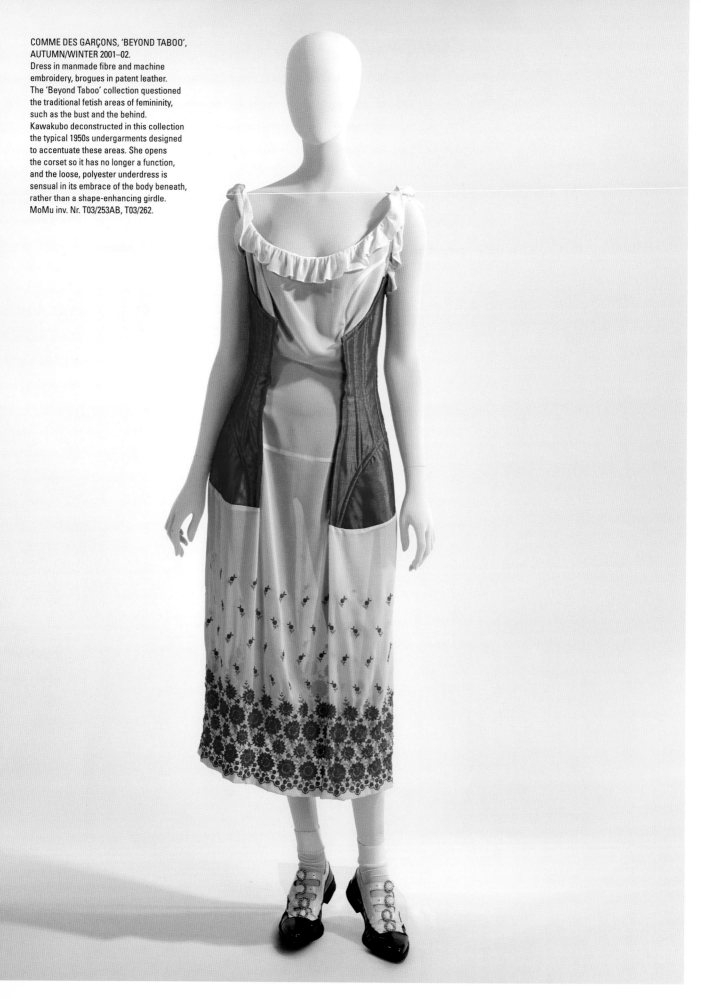

COMME DES GARÇONS, 'BEYOND TABOO',
AUTUMN/WINTER 2001–02.
Dress in manmade fibre and machine
embroidery, brogues in patent leather.
The 'Beyond Taboo' collection questioned
the traditional fetish areas of femininity,
such as the bust and the behind.
Kawakubo deconstructed in this collection
the typical 1950s undergarments designed
to accentuate these areas. She opens
the corset so it has no longer a function,
and the loose, polyester underdress is
sensual in its embrace of the body beneath,
rather than a shape-enhancing girdle.
MoMu inv. Nr. T03/253AB, T03/262.

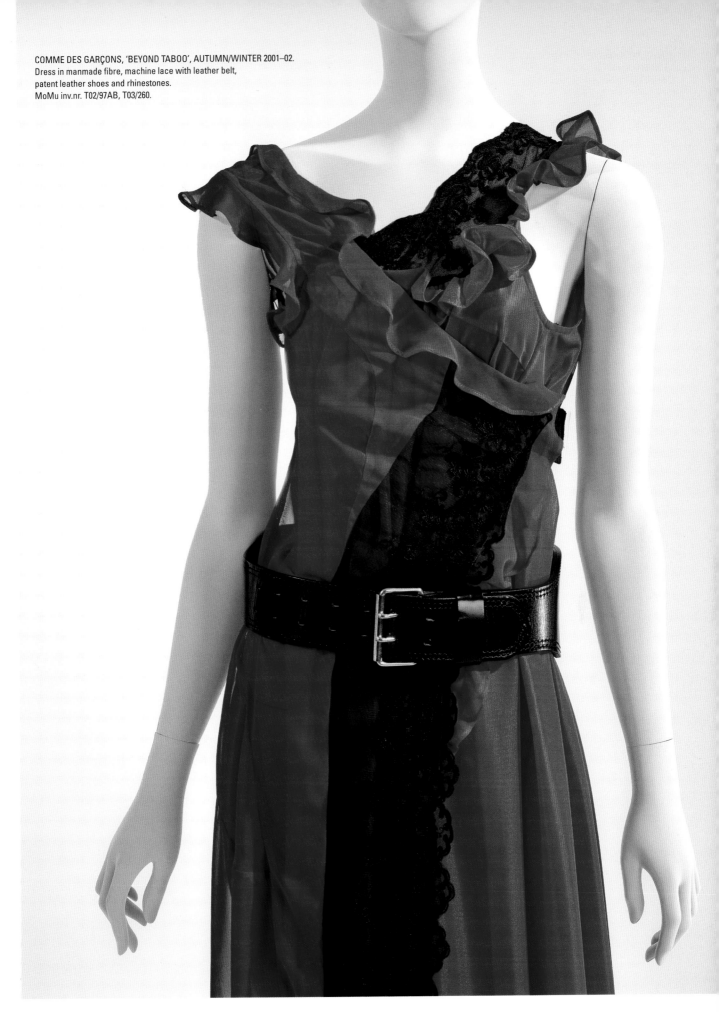

COMME DES GARÇONS, 'BEYOND TABOO', AUTUMN/WINTER 2001–02.
Dress in manmade fibre, machine lace with leather belt,
patent leather shoes and rhinestones.
MoMu inv.nr. T02/97AB, T03/260.

COMME DES GARÇONS, 'BEYOND TABOO', AUTUMN/WINTER 2000–01.
Dress in manmade silk, gauze, and machine lace,
patent leather shoes with rhinestones.
MoMu inv.nr. T03/256, T03/261.

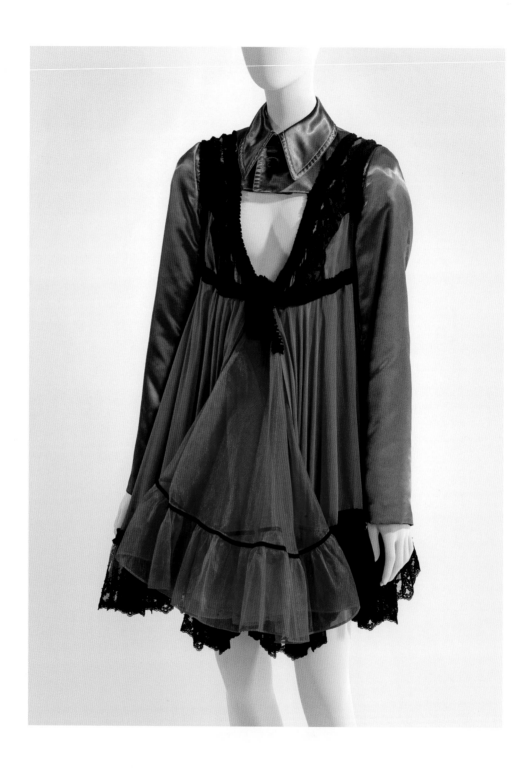

COMME DES GARÇONS, 'BEYOND TABOO', AUTUMN/WINTER 2001–02.
Jacket in imitation leather, cotton, and tulle and knitted woollen shorts.
MoMu inv.nr. T03/254AB.

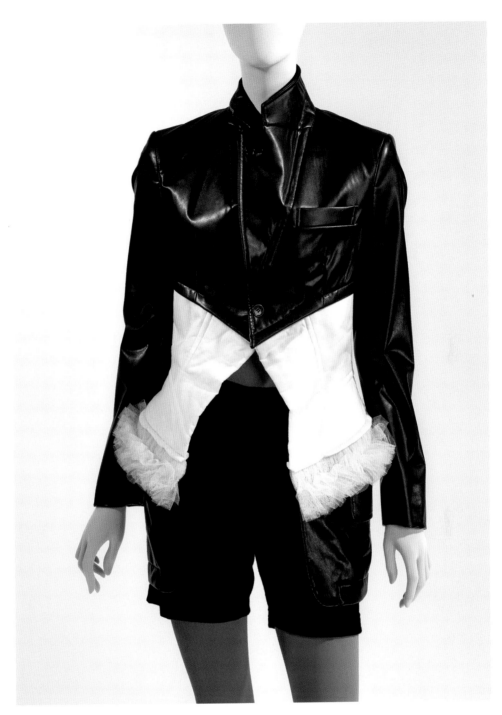

CHAPTER 7 — CULTURAL LIBERATION SPRINGING FROM PHYSICAL LIBERATION

ISOLDE PRINGIERS ON WEARING COMME DES GARÇONS
— HETTIE JUDAH

I first learned about Comme des Garçons in the 1980s when I was seventeen and studying in Japan. Fashion in Japan then was eclectic and very different to Western fashion. The Japanese economy was booming and I remember people used to spend enormous amounts on clothes, but had small living spaces: it was all about going out. I immediately took to the groundbreaking proportions and silhouettes of Issey Miyake. Gradually, I moved through different stages: from Miyake and Yohji Yamamoto in the second part of the 1980s, to Ann Demeulemeester, Romeo Gigli and Maison Martin Margiela at the beginning of the 1990s. I then moved on to Junya Watanabe and, increasingly, Margiela in the 2000s. I began acquiring more Comme des Garçons pieces from 2005, and collecting in a more structured way, going to the shows and visiting the showrooms. Not only did this give me first-hand access to the pieces I really wanted, it also gave me a comprehensive inside understanding of the collections.

I have always liked the idea of clothes as a kind of architecture and was drawn to how Rei Kawakubo went beyond the norm in all respects. I liked the clothes as housing for the body. I liked the humour and irreverence in them. I buy and wear almost exclusively runway pieces, as those are the purest and strongest. CDG clothes are first and foremost city clothes: they only seem to work in a cosmopolitan context, and only in certain seasons. The pieces that I have are difficult to style or combine since they are generally very voluminous. It is almost impossible to wear a coat or jacket over some of my dresses: other garments will have no sleeves or bizarre openings that make them impractical. Once I put on the clothes I usually forget I am wearing them. I have, however, experienced the occasional logistical difficulty: when driving a car, for example, or having to move sideways along the gangway of a plane because a skirt was too voluminous, or having a boyfriend ask me to follow him in a taxi because I wouldn't fit into his sports car.

I generally end up wearing CDG on evenings out in the art or fashion world. I usually style an extreme piece with something very simple like leather leggings or a pair of shorts, a singlet or turtleneck and simple pumps and perhaps one ring. I rarely wear 'total look' CDG and never the type of shoes they are shown with on the runway: I suppose I wear the garments in a more dressy way. CDG clothes also don't work very well in summer as they are often made of thick materials. A suitcase to travel to the tropics or to the South of France will almost never contain CDG items.

I feel myself in these clothes. Getting dressed for me has always been about getting the look that is as close as possible to my inner self at that moment and not the other way around. This means that while the silhouettes may sometimes seem extreme to others, I never feel overdressed in them. It is as if I recognize in the clothes the emotion of how I wish to be dressed. I suppose I wear them with confidence and when one does that they don't look out of place.

16581

Société Anonyme Louiseboulanger.

couture;

3, rue de Berri. Paris.

représentée par Melle. H. Vonin, 25, rue Vergenne. Versailles.

-:-:-:-:-:-:-:-:-:-:-

Photographie représentant un modèle de robe (Nº 10) compris dans
un dépôt de 29 Modèles.

Modèles déposés le 14 Février 1929 au Secrétariat du Conseil de
Prud'hommes de Paris (Tissus) sous le Nº 11707.

La publicité a été requise par la mandataire le 6 Janvier 1930.

Le dépôt a été ouvert le 15 Janvier 1930 pour être mis à la dispo-
sition du Public et du Tribunal s'il y a lieu.

L'épreuve photographique de ce modèle établie par les soins de l'Of-
fice National de la Propriété Industrielle, a été exposée dans la Salle
de Communication, a partie du 27 JANV 1930

-:-:-:-:-:-:-:-:-

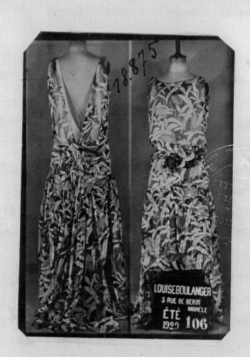

Nº 10 - Modèle 106.

Robe du soir en mousseline imprimée fond écru brun jaune décol-
leté en pointe dans le dos, corsage droit légèrement drapé à la taille
avec un noeud dans le dos jupe courte devant avec volants plats, panneaux
très longs dans le dos et franxx froncés, fleur sur le corsage devant.
Ce modèle est répété par la maison dans tous les tissus de toutes tein-
tes.
-:-:-:-:-:-:-:-:-:-:-:-:-:-

MORE GAME CHANGERS

— MIREN ARZALLUZ, ALEXANDRE SAMSON, KAREN VAN GODTSENHOVEN

LOUISE BOULANGER

On 25 December 1928, Marcel L'Herbier's film *L'Argent* (*Money*) was released. Portraying the dangers of financial speculation, this major film preceded, by ten months, a financial crash that would change the face of the twentieth century. Free from concerns of such an event, audiences watched the actress Brigitte Helm in the role of Baroness Sandorf, wearing a theatrical, silver lamé dress. The length, train and femininity of this glamorous dress put the short dresses so symbolic of the 1920s out of fashion in one fell swoop. Audiences, fashion journalists, and historians alike would consider this costume a precursor to the 1930s fashion of long, flowing garments highlighting the soft curves of the body. The dress was from the Parisian couture house Louiseboulanger.

Louise Boulanger (1878–1950) began her career in Paris as a designer for the Chéruit fashion house. She and husband Louis Boulanger created their label in 1923 by combining her first and his last names. The designs that appeared in fashion papers that summer were loyal to the spirit of the 1920s – flowing dresses masking the waist and the chest; skirts hardly covering the knees. Over the next decade, the house's tasteful creations would earn the respect of its contemporaries.

The popular long dress created for *L'Argent* would become even more famous, and influential when the couturière took the silhouette and used it in her summer collection, presented on 3 February 1929. Fashion in 1929 hinged on one point and one point only: whether to keep the short dress or make it longer. In early 1930, the press gave its verdict: 'The spell has been cast: long dresses are in.'[1]

This shift has historically been credited to Louise Boulanger. However, in making the dresses for *L'Argent* she was only following the instructions of costume designer Jacques Manuel. Furthermore, Jacques Manuel reveals that the couturière appeared reluctant to create a long dress.[2] One is left to wonder about the central role the couturière is supposed to have played in this change in silhouette, whilst other houses were presenting similar designs at the same time; for example, Jean Patou, whose 1929 evening dresses 'fall irregularly down to the floor, the leg being almost entirely hidden down to the ankle'.[3]

Film still from *L'Argent* (1928) by Marcel L'Herbier, featuring Louise Boulanger's famous long, asymmetric train dress.

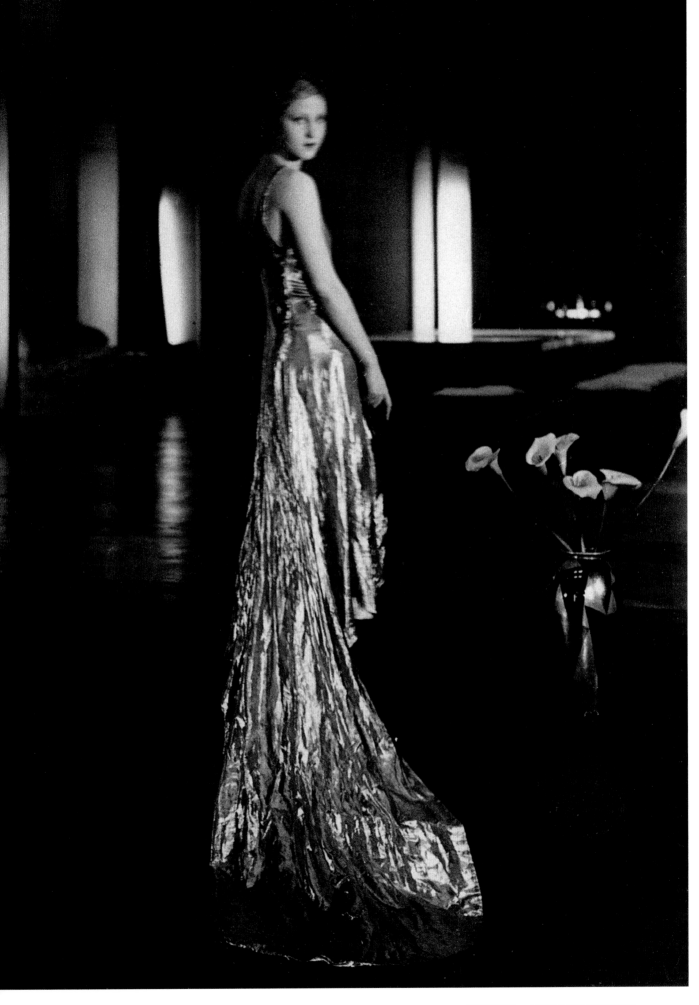

CHAPTER 8 — MORE GAME CHANGERS

Sandra wearing Courrèges glasses, 1965.

It seems, however, that this plunging dress, officially presented in the summer 1929 collection, bestowed a particular importance upon the couturière. Indeed, the only design that Louise Boulanger ever guarded against replication is a dress from this famous collection: 'Number 106', a printed muslin take on the film's dress, which was removed only eleven days after its presentation.

Although her role is contested today, Louise Boulanger nonetheless knew how to foresee and fuel the break with the fashion of the 'roaring Twenties', made necessary by fashion itself, by personifying the change brought about by the zeitgeist.

The Louiseboulanger label survived the 1929 crisis but her fame, at its height in the mid 1930s, would gradually decline until the house's closure in 1939.

ANDRÉ COURRÈGES

Born in Pau in 1923, André Courrèges reached Paris in 1945. Interested in fashion design, he began his career at fashion house Jeanne Lafaurie. In 1950, he joined the tailors' workshop at Balenciaga. Balenciaga, considered a master by his peers, earned the young tailor's admiration and respect.

In the summer of 1962, Courrèges presented the first haute couture collection bearing his name. The press praised the balance of his finely proportioned coats and the precision of his lines, but, most importantly, saw him as 'Balenciaga's disciple'.[1] Six collections went by in this way, without a hitch, until the 'bomb' of spring/summer 1965, when the public bore witness to an unprecedented futurist manifesto, more than just an haute couture collection.

His experimentation became more radical, breaking all ties with his earlier collections. While the 1920s liberated women's bodies by adopting men's ease as a model, Courrèges fuelled his own revolution by tapping into the dynamism of childhood. His reformed dresses play down the chest, eliminate the waist and uncover the knees in both miniskirts and hot pants. Trousers were for all occasions. Raw materials, such as the double woollen gabardine he had used since 1964, were adapted for a variety of garments, elongating the body in a sculptural way. The dynamic allure was accentuated by the flat ankle boots that the couturier had held dear since 1963. Cowboy-inspired hats created a silhouette that is hard to categorize, made all the more complicated by Arctic-style sunglasses with slits in them. An icy white, the colour of pure light, lit up all his garments, brightened here and there by vivid and acidic notes, found in stripes or inlaid.

Unusual for the history of fashion, the collection's success would be such that Courrèges would not give a show before the press until spring/summer 1967. The consistent couturier would continue his race for the pure line, this time spiced up by baby colours, the use of daisy

Courrèges, 1965.

Nicole De Lamargé in Cardin, 1967.

seeding and short suits. Always on the lookout for total freedom of movement, in 1969 Courrèges would present second-skin suits entirely made of white-sided jersey.

Courrèges's success was to appeal to young people by continuing to uphold the codes from his apprenticeship at Balenciaga. Inspired by Bauhaus doctrines whereby function determines the object, the couturier made his creations into a lifestyle, echoing a new generation's desire for freedom.

PIERRE CARDIN

Pietro Cardini was born in Italy in 1922, but it was in France, under the name Pierre Cardin, that he began his career as a tailor at the age of fourteen. In 1945 he went to Paris and joined the fashion house of Paquin, then Schiaparelli, before entering a new house in 1946: Christian Dior. Named head tailor, he contributed to the success of the first collection in summer 1947 which, dubbed the 'New Look', would influence fashion in the second half of the twentieth century.

Three years later he left Dior and bought the Pascaud house, which specialized in theatre costumes, an area in which Cardin had experience.

However, it was through his flawless work, praised by tailors, that he made a name for himself in the press from summer 1951 onwards. His discreet, supple and precise style offered an alternative to the sophisticated silhouettes of Dior and the architectural volumes of Balenciaga. Despite this, the influence of these two major couturiers would remain perceptible in Pierre Cardin's creations throughout the 1950s.

In 1958, Cardin's style evolved. For the winter collection, he worked more on the volume of certain areas, like the collar, aiming for a 'mushroom' shape. Changing the shape of one selected detail in this way would eventually spread to other parts of the body, sometimes touching on an abstraction for which the press would reproach him. In 1966, woollen dresses inlaid with targets or checks were accessorized with riding hats and hybrid hoods lined with swan down. These 'futurist' creations mark the beginning of an experimentation with volume, which Pierre Cardin would relentlessly continue to the present day. He would also create a material made of concentrated synthetic fibres – cardine – which could be heated and moulded into three-dimensional geometric shapes.

A laboratory experimenting with matter as well as volume, the Cardin house would additionally contribute to the evolution of the fashion world. Passionate about sociology, the couturier wanted to disseminate his creations outside of high society. From 1954 he developed an off-the-peg line called 'Eve', followed by 'Adam' in 1957. The following year, he launched the first unisex line in Paris. Although

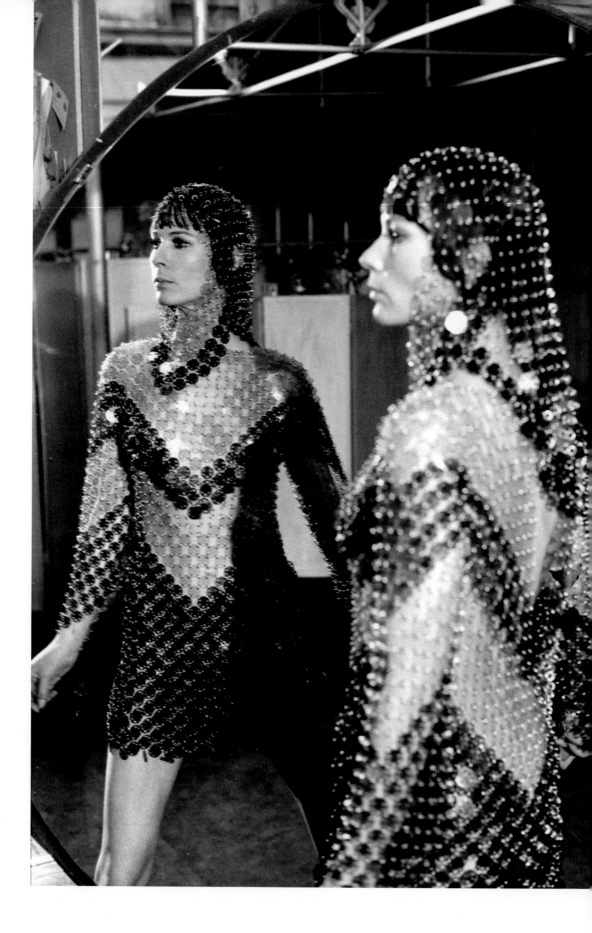

PACO RABANNE, 1969.

these iconoclastic experiments would cause him to be shunned by his peers, Cardin nonetheless stayed on track. He based a lucrative licensing system around Dior's model, spreading his name around the world, tapping into the potential of the Asian market four decades before anyone else, and becoming the first Paris-based fashion designer to take his brand to China in 1978.

Pierre Cardin created the 'futurist' fashion of the 1960s. His tailoring expertise, his – at times unbridled – ingenuity, and his talent for marketing make him a reference to which fashion today is indebted.

PACO RABANNE

I have always had the impression of being a time accelerator. Of going as far as is reasonable for one's time and not indulge in the morbid pleasure of the known things, which I view as decay. I talk of mutation, of the unquenchable thirst for novelty, and of permanent rupture. To be fixed in a concept is to become a living corpse.[1]

Paco Rabanne's words reflect his iconoclastic approach to fashion, marking his work from the beginning to the end. His commitment to questioning established ideas about dress, his experimentation with unconventional materials, and his architectural vision were at the heart of some of the most iconic designs of the twentieth century.

Rabanne's characteristic resilience and combative temperament were forged very early in life. After fleeing the Spanish Civil War, the young Paco moved to Paris in 1952, where he initiated his studies in architecture. For over ten years he combined his studies with designing accessories for reputed houses such as Balenciaga, Courrèges, Pierre Cardin, and Givenchy. Rabanne's mother had worked for Cristóbal Balenciaga as a head seamstress in his San Sebastian atelier before the war forced them both to leave. However, it was Rabanne's determination and use of materials that encouraged Balenciaga to incorporate Rabanne's designs into his couture creations of the late 1950s and early 1960s. Years later Paco Rabanne would repeatedly acknowledge his admiration and creative debt to Balenciaga's pure and architectural vision, considering himself 'one of his disciples' and 'a member of his school, a school of rigour and exactitude'.[2]

On 1 February 1966, Rabanne presented at the Hôtel George V his first 'Manifesto' collection, '12 Unwearable Dresses in Contemporary Materials', in which twelve barefoot models paraded clad in scandalous outfits, made entirely of rhodoid sequins and plaques linked together with metallic rings. The choice of such an ignoble and inappropriate material as rhodoid (a type of rigid plastic) was in line with the Dada and Panique movements favoured by Rabanne in his early years. His penchant for the uncommon grew more radical in successive collections, especially from 1968 onwards, with his use of metal, the material of discomfort par excellence. His metallic dresses were viewed by many as incompatible with the search for freedom for

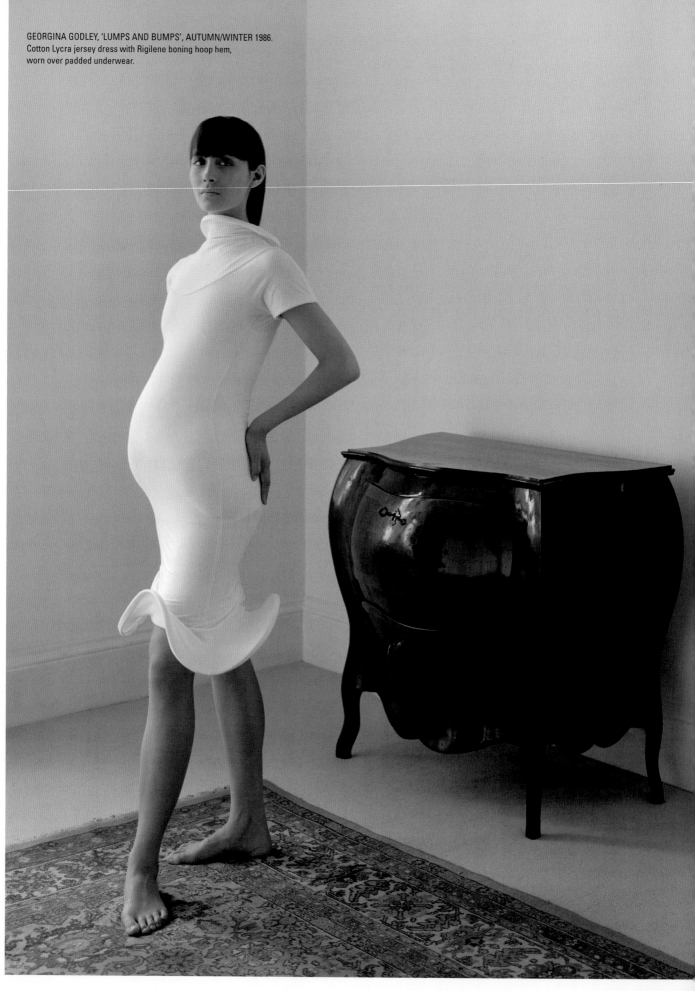

GEORGINA GODLEY, 'LUMPS AND BUMPS', AUTUMN/WINTER 1986.
Cotton Lycra jersey dress with Rigilene boning hoop hem,
worn over padded underwear.

movement that characterized the work of most designers of the time. Rabanne explained:

In my view, fashion is a reflection of a political, social and artistic moment. [...] I was disheartened by the discrepancy between the innovations achieved by painters and sculptors and the incredible conformity which reigned within this metier. Therefore, I tried to bring in the modern elements that had not yet entered this art, which was self-contained and oblivious of its times. This is why I've worked with plastic, leather, metal ...[3]

Paco Rabanne remained an irremediable iconoclast, loyal to the principles that guided his revolutionary work, until his retirement in 1999.

GEORGINA GODLEY

Georgina Godley, a British fashion designer whose design career spanned the larger part of the 1980s, can be situated in the culture clash of London's post-New Romantic, pre-Yuppie, club-going and gender-blurring scene. Coming to fashion as an intellectual outsider, she graduated in Fine Arts from Brighton and Chelsea art colleges, where she experimented with clothing as fine art and the female form. However, it was mostly her own love for dressing up, clubbing and the performative aspect of fashion which made her gravitate towards fashion, as a less elitist and more direct form of expression than the art world. Godley started to work as a freelance designer for Brown's, first making mannequins and later as an assistant designer at Brown's menswear, learning the technical aspects of tailoring and pattern cutting. She opened a shop in Dover Street with her partner, Scott Crolla in 1981, selling clothes for 'the New Man', London dandies, juxtaposing Savile Row tailoring and textiles made by craftswomen from Wales. In 1984, she started designing women's clothes under the Crolla brand, flying in the face of the 1980s athletic female appearance which required women to relinquish their femininity by wearing shoulder pads, aggressive heels and sport torsos like male athletes. Godley's silhouettes were nostalgic, with oversized chintz roses and floral patterns.

In 1986, Godley split from Crolla and presented her first solo collection, 'Body and Soul', which consisted of a body dress, a soul dress and a muscle dress. The stretch Lycra fabrics (new at the time) were draped and stretched over the body, celebrating and exaggerating women's curves. The dresses curved out below with a hooped hem, giving a Space Age romantic twist to the silhouette. In January 1986 she came out with 'Lumps and Bumps', inspired by a study of African fertility dolls. The padded underwear became a sculptural and surreal dilation of women's curves.

The garments could be inhabited by the female form as an expression of fecundity and power. For this collection, Godley took Barbie dolls ('a horrible distortion of the female form') and modelled

GEORGINA GODLEY, SPORT COUTURE, AUTUMN/WINTER 1990.
Pale blue suede, cropped goose-feather-filled puffer jacket.

clay on them until they felt right. This approach led to padded shapes which could be slipped on and off the Lycra. She developed four shapes, of which two were produced commercially: an aestheticized pregnant belly with an indent at the pelvis and an asymmetric pannier that gave a growth on the right side shaped down to the seat and hip on the left. Although her clothing was regarded as highly conceptual and as a collector's item at the time, Godley's bold, womanly shapes provided a creative exit from the choice between 1980s shapelessness or sexiness. She paved the way for further explorations of the relationship between the female body and garment in the 1990s.

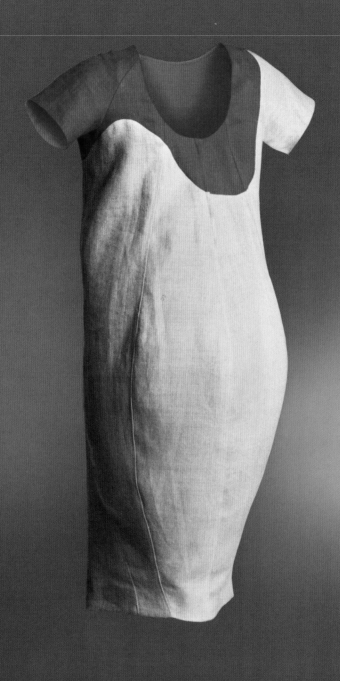

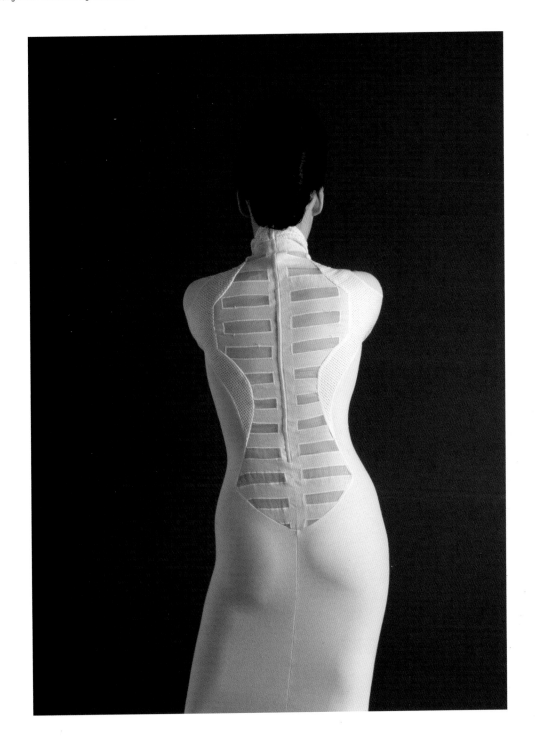

CHAPTER 8 — MORE GAME CHANGERS

GEORGINA GODLEY, SPORT COUTURE, AUTUMN/WINTER 1990.
Suede backpack corset top.

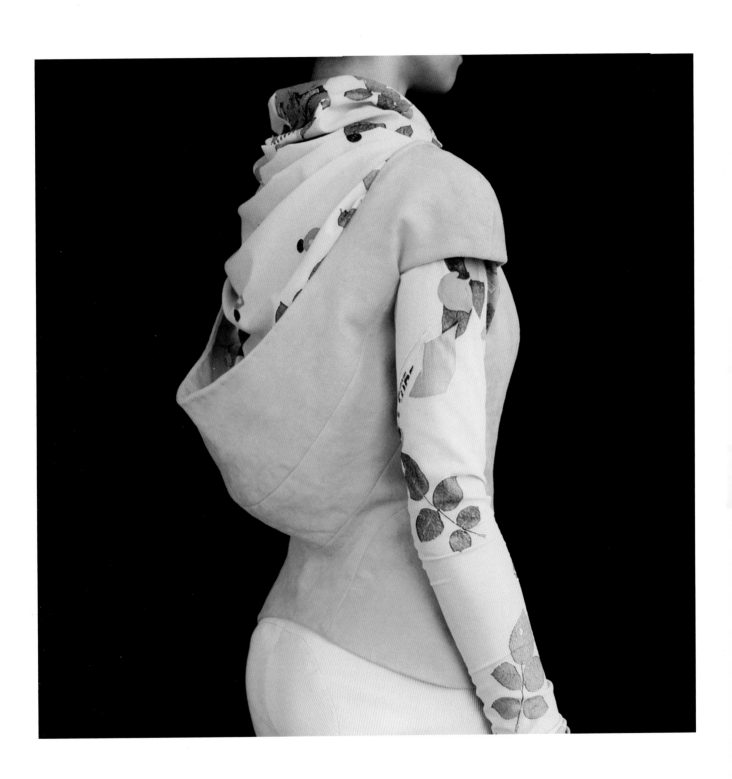

CHAPTER 8 — MORE GAME CHANGERS

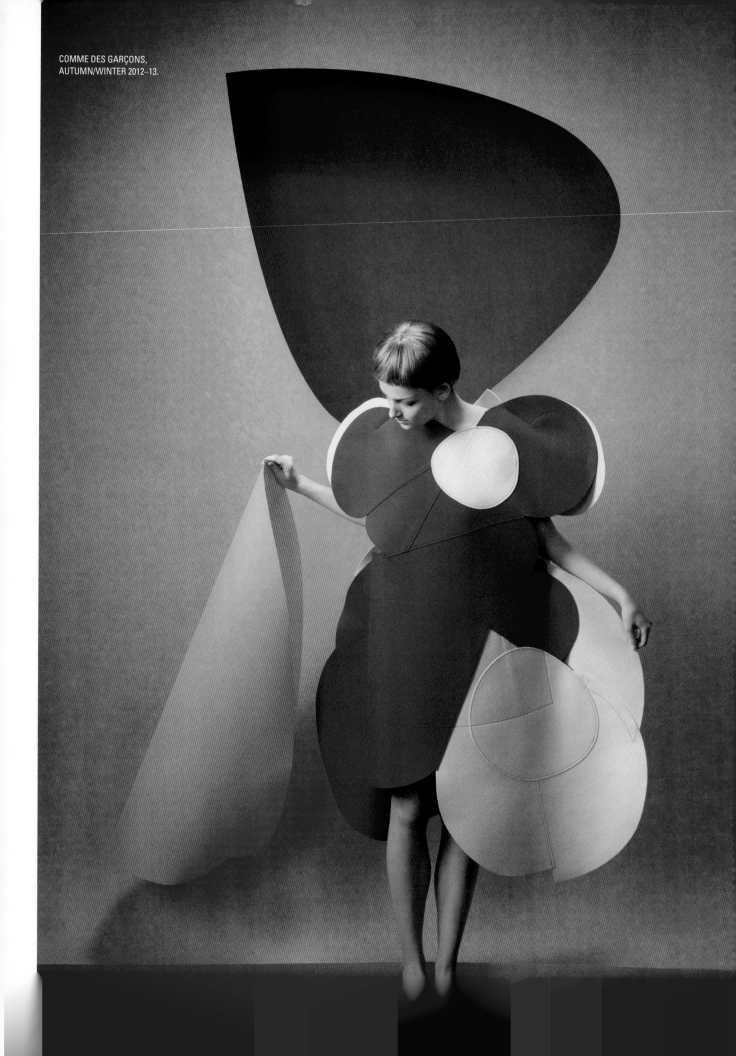

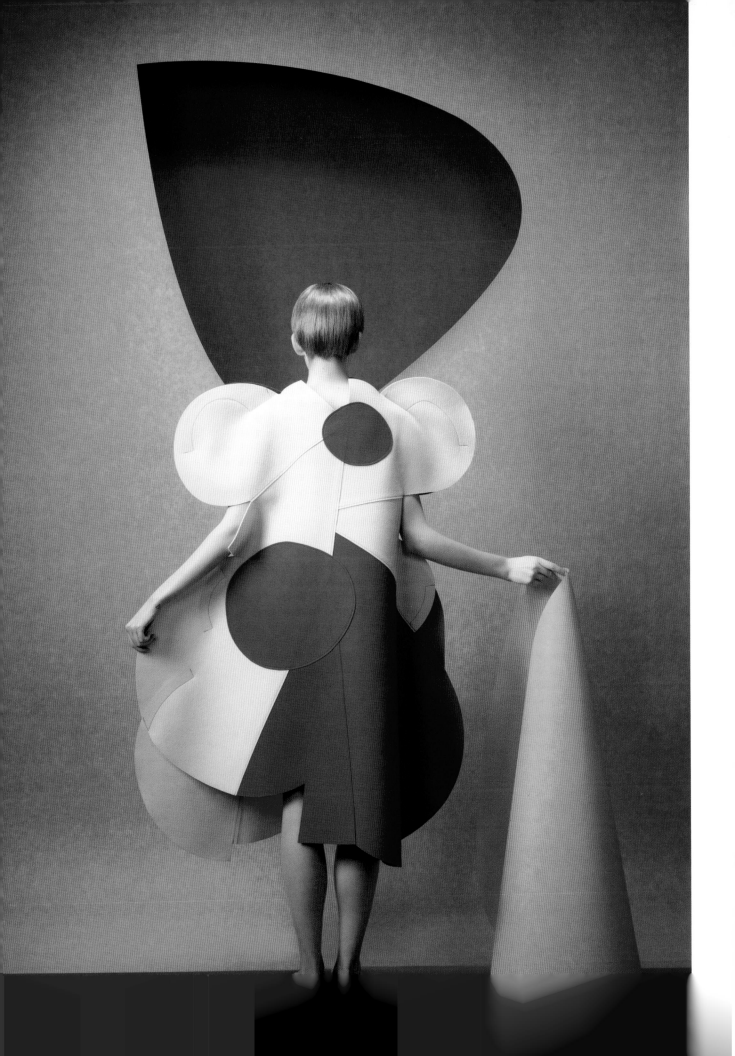

ENDNOTES

CHAPTER 2

1. V. Leduc, 'Balenciaga', *Vogue* (US) (15 April 1965), 83.
2. Ibid.
3. R. Hargrove, 'Wasp Waists and (Sh-h-h!) Hips Stressed by Paris', *The Independent Record* (5 March 1939), 11.
4. 1942E000D00040-CC01, Balenciaga Archives, Paris.
5. For the early personal and professional development of Cristóbal Balenciaga, see M. Arzalluz and L. Miller, *Cristóbal Balenciaga: The Making of a Master (1895–1936)* (London: V&A Publishing, 2011).
6. Based on Cristóbal Balenciaga's own testimony from an interview for *Paris Match* magazine following the closure of Maison Balenciaga in 1968. V. Merlin, 'Balenciaga devient un visage', *Paris Match* (no. 1005, 10 August 1968).
7. *El Liberal* (1 November 1918), 4.
8. CBM 2005.12, based on the 'Marguerite de la nuit' design by Jeanne Lanvin, from her summer 1929 collection.
9. P. Glynn, 'Balenciaga and la vie d'un chien', *The Times* (3 August 1971).
10. M. De Mun, 'Páginas amenas de la Perfumería Floralia', *La Esfera* (10 March 1917), 167.
11. Ibid.
12. Duplicated in A. de la Haye and S. Tobin, *Chanel: The Couturiere at Work* (London: Victoria & Albert Museum, 1994), 17.
13. Tobé report (10 February 1955), B.
14. Ibid.
15. B. Kirke, *Madeleine Vionnet* (San Francisco: Chronicle Books, 1998), 103–105.
16. C. Snow, 'Carmel Snow's Paris Report', *Harper's Bazaar* (March 1955), 131.
17. Tobé report (15 August 1957), A.
18. S. Irvine, *Vogue on Cristóbal Balenciaga* (London: Quadrille Publishing Ltd, 2013), 24.

CHAPTER 3

1. B. English, *Japanese Fashion Designers. The Work and Influence of Issey Miyake, Yohji Yamamoto and Rei Kawakubo* (London, New York: Berg, 2011), 70.
2. R. Pope, *Creativity: Theory, History, Practice* (Abingdon and New York: Routledge, 2005), 103.
3. D. Sudjic, *Rei Kawakubo and Comme des Garçons* (London: Fourth Estate, 1990), 43–4.
4. Different authors stress the link between creative freedom and auto-didacticism: 'It becomes difficult for those who are trained to break the mould of conventions that define a quality garment. It is probably not a coincidence that Kawakubo was never trained as a fashion designer.' Y. Kawamura, *The Japanese Revolution in Paris Fashion* (Oxford: Berg, 2004), 134.
5. Harold Koda, 'Rei Kawakubo and the Art of Fashion' in *ReFusing Fashion: Rei Kawakubo*, ed. L. Dresner, S. Hilberry and M. Miro (Detroit: Museum of Contemporary Art, 2008), 30.
6. P. Golbin, *Madeleine Vionnet: Puriste de la Mode*, tent. cat. (Paris: Les Arts Décoratifs, 2009), 24.
7. Ibid., 26.
8. A. de la Haye, *Chanel, Couture and Industry* (London: V & A Publishing, 2011), 26.
9. H. Koda and J. G. Reeder, *Charles James: Beyond Fashion* (New York: Metropolitan Museum of Art, 2014), 54.
10. H. Koda, *Extreme Beauty: The Body Transformed* (New York: Metropolitan Museum of Art, 2001), 12.
11. Kawamura, *The Japanese Revolution in Paris Fashion*, 147.
12. Georgina Godley, a British fashion designer who was mostly active in the avant-garde fashion scene of London in the 1980s, might be less known than the other designers discussed here, but this chapter aims to shed new light on her oeuvre because her designs and artistic influences were very important for the changing perspective on the female body and the relationship be-

tween body and garment in the 1980s.

13. Rob Pope points towards the collective roots of the latin word genius, closely associated with the collective identity of the tribe, kin or family (gens, ingens) and more particularly with tribal or family spirits (*genii*). Pope, *Creativity*, 101.

14. Judith Thurman, 'The Misfit' in *ReFusing Fashion: Rei Kawakubo*, ed. L. Dresner, S. Hilberry, and M. Miro (Detroit: Museum of Contemporary Art, 2008), 71.

15. Kawamura, *The Japanese Revolution in Paris Fashion*, 146.

16. 'From a design and technical perspective, Kawakubo's works are beyond our comprehension and also unbelievable for those of us who were professionally trained in fashion schools.' (Ibid., 133–4.)

17. Koda, 'Rei Kawakubo and the Art of Fashion', 31.

18. 'Once she gave us a piece of crumpled paper and said she wanted a pattern for a garment that would have something of that quality.' D. Sudjic, *Rei Kawakubo and Comme des Garçons* (London: Fourth Estate, 1990), 34; 'all Miyake said to the woman at the head of his fabric studio one season was the word "clouds".' Kawamura, *The Japanese Revolution in Paris Fashion*, 147.

19. Thurman, 'The Misfit', 66.

20. Arzalluz, *Cristóbal Balenciaga: The Making of a Master*, 21.

21. De la Haye, *Chanel, Couture and Industry*, 24.

22. Yamamoto's mother was a war widow.

23. Thurman, 'The Misfit', 62.

24. Cathy Horyn writes, 'Kawakubo proposed that women were strong and self-determined. Demeulemeester, born a generation later, just assumed that they were.' I. Loschek, *When Clothes Become Fashion: Design and Innovation Systems* (Oxford, New York: Berg, 2009), 144.

25. See A. Fukai, *Future Beauty: 30 Years of Japanese Fashion* (London: Merrell Publishers Limited and Barbican Art Gallery, 2010); A. Fukai, 'Japonism in Fashion', *Japonism in Fashion* supervised by A. Fukai (Kyoto: National Museum of Modern Art Kyoto Costume Institute, 1996); A. Fukai, 'Visions of the body: Fashion or Invisible Corset', *Visions of the Body* supervised by Shinju Kohmoto and Akiki Fukai (Kyoto: Kyoto Costume Institute, 1996).

26. Kawakubo: 'I don't understand the term body conscious very well… I enter the process from interest in the shape of the clothing and the feeling of volume you get from the clothing, which is probably a little different from the pleasure Western women take in showing the shapes of their bodies. It bothers Japanese women…' and 'form fitting fashions are quite boring, I design for women who are beyond that.' Kawamura, *The Japanese Revolution in Paris Fashion*, 137.

27. Chanel's nickname for Dior's historicist New Look.

28. 'Fashion, which had pursued the vanishing waistline until it could go no further, began to feel its way toward a different source of inspiration. It was then that the chiton and kimono came onto the scene. Cloth fell from a woman's shoulders, creating a beautiful, smooth form that flowed from the natural drape of the fabric.' Kohmoto and Fukai, *Visions of the Body*.

29. Fukai, *Future Beauty*, 16.

30. Arata Isuzaki, 'What are Clothes?' in *Issey Miyake: East Meets West*, ed. K. Koike (Tokyo: Heibonsha, 1978), 55.

31. S. Irvine, *Vogue on Cristóbal Balenciaga* (London: Quadrille Publishing Ltd, 2013), 101.

32. English, *Japanese Fashion Designers*, 27.

33. Miyake innovated the pleating technique in 1983 by first cutting and sewing a piece of cloth that was nearly three times larger than the size of the final garment, and then permanently pleating the cloth, instead of first pleating the fabric.

34. Michael Stone-Richards, 'I am a cat: A Dossier on Comme des Garçons and Surréalisme' in *ReFusing Fashion: Rei Kawakubo*, ed. L. Dresner, S. Hilberry, and M. Miro (Detroit: Museum of Contemporary Art, 2008), 111.

35. B. Vinken, *Fashion Zeitgeist: Trends and Cycles in the Fashion System* (Oxford: Berg, 2005), 103.

36. Personal conversation with Ann Demeulemeester, September 2015.

37. Vinken, *Fashion Zeitgeist*, 141.

38. Ibid., 45.

39. English, *Japanese Fashion Designers*, 54.

40. Vinken, *Fashion Zeitgeist*, 23.

41. Ibid., 31.

42. 'Haute couture creates a reproducible, idealistic design and fits this on the individual body to hide its weaknesses. Margiela traces the ideal figure of the dummy on the individual body, which

appears as a divergence from ideality.' Ibid., 144.

43. Interview with Georgina Godley, July 2015.

44. Suzy Menkes calls Godley's work, as a reclaiming of misogynistic surrealist techniques, a feminist victory. S. Menkes, 'The Flesh and fabric of surrealist design', *The Age* (24 August 1988).

45. The full version according to the press release was: 'Body Meets Dress, Dress Meets Body and become one'.

46. Comme des Garçons press release, 1997.

47. Rei Kawakubo, quoted in English, *Japanese Fashion Designers*, 82.

48. Adrian Joffe, quoted in J. Thurman, 'The Misfit' *The New Yorker* (4 July 2005).

49. Sotheby's website, describing an auction of a 1997 Comme des Garçons dress, July 2015 http://www.sothebys.com/en/auctions/ecatalogue/2015/collection-didier-ludot-pf1570/lot.151.html (accessed 25 November 2015)

50. Merce Cunningham, quoted in Koda, 'Rei Kawakubo and the Art of Fashion', 34.

51. Jake Hall, 'Body Meets Dress, Dress Meets Body', *StyleJourno* blog (18 July 2013), http://stylejourno.blogspot.be/2013/07/body-meets-dress-dress-meets-body.html

52. Kawamura, *The Japanese revolution in Paris fashion*, 142.

53. Kate Betts, 'Women in Fashion' *Time* magazine (9 February 2004).

54. G. Wood (ed.), *Surreal Things: Surrealism and Design* (V&A Publishing, 2007), 178.

55. Stone-Richards, 'I am a cat', 110.

56. Ibid., 111.

57. Rainer Maria Rilke, *Duino Elegies, The Eighth Elegy*, 1923, translated by AS Kline, 2004.

58. Diana Crane in Kawamura, *The Japanese Revolution in Paris Fashion*, 130.

59. 'Now anti-fashion is of course, a major part of the history of fashion. [...] a crucial part of fashion is the turning of anti-fashion statements into fashion. Fashions are, as it were, propelled forward by their criticism.' M. Wigley, *White Walls, Designer Dresses: The Fashioning of Modern Architecture* (Cambridge, MA: Massachusetts Institute of Technology, 1995), XXIII.

CHAPTER 4

1. Haiku attributed to Sora in *Matsuo Basho, The Narrow Road to the Deep North and other Travel Sketches* (London: Penguin Classics, 2005), 122.

2. Polly Mellen, *Washington Post* (16 October 1982), quoted in A. Fukai, 'Japan and Fashion', in *The Power of Fashion – About Design and Meaning* ed. J. Brand, J. Teunissen and A. Van Der Zwaag (Arnhem: Terra Lannoo BV and ArtEZPress, 2006), 291.

3. '*Wabi-sabi* refers to the beauty of the imperfect, transitory and unfinished things. It refers to the beauty of the unpretentious, simple and unconventional. It is anti-rationalistic and implies an intuitive world view; it aims at individual solutions that are specific to every object; uniqueness instead of mass production; organic forms; toleration of neglect and wear; corrosion and contamination used to intensify the expression; ambiguity and contradiction; suitability being less important. Beauty can be enticed out of ugliness.' Leonard Koren, *New Fashion Japan* (Tokyo: Kodansha Internacional, 1984), quoted in English, *Japanese Fashion Designers*, 148.

4. Jamie Huckabody, 'Perfection is an Ugly word', *i-D* (no. 219, April 2002), 147, 151, quoted in F. Bonnet, *Playing with Limits: A Couture of Excess. Yohji Yamamoto – An Exhibition Triptych* (The Press, 2006), 8.

5. Mark O'Flaherty, 'In the Black', *Financial Times Weekend* (11 October 2009), quoted in English, *Japanese Fashion Designers*, 146.

6. L. Derycke and S. Van de Veire, eds., *Belgian Fashion Design* (Bruges, Belgium: Ludion Press, 1999), 303, quoted in English, *Japanese Fashion Designers*, 148.

7. U. Lehmann, T*igersprung: Fashion in Modernity* (MIT Press, 2001), 301.

8. '[...] *Tigersprung* – the tiger's leap which was employed as a "dialectical image" by Walter Benjamin in the late 1930s to attack the prevalent view in evaluating cultural objects from the past and contemporary philosophy of history', U. Lehmann, '*Tigersprung*: Fashioning History' in *The Power of Fashion*, 43.

9. U. Lehmann, *Tigersprung: Fashion in Modernity*, xviii. Lehmann, '*Tigersprung*: Fashioning History', 47, 52.

10. A. Fukai, 'Japan and Fashion', 291.

11. Paul Poiret (1879–1944) epitomized Orientalism, a colourful, liberating and innovative trend

characterized by the integration of diverse themes and cultures.

12. Mariano Fortuny (1871–1949) developed fabric production and draping techniques, gowns inspired by ancient Greek dresses (like the emblematic Delphos) worn without corset, and kimono coats.

13. Grès (1903–93) explored the sculptural possibilities of draped cloth, taking inspiration from classical antiquities. Her work relies on sophisticated draping techniques, the fabric gathered into obsessively fine pleats, echoes of the classical drapery found on Roman and Greek statuary, particularly referencing the chiton of ancient Greece and sometimes the vestments of Japanese monks.

14. The classical techniques of garment construction respected the width of cloth and used minimal cutting. Madeleine Vionnet (1879–1944) combined these methods with non-Western techniques. Vionnet adapted kimono sleeves to use in Western dress, thus providing deeper armholes and ease of movement. The designer, credited to be the inventor of the bias cut (where the fabric is cut on the diagonal, at 45 degrees to the grain, rather than along it), worked directly onto a half-size mannequin, draping, pinning and cutting the cloth around the form of the body.

15. With his purist and abstract lines, Cristóbal Balenciaga (1895–1972) bridges the modern silhouettes of the avant-garde and the post-modern Japanese and Belgian movements.

16. R. Knafo, 'The New Japanese Standard: Issey Miyake', *Connoisseur* (March 1988), 108, quoted in English, *Japanese Fashion Designers*, 21.

CHAPTER 5

1. Examples include James Abbott McNeill Whistler, *Rose and Silver: The Princess from the Land of Porcelain (1863–64)*, Freer Gallery; James Joseph Jacques Tissot, *La Japonaise au Bain* (1864), Museum of Fine Arts Dijon; Dante Gabriel Rossetti, *The Loved One* (1864–65), Tate Gallery.

2. Ernest Chesneau, 'Le Japon à Paris-1', *Gazette des Beaux Arts* (1 September 1878), 387.

3. Ibid.

4. Shuji Takashina, 'Revised: Eyes on Japanese Art (*nihonbijutsu o miru me*)', *Iwanami Gendai Bunko* (2009), 78.

5. Kimono was called 'Japonse Roken' in Holland at that time, seen in seventeenth-century Dutch paintings and housed in museums.

6. Refer to Note 1.

7. *Journal des Demoiselles* (October 1867).

8. There are examples held at the Musée de la mode de la Ville de Paris, Palais Galliera, The Kyoto Costume Institute and others.

9. Refer to Renoir's painting of *Madame Hériot* (1882), Kunsthalle, Hamburg, Balzac's novel *Bel-ami* (1885) and others.

10. Laura Dimitrio, 'La naissance du japonisme dans la mode italienne', *Dresstudy*, bulletin of The Kyoto Costume Institute (vol. 63, spring 2013).

11. He released photo advertisements for fifteen months from December 1904 to February 1906.

12. 'Depuis que le *Figaro-Modes* a parlé des délicieux costumes d'intérieur que M. Babani a spé-cialement, à l'usage des Parisiennes, emprunté au Japon, c'est devenu le cri du jour: les femmes élegantes ne veulent plus entendre parler que du Kimono, et comme elles ont raison! Peut-on en effet rêver un vêtement tout à la fois plus gracieux, plus commode et plus confortable que ces amples soieries qui enveloppent avec tant de séduction la silhouette d'une femme sans meme gêner aucun de ses mouvements? […]' (emphasis added by author). Abridged translation: 'Since the *Figaro* has mentioned the delightful house costumes that Mr Babani has borrowed especially from Japan for Parisian ladies, these have become a must have. Elegant ladies only want to hear about the Kimono, and rightfully so! Can one but dream of a more graceful and comfortable garment than these loose silks which envelop with such seduction the contours of a woman without hindering her movements?)'. 'La Mode at home', *Figaro-Modes*, (no. 26, 15 February 1905), 17.

13. Paul Poiret, *En Habillant l'Époque* (Paris: Grasset, 1930), 49.

14. Yvonne Deslandres, *Poiret* (Paris: Editions du Regard, 1986), 151–2.

15. Japanese-themed plays and operas were continually performed from the latter half of the nineteenth century such as *Mikado* in London, in 1885, 'ma camarade' (the popular actress, Réjane, wore kimono), in 1900, the Parisian performance of *Sadayakko*, who made the front cover of the October 1900 issue of *Le Théâtre*, a theatrical performance magazine. In 1907, Judith Gautier's *Princesses d'amour* and *Madame Butterfly* were put on and the Japanese

actress, Hanako, performed at a small theatre in Paris.

16. *Les Modes* (March 1907).

17. Betty Kirke wrote in *Madeleine Vionnet* (Kyuryudo, 1998), 32–33, that kimono sleeves were incorporated into Western clothing because of Mrs Gerber of the Callot Sœurs.

18. B. Kirke, *Madeleine Vionnet* (Kyuryudo, 1998), 46.

19. Ibid., 48.

20. Ibid., 22, 53.

21. R. Martin, H. Koda, *Orientalism: Visions of the East in Western Dress* (New York: The Metropolitan Museum of Art, 1994), 74.

22. 'Ideal art crosses off the small, feeble animal-like life tissue – blood vessels, wrinkles, lanugo hair, etc. – that appears when modelling various parts of the human body and greatly projects the spiritual forms among the contour lines that pulsate from life and that work will be incorpo-rated into the clothing here. What clothing hides is obviously necessary for personal preservation of the body and digestion but it's a useless and superfluous organ for spiritual expression.'
G. W. F. Hegel, *Aesthetics: Lecture on Fine Art* trans. Hiroshi Hasegawa (Sakuhinsha, 1996), 347.
G. W. Hegel, *Aesthetics: Lecture on Fine Art*, trans. T. M. Knox (Oxford: Clarendon Press, 1975), 744–5.

23. Miren Arzalluz points out Vionnet's influence on Balenciaga in *Cristóbal Balenciaga: The Making of a Master*.

CHAPTER 7

1. Editor of arts and architecture for *Village Voice*, 1981–95.

2. Design and architecture critic for *The Observer* and co-founder, in 1983, of the architectural and design magazine *Blueprint*.

3. Such as Mark Lebon, 'Love in London (playing host to the world)', *i-D* (July 1985), 32, 33, 35.

4. Notable examples are Max Vadukul's early catalogue shoots for Yohji Yamamoto in which he was given free creative rein and captured the garments against the textures of the city.

5. B. Morris, 'Tokyo Savoir-Faire', *New York Times* (25 August 1985).

6. Published in *Re-Made in Japan: Everyday Life and Consumer Taste in a Changing Society*, ed. Joseph J. Tobin (Yale: Yale University Press, 1992).

7. V. Carnegy, *Fashions of a Decade: The 1980s* (Batsford, 1990).

8. 'A Wave or a Trickle? You've heard about it but will you buy?', *Village Voice* (19 April 1983).

9. Which in the majority of cases, is to say not nearly as much as she'd have liked. Sexism in the workplace was still rife, an issue delightfully skewered in comedies of the era such as *Nine to Five* (1980), and sexual aggression toward women high, as outlined in 'Danger: Women at Work', a campaigning editorial in *Elle* UK in January 1987: 'Women are called on to be both tough and tender, sweet and successful, often with near-disastrous consequences.'

10. B. Polen, 'I'm a Feminist but…', *Elle* UK (November 1986).

11. Quoted in John Duka, 'Yohji Yamamoto Defines his Fashion Philosophy', *New York Times* (23 October 1983).

12. A written statement delivered on behalf of Kawakubo by her design team to Nicholas Coleridge. Quoted in Coleridge, *The Fashion Conspiracy* (Portsmouth: Heinemann, 1988).

13. 'A Wave or a Trickle? You've heard about it but will you buy?', Village Voice (19 April 1983).

14. D. Claridge, 'Meanwhile … on the other side of the Pacific', *i-D* (no. 6, 1982).

15. Ted: 'Ted only wears black except when he is in the home, then he wears pink.'/Julia: 'I'd buy my clothes from M&S if they were black', both featured in 'Straight Up', *i-D* (no. 4, 1981).

16. C. McDowell, *Colin McDowell's Directory of Twentieth Century Fashion* (London: Frederick Muller, 1984).

17. S. Orbach, *Fat is a Feminist Issue* (New York: Paddington Press, 1978).

18. 'Some people call Japanese-designed clothing intellectual clothing. Is that a polite way of saying they don't like it? It's like looking at a baby and saying it's intelligent rather than cute.' Barbara Weiser, co-owner of the Charivari boutiques in New York that were early champions of the designs of Issey Miyake, Comme des Garçons and Yohji Yamamoto, quoted in 'A Wave or a Trickle? You've heard about it but will you buy?' *Village Voice* (19 April 1983).

19. There is a pricelessly bitchy interlude in Nicholas Coleridge's *The Fashion Conspiracy* where he has lunch with Meredith Etherington Smith, the London correspondent of *Women's Wear Daily*, and the pair sit watching the entire editorial team of *Elle* at an adjacent table all dressed

head to toe in black Japanese-designed garments. '"The trouble with Yohji's clothes," said Meredith, "is you can't get out of them in a hurry. Do you suppose those girls get any sex at all?"' Coleridge, *The Fashion Conspiracy*.

CHAPTER 8

PACO RABANNE
1. Lydia Kamitsis, 'Entretien de Paco Rabanne', in *Paco Rabanne* [exhibition catalogue] (Marseille: Musée de la Mode, 1995), 10.
2. Lydia Kamitsis, 'Entretien de Paco Rabanne'.
3. *Le Fait Publique* (March 1969), cited in Lydia Kamitsis, 'L'oeuvre hors norme', in *Paco Rabanne* [exhibition catalogue] (Marseille: Musée de la Mode, 1995), 14.

LOUISE BOULANGER
1. *La Femme de France* (16 February 1930).
2. Guillaume Garnier, 'Quelques couturiers. Quelques modes' in *Paris Couture, Années 30* [exhibition catalogue] (Paris Musées, 1987), 9.
3. *L'Officiel de la Couture et de la Mode de Paris* (no. 91, March 1929), 19.

ANDRÉ COURRÈGES
1. *L'Officiel de la Couture et de la Mode de Paris* (September 1962), 79.

BIBLIOGRAPHY

BOOKS

Arizzoli-Clémentel, P., M. Arzalluz, L. Cerillo Rubio, M. A. Jouve. *Balenciaga: Cristóbal Balenciaga Museoa*. San Sebastian: Fundacion Cristóbal Balenciaga Fundazioa & Nerea, 2011.
Arzalluz, M. and L. Miller. *Cristóbal Balenciaga: The making of a master (1895–1936)*. London: V&A Publications, 2011.

Bashô, M. *O Gosto Solitário do Orvalho/O Caminho Estreito*. Lisbon: Assírio & Alvim, 2003.
Bénaïm, L. *Fashion Memoir: Issey Miyake*. London: Thames and Hudson Ltd, 1997.
Benjamin, W. *The Arcades Project*. Cambridge: Harvard University Press, 2002.
Blume, M. *The Master of Us All: Balenciaga, His Workrooms, His World*. New York: Farrar, Straus and Giroux, 2013.
Bonnet, F. *Playing with Limits: A Couture of Excess. Yohji Yamamoto – An Exhibition Triptych*. Firenze: Correspondences, 2006.
Brand, J., J. Teunissen and A. Van Der Zwaag (eds.). *The Power of Fashion – About Design and Meaning*. Arnhem: Terra Lannoo BV and ArtEZPress, 2006.
Bunka Gakuen, *Fukushoku Hakubutsukan. Nihon fukushoku no bi: Bunka Gakuen Fukushoku Hakubutsukan zohin [Masterpieces of Japanese dress from the Bunka Gakuen Costume Museum]*. Tokyo: Bunka Gakuen Costume Museum, 2005.

Callaway, N. (ed.). *Issey Miyake*. New York: New York Graphic Society, 1988.
Carnegie, V. *Fashions of a Decade: The 1980s*. Batsford: Batsford, 1990.
Chandès, H. *Entretien avec Issey Miyake. Issey Miyake – Making Things*. Paris: Fondation Cartier pour l'Art Contemporain, 1998.
Charles-Roux, E. *Le Temps Chanel*. Paris: Editions de la Martinière, 1996.
Clarke, J., Frankel, S., Violette, R., *Hussein Chalayan*. New York: Rizzoli, 2011.
Coleridge, N. *The Fashion Conspiracy*. Portsmouth: Heinemann, 1988.

Debo, K. *Maison Martin Margiela '20' the exhibition*. MoMu Fashion Museum, Province of Antwerp. Bruges: Die Keure, 2008.
De la Haye, A. *Chanel, Couture and Industry*. London: V&A Publishing, 2011.
Derycke, L. and S. Van de Veire (eds). *Belgian Fashion Design*. Bruges: Ludion Press, 1999.
Dresner, L., S. Hilberry, M. Miro. *ReFusing Fashion: Rei Kawakubo*. Detroit: Museum of Contemporary Art, 2008.
Durland Spilker, K. and S. Sadako Takeda. *Breaking the Mode: Contemporary Fashion from the Permanent Collection – Los Angeles County Museum of Art*. Milan: Skira, 2007.

English, B. *Japanese Fashion Designers: The Work and Influence of Issey Miyake, Yohji Yamamoto and Rei Kawakubo*. London, New York: Berg, 2011.

Fogg, M. (ed). *Fashion: The Whole Story*. London: Thames & Hudson, 2013.
Fukai, A. *Future Beauty: 30 Years of Japanese Fashion*. London: Merrell

Publishers Limited and Barbican Art Gallery, 2010.
Fukai, A. (supervisor). *Japonism in Fashion*. Kyoto: National Museum of Modern Art, The Kyoto Costume Institute, 1996.

Gauthier, C. *Yamamoto & Yohji*. New York: Rizzoli, 2014.
Godfrey, J. (ed). *A Decade of i-Deas: The Encyclopedia of the '80s*. London: Penguin, 1990.
Golbin, P. *Madeleine Vionnet: Puriste de la Mode*. Paris: Les Arts Décoratifs, 2009.
Golbin, P. and F. Baron. *Balenciaga*. Paris: Thames and Hudson, 2006.
Grumbach, D. *Histoires de la Mode*, Paris: Editions du Regard, 2008.

Hodge, B., P. Mears, and S. Sidlauskas. *Skin + Bones: Parallel Practices in Fashion and Architecture*. Tokyo: National Art Centre, 2007.
Holborn, M. *Issey Miyake*. Cologne: Taschen, 1995.

Irvine, S. *Vogue on Cristóbal Balenciaga*. London: Quadrille Publishing Ltd, 2013.

Jones, T. (ed.). *Rei Kawakubo*. Cologne: Taschen, 2012.
Jouve, M. A. and J. Demornex. *Balenciaga*. London: Thames and Hudson, 1989.

Kawamura, Y. *The Japanese Revolution in Paris Fashion*. Oxford: Berg, 2004.
Kirke, B. and I. Miyake. *Madeleine Vionnet*. San Francisco: Chronicle Books, 1998.
Koda, H. *Extreme Beauty: The Body Transformed*. New York: Metropolitan Museum of Art, 2001.
Koda, H. and J. G. Reeder. *Charles James: Beyond Fashion*. New York: Metropolitan Museum of Art, 2014.
Koike, K. *Issey Miyake: East Meets West*. Tokyo: Heibonsha, 1978.
Koren, L. *New Fashion Japan*. Tokyo: Kodansha Internacional, 1984.
Kries, M., A. von Vegesack, I. Miyake and D. Fujiwara. *A-POC Making: Issey Miyake & Dai Fujiwara*. Berlin: Vitra Design Museum, 2001.

Lehmann, U. *Tigersprung: Fashion in Modernity*. MIT Press, 2001.
Loschek, I. *When Clothes Become Fashion: Design and Innovation Systems*. Oxford, New York: Berg, 2009.

Maison Martin Margiela. *Maison Martin Margiela*. New York: Rizzoli, 2009.
Martin, R. *Fashion and Surrealism*. New York: Rizzoli, 1987.
Mason, H. *Issey Miyake*, vol. 13. London: Thames & Hudson, 1997.
McDowell, *C. McDowell's Directory of Twentieth Century Fashion*. London: Frederick Muller, 1984.
Mears, P., V. Steele, Y. Kawamura and H. Narumi. *Japan Fashion Now*. New Haven: Yale University Press, 2010.
Mendes, V., de la Haye, A. *20th Century Fashion*. London: Thames & Hudson, 1999.
Miller, L. E. *Balenciaga*. London: V&A Publishing, 2007.
ModeMuseum Provincie Antwerpen. *ModeMuseum Antwerp Presents*

Maison Martin Margiela: '20' the Exhibition. Antwerp: ModeMuseum Provincie Antwerpen, 2008.

Parkins, I. *Poiret, Dior and Schiaparelli: fFashion, Femininity and Modernity*. London: Berg, 2012.

Penn, I. *Irving Penn Regards the Work of Issey Miyake*. Boston: Bullfinch Press, 1999.

Pope, R. *Creativity: Theory, History, Practice*. Abingdon and New York: Routledge, 2005.

Rabanne, P. *Trajecten: van het ene leven in het andere: de befaamde mode-ontwerper en parfumeur over reïncarnatie, occultisme en religie*. Baarn: Uitgeverij Bigot en Van Rossum, 1992.

Salazar, L. (ed.). *Yohji Yamamoto*. London: V&A Publishing, 2011.

Sato, K. *Des Vêtements par-delà le Temps. Issey Miyake – Making Things*. Paris: Fondation Cartier pour l'Art Contemporain, 1998.

Simms, A. *Future Beauty: 30 Years of Japanese Fashion*, 15 oct/10 – 6 Feb/11. London: Barbican Artgallery, 2001.

Steele, V. *Paris Fashion – A Cultural History*. New York, Oxford: Berg, 1998.

Street Magazine. *Street Magazine Maison Martin Margiela: special volumes 1 & 2*. Paris: Maison Martin Margiela, 1999.

Sudjic, D. *Rei Kawakubo and Comme des Garçons*. London: Fourth Estate, 1990.

Van Assche, A. and S. Ember. *Fashioning Kimono: Dress and Modernity in Early Twentieth Century Japan: the Montgomery Collection*. Milan: 5 Continents and V&A Museum, 2005.

Vinken, B. *Angezogen: das Geheimnis der Mode*. Stuttgart: Klett-Cotta, 2013.

Vinken, B. *Fashion Zeitgeist: Trends and Cycles in the Fashion System*. Oxford: Berg, 2005.

Wilcox, C. (ed.). *Radical Fashion*. London: V&A Publications, 2001.

Wigley, M. *White Walls, Designer Dresses: The Fashioning of Modern Architecture*. Cambridge, MA: Massachusetts Institute of Technology, 1995.

Yamamoto, Y., K. Washida and C. Sozzani. *Talking to Myself: 1981–2002*. Göttingen: Steidl, 2002.

ARTICLES

'Pacific Overtures: A Report on the New Japanese Designers', *Village Voice*, 19 April 1983.

Bennetts, L. 'Culture of Japan Blossoming in America', *New York Times*, 7 August 1982.

Betts, K, 'Women in Fashion', *Time* magazine, 9 February 2004.

Claridge, D. 'Meanwhile … on the other side of the Pacific', *i-D* (no. 6.), 1982.

Fukai, A. 'Visions of the Body: Body Image and Fashion in the 20th Century' in

Visions of the Body: Fashion or Invisible Corset, supervised by Shinju Kohmo-to and Akiko Fukai. Kyoto: Kyoto Costume Institute, 1999.

Glynn, P. 'Balenciaga and *la Vie d'un Chien*', *The Times*, 3 August 1971.
Gross, M. 'Notes on Fashion', *New York Times*, 10 December 1985.
Gross, M. 'Notes on Fashion', *New York Times*, 25 March 1986.

Huckbody, J. 'Perfection is an Ugly word', *i-D* (no. 219), April 2002.

Jones, T. 'Yohji Yamamoto', *i-D*, March 1999.

Kondo, D. 'The Aesthetics and Politics of Japanese Identity in the Fashion Industry' in *Re-Made in Japan: Everyday Life and Consumer Taste in a Changing Society*, ed. Joseph J. Tobin. Yale: Yale University Press, 1992.
Knafo, R. 'The New Japanese Standard: Issey Miyake', *Connoisseur*, March 1988.

Leduc, V. 'Balenciaga', *Vogue* (US), 15 April 1965, 83.

Mayer Stinchecum, A. 'The Japanese Aesthetic: A New Way for Women to Dress', *Village Voice* (19), April 1983.
Menkes, S. 'The Flesh and Fabric of Surrealist Design', *The Age*, 24 August 1988.
Merlin, V. 'Balenciaga devient un visage', *Paris Match* (no. 1005), 10 August 1968.
Morris, B. 'From Japan, New Faces, New Shapes', *New York Times*, 14 December 1982.
Morris, B. 'Loose Translator', *New York Times*, 30 January 1983.
Morris, B. 'The Japanese Challenge to French Fashion', *New York Times*, 21 March 1983.
Morris, B. 'Clothes that Outsmart In-Between Days', *New York Times*, 2 October 1983.
Morris, B. 'Tokyo Savoir-Faire', *New York Times*, 25 August 1985.
Morris, B. 'From the Japanese in Paris, Softer Designs', *New York Times*, 17 October 1985.

O'Flaherty, M. 'In the Black', *Financial Times Weekend*, 11 October 2009.

Polen, B. 'I'm a Feminist, But…', *Elle* (UK), November 1986.

Simon, J. 'Miyake Modern', *Art in America*, February 1999.

Thurman, J. 'The Misfit', *The New Yorker*, 4 July 2005.

Weir, J. 'The Rising Prestige of Tokyo', *New York Times*, 27 June 1982.

NOTES ON CONTRIBUTORS

MIREN ARZALLUZ is a fashion historian and freelance fashion curator specializing in Cristóbal Balenciaga. She was curator and head of collections at the Cristóbal Balenciaga Foundation from 2007 to 2013. In 2011 she published *Cristóbal Balenciaga: The Making of a Master (1895–1936)* and she continues her research on 20th century fashion as a PhD candidate at the University of Deusto and the University of Antwerp.

ANABELA BECHO has been the Fashion Conservator at MUDE – Museu Design e da Moda, Coleção Francisco Capelo since 2011. She has written for several publications including: *Vogue* Portugal, *Elle*, *GQ*, *Ícon*, *Número*. In 2015, she curated the exhibition *Kaleidoscope – The Couture of Christian Lacroix* (MUDE). She is a PhD student in Fashion Design at the University of Lisbon.

KAAT DEBO (Antwerp University) has been Director of MoMu – Fashion Museum Antwerp since 2008. She is an expert in Belgian fashion design and has curated over twenty exhibitions including *Dreamshop – Yohji Yamamoto*; *Bernhard Willhelm: Het Totaal Rappel*; *Maison Martin Margiela: '20' the Exhibition*; *Stephen Jones & the Accent of Fashion*; and *Walter Van Beirendonck. Dream the World Awake*. Her contributions to fashion theory, conceptual exhibition design and digital fashion heritage projects like Europeana are internationally acclaimed.

AKIKO FUKAI is Director and Curator Emeritus of The Kyoto Costume Institute. She joined KCI in 1979 and has been its chief curator since 1990, having curated high-profile exhibitions including *Japonism in Fashion* (The National Museum of Modern Art, Kyoto, 1994) and *Future Beauty* (Barbican Art Gallery, 2010), which investigated the impact of Japan on western fashion. The exhibitions were shown in seven museums around the world and initiated a new direction in the study of Japonism, bringing the subject of fashion into this area of research.

HETTIE JUDAH is a British author who has written extensively about fashion, art and design in various international publications. She is a contributing editor to *ArtReview*, for which she has a long-running column on visual culture, and a features writer for the *Business of Fashion*, the *New York Times* and the *Independent*. Recent books include *Footprint: The Tracks of Shoes in Fashion* and *Pattern: 100 Fashion Designers, 10 Curators*.

OLIVIER SAILLARD is Director of the Musée de la Mode de la Ville de Paris – Palais Galliera and an internationally acclaimed curator of exhibitions such as *Madame Grès: la couture à l'œuvre*; *Alaïa*; *Jeanne Lanvin*; *Comme des Garçons: White Drama*; and *Cristóbal Balenciaga: collectionneur de modes*. He is a well-known author of publications on fashion history and pushes the frontiers of fashion performance and film, collaborating with Tilda Swinton on a series of live performances with Galliera's collection items.

ALEXANDRE SAMSON works with Olivier Saillard at Musée de la Mode de la Ville de Paris – Palais Galliera, where he works on exhibitions, publications and performances. He is in charge of contemporary fashion design and in 2014, curated *Fashion Mix, Mode d'ici créateur d'ailleurs* at the Palais de la Porte Dorée, Paris.

KAREN VAN GODTSENHOVEN is Exhibitions Curator at MoMu – Fashion Museum Antwerp. She has curated exhibitions including *Unravel: Knitwear in Fashion*; *Happy Birthday Dear Academie*; *Birds of Paradise: Plumes & Feathers in Fashion*; and published widely on avant-garde Belgian fashion in international publications. Her collaborations with different artists and designers for MoMu's exhibitions turn the museum into a catalyst for contemporary creation and innovation.

PHOTO CREDITS

INDEX

ACKNOWLEDGEMENTS

EXHIBITION

THIS EXHIBITION WAS ORGANIZED BY THE EXECUTIVE
BOARD OF THE COUNCIL OF THE PROVINCE OF ANTWERP
BOARD PROVINCIEBESTUUR ANTWERPEN

PROVINCIAL GOVERNOR
Cathy Berx

PROVINCIAL REGISTRAR
Danny Toelen

MEMBERS OF THE EXECUTIVE BOARD
Luk Lemmens
Ludwig Caluwé
Inga Verhaert
Bruno Peeters
Peter Bellens
Rik Röttger

HEAD OF CULTURAL SERVICES
Walter Rycquart

EXHIBITION DESIGN
Bob Verhelst
CURATORS
Karen Van Godtsenhoven
Miren Arzalluz
GRAPHIC DESIGN
Paul Boudens

MOMU – FASHION MUSEUM

DIRECTOR
Kaat Debo
CURATOR
Karen Van Godtsenhoven
ADVISOR EXHIBITIONS
Danique Klijs
PRODUCTION MANAGER
Robby Timmermans
PRESS & COMMUNICATION
David Flamée & Leen Borgmans
CONSERVATION & INSTALLATION OBJECTS
Wim Mertens
Frédéric Boutié, Kim Verkens,
Ellen Machiels
LIBRARY AND DOCUMENTATION
Birgit Ansoms, Monica Ho
EDUCATION
Klaartje Patteet

WITH SPECIAL THANKS TO
MoMu staff, interns and volunteers
MoMu thanks the Municipality of Lisbon/
MUDE – Museu do Design e da Moda,
Coleção Francisco Capelo, the Director,
Bárbara Coutinho, and the Fashion
Conservator, Anabela Becho, for all their
collaboration and support in this edition.

Etsuko Kurihara, Cultural Centre
Embassy of Japan in Belgium.
Port of Antwerp.

LOAN GIVERS

MUSEUMS
Modemuseum Hasselt: Kenneth
Ramaekers, Karolien de Clippel
Kunstgewerbemuseum – Staatliche
Museen zu Berlin: Sabine Thümmler,
Christine Waidenschlager
Museum für Kunst und Gewerbe
Hamburg: Sabine Schulze, Angelika Riley
Palais Galliera – Musée de la Mode
de la Ville de Paris: Olivier Saillard,
Marie-Ange Bernieri, Alexandre Samson
Centraal Museum: Edwin Jacobs,
Ninke Bloemberg, Martine Kilburn
Gemeentemuseum Den Haag: Benno
Tempel, Madelief Hohé
Groningermuseum: Andreas Blühm,
Marieke van Loenhout

Municipality of Lisbon/MUDE – Museu
do Design e da Moda, Coleção Francisco
Capelo: Bárbara Coutinho, Anabela
Becho
"In 2002, Lisbon City Council acquired
the Francisco Capelo Collection, which is
outstanding due to the designers repre-
sented and the quality and significance
of the objects of design and fashion it
contains. The public purchase of this
important collection and the safeguard-
ing of its heritage were made possible
thanks to the generosity of the collector
and the desire he always expressed that
the Francisco Capelo Collection remain in
this city" (Acquisition Protocol).

Victoria & Albert Museum: Martin Roth,
Rebekka Deighton
The Museum at FIT: Valerie Steele,
Sonia Dingilian
School of the Art Institute of Chicago:
Gillion Carrara, Caroline M. Bellios

PRIVATE LENDERS

BVBA 32: Anne Chapelle, Martijn Swolfs,
Krystyna Metz
Dries van Noten: Jan Vanhoof

Balenciaga: Gaspard de Massé

Chanel: Marie Hamelin, Odile Premel
Iris van Herpen: Bradly Dunn Klerks
Maison Martin Margiela: Axel Arres
Paco Rabanne: Pauline Agostini, Margot
Girard
Yohji Yamamoto: Caroline Ponomarenko,
Richard Ghionghios
Comme des Garçons: Adrian Joffe,
Chigako Takeda
Sybilla: Luis Arias
Alexander McQueen: Hongyi Huang

Hussein Chalayan: Erin Adair

Isolde Pringiers
Georgina Godley

WITH SPECIAL THANKS TO
Ann Demeulemeester
Liliane Lijn, Isolde Pringiers, Karin Dillen
Daniel Sannwald
Stany Dederen
Rie Nii, The Kyoto Costume Institute
New John Nissen Mannequins, Rina Njoli

CATALOGUE

THIS CATALOGUE IS PUBLISHED IN ASSOCIATION WITH THE EXHIBITION
'GAME CHANGERS: REINVENTING THE 20TH-CENTURY SILHOUETTE'
MOMU — FASHION MUSEUM PROVINCE OF ANTWERP
MARCH 18, 2016 — AUGUST 14, 2016

AUTHORS
Miren Arzalluz
Anabela Becho
Kaat Debo
Akiko Fukai
Hettie Judah
Olivier Saillard
Alexandre Samson
Karen Van Godtsenhoven

GRAPHIC DESIGN
Paul Boudens

IMAGE RESEARCH
Birgit Ansoms, Monica Ho,
Karen Van Godtsenhoven
Aimélie De Belder

BLOOMSBURY PUBLISHING PLC
ISBN: 978-1-4742-7904-8